D1072479

Photography in New Mexico

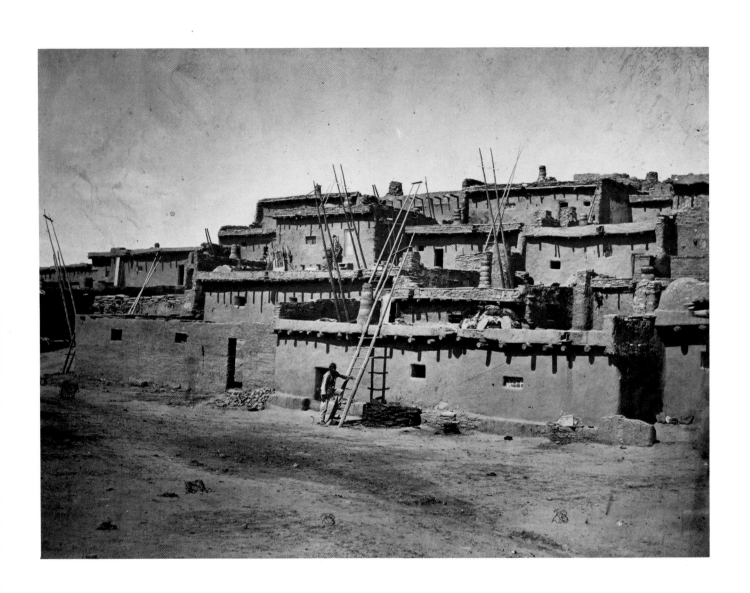

Van Deren Coke

Photography in New Mexico

From the Daguerreotype to the Present

Foreword by Beaumont Newhall

UNIVERSITY OF NEW MEXICO PRESS Albuquerque

To my son Sterling and daughter Browning who, although born elsewhere, are now truly New Mexicans.

Library of Congress Cataloging in Publication Data

Coke, Van Deren, 1921–
 Photography in New Mexico.

 Bibliography: p. 149
 Includes index.
 1. Photography—New Mexico—History.
2. New Mexico—History. I. Title.
TR24.N6C64 770'.9789 78-21370
ISBN 0-8263-0495-8

Contents

Illustrations		vii
Foreword		ix
Preface		xi
1	The Early Photographers	1
2	The Great Surveys	4
3	Pictures of New Mexico's Land and People	10
4	The Early Modern Photographers	22
5	The Farm Security Administration and Office of War Information Photographers	30
6	The Postwar Period	32
7	The 1960s and 1970s	37
Plates		47
Notes		148
Selected Bibliography		149
Chronology		153
Index		155

Illustrations

PLATES

1. Alexander Gardner, *Across the Continent on the Union Pacific Railway, E. D.* (El Moro, Inscription Rock), 1867
2. Alexander Gardner, *Across the Continent on the Union Pacific Railway, E. D.* (Rio Grande del Norte), 1867
3. William H. Rau, *Carretta: Pueblo San Juan*, 1881
4. William Henry Brown, *Santa Fe and Vicinity: A Mexican Residence*, c. 1880
5. William Henry Brown, *Pueblo Tesuque Series: Mexican Carreata*, c. 1880
6. John K. Hillers, *Middle Court of Zuni*, c. 1880
7. John K. Hillers, *Hedida, a Navajo Woman*, c. 1880.
8. John K. Hillers, *Pueblo de San Ildefonso, N.M.*, c. 1880
9. Timothy H. O'Sullivan, *Cañon de Chelle, Walls of the Grand Cañon*, 1873
10. Timothy H. O'Sullivan, *Aboriginal Life among the Navajoe Indians*, 1873
11. Timothy H. O'Sullivan, *Old Mission Church, Zuni Pueblo, N.M.*, 1873
12. Timothy H. O'Sullivan, *Ancient Ruins in the Cañon de Chelle, N.M.*, 1873
13a. Franklin A. Nims, *Old Church, Laguna*, c. 1890
13b. W. Calvin Brown, *Church at Laguna, N.M.*, c. 1885
14. William Henry Brown, *San Francisco St. Looking East*, n.d.
15. William Henry Jackson, *Pueblo de Taos*, c. 1880
16. William Henry Jackson, *Pueblo of Taos*, c. 1880
17. William Henry Jackson, *Pueblo Indian and Burro*, c. 1880–90
18. William Henry Jackson, *Maria and Benina, Pueblo Women*, c. 1880
19. George Ben Wittick, *Man and Woman of Pueblo Laguna*, c. 1885
20. George Ben Wittick, *A View in Zuni Pueblo*, c. 1880
21. George Ben Wittick, *View in Pueblo Zuni*, c. 1890
22. J. L. Clinton, *Adobe House and Burros*, c. 1890
23. William Henry Brown, *The Governor of Cochiti and His Family*, 1881–82
24. Dana B. Chase, *Signor Peso, Chief of Scouts Who Captured Geronimo*, c. 1889
25. Joseph Edward Smith, *Garcia Opera House, Socorro*, 1887
26. Henry A. Schmidt, *Clown*, c. 1909
27. Henry A. Schmidt, *Martin Miranda and Family*, c. 1909
28. Eddie Ross Cobb and William Henry Cobb, *Boss Saloon, Albuquerque*, 1897
29. Attrib. to James N. Furlong, *Catching Horses in the Morning*, c. 1887
30. Adam Clark Vroman, *Rain Dance With Clowns*, 1899
31. Adam Clark Vroman, *Zuni Interior*, 1897
32. Arnold Genthe, *Untitled* (children and pueblo houses), 1899 or 1926
33. William Pennington, *Navajo Portrait*, c. 1911
34. Karl E. Moon, *Indian Seated in Front of Fire*, c. 1907
35. Karl E. Moon, *Isleta Indian Woman*, c. 1905
36. Edward S. Curtis, *The Potter—Santa Clara*, c. 1904
37. Edward S. Curtis, *Waíhusiwa, a Zuni Kyáqĭmâssi*, c. 1902
38. Laura Gilpin, *Taos Indian Woman*, 1923
39. Ansel Adams, *Pueblo Laguna*, c. 1929
40. Ansel Adams, *Interior, Penitente Morada*, c. 1929
41. Ansel Adams, *Moonrise, Hernandez*, 1941
42. Paul Strand, *Buttress, Ranchos de Taos Church*, 1931
43. Paul Strand, *Roberta Hawk, Taos*, 1931
44. Paul Strand, *Ghost Town*, 1931
45. Edward Weston, *Aspen Valley*, 1937
46. Edward Weston, *Nude in Albuquerque*, 1937
47. Edward Weston, *Santa Fe–Albuquerque Highway*, 1937
48. Willard Van Dyck, *Ovens, Taos*, 1931
49. T. Harmon Parkhurst, *Buffalo Dance, San Ildefonso Pueblo*, c. 1935
50. Philip E. Harroun, *Procession of La Conquistadora, Santa Fe*, 1897
51. H. F. Robinson, *Corn Dance, Santa Clara Pueblo*, c. 1915
52. Barbara Morgan, *Willard Morgan with Leica, Bandelier National Monument*, 1928
53. Ernest Knee, *Taos Pueblo*, 1941
54. Laura Gilpin, *Navaho Covered Wagon*, 1934
55. Laura Gilpin, *Camposanto El Valle*, 1961

56. Laura Gilpin, *Church at Picuris,* 1962
57. John S. Candelario, *Two Crosses,* c. 1942
58. Arthur Rothstein, *Mescalero Reservation Teepee,* 1936
59. Jack Delano, *Almeta Williams, Beatrice Davis, and Liza Goss Cleaning Out Potash Cars, Clovis, N.M.,* 1943
60. Russell Lee, *Caudill and Neighbor Building a Dugout, Pie Town,* 1940
61. Russell Lee, *Community Sing, Pie Town,* 1940
62. Russell Lee, *Dance at Peñasco,* 1940
63. Dorothea Lange, *Powell Family,* 1937
64. John Collier, *Lopez Home, Trampas,* 1943
65. Harvey Caplin, *Bell Ranch,* 1946
66. Henri Cartier-Bresson, *Taos,* 1947
67. Wright Morris, *Powerhouse and Palm Tree,* 1940
68. Robert Frank, *Santa Fe,* 1955
69. Robert Frank, *Gallup,* 1955
70. Todd Webb, *Untitled* (bones in Abiquiu), c. 1968
71. Eliot Porter, *Cow Bones,* 1972
72. Brett Weston, *Untitled* (sand and scrub), 1946
73. Cavalliere Ketchum, *Stella Silva, Maureen O'Sullivan, and the Virgin Mary,* 1970
74. Anne Noggle, *Santa Fe Summer No. 1,* 1976
75. Danny Lyon, *Llanito,* 1970
76. Thomas E. Zudik, *John D. Robb,* 1969
77. Minor White, *Wall, Santa Fe,* 1966
78. Wayne Gravning, *Canjilon Lakes,* 1966
79. Arthur LaZar, *Rooftop—Cordova,* 1973
80. Richard Faller, *White Sands,* 1969
81. Thomas J. Cooper, *Untitled* (woods), 1972
82. Arthur LaZar, *Lava Flow,* 1970
83. Robert d'Alessandro, *John and Susan and Jimmy, Placitas,* 1976
84. Meridel Rubenstein, *C. C. Cass and "The Good Old Days,"* 1976
85. Frank W. Gohlke, *Landscape—Albuquerque, 1974,* 1976
86. Rick Dingus, *Untitled #12,* 1977
87. Lee Friedlander, *Santa Fe,* 1975
88. Lee Friedlander, *Valley of the Fire,* 1975
89. Paul Diamond, *Tourist, N.M.,* 1971
90. Betty Hahn, *Starry Night Variation #2,* 1977
91. Kevin Wrigley, *#6: Impregnated Sheathing,* 1977
92. Nicholas Nixon, *La Fonda, Santa Fe,* 1973
93. Paul Caponigro, *Acoma Pueblo,* 1970
94. Joe Deal, *Untitled View* (Albuquerque), 1975
95. William Clift, *Rainbow, Waldo, N.M.,* 1978
96. Edward Ranney, *Quarai, N.M.,* 1978
97. Ray Metzker, *Untitled* (sky, wall, palm, and rocks), 1972
98. Ralph Gibson, *Untitled* (hand with gun), 1972
99. Thomas Patton, *Untitled* (wall with stairwell), 1977
100. Richard Barish, *Untitled* (asphalt with strip), 1977
101. Kenneth W. Baird, *Untitled* (horizon), 1977
102. James K. Dobbins, *Albuquerque 76Z178,* 1976

Foreword

The roster of photographers who have done major work in New Mexico is a microcosm of the history of photography. Great names resound in the roll call, reaching from Edward Weston, Paul Strand, Ansel Adams, Henri Cartier-Bresson, and Eliot Porter back to the hardy pioneer expeditionary photographers of the nineteenth century: Alexander Gardner, Timothy H. O'Sullivan, William Henry Jackson, and J. K. Hillers.

These master photographers and dozens more, whose names and work we are only beginning to know, were pulled to this area of the United States as by a magnet. As Professor Coke points out, and as the plates he selected for this book so clearly show, these photographers were drawn by a variety of attractions: by the sheer beauty of the land, the magnificence of mountain and desert; by the opportunity to record the remnants of a past civilization and the manners and customs of living Indian tribes; by the indigenous, highly photogenic architecture of Spanish America. They came at first to photograph the lay of the land and the ways of the people they met, creating pictures as documents to support the maps of the cartographers and the reports of the geologists, anthropologists, and other scientists whom they accompanied over the uncharted ground, packing their huge cameras and processing gear on mules, developing their negatives on the spot.

They found more than they sought: the light of the Southwest. Light, as the explorer-journalist-photographer Charles Lummis wrote, "that has that ineffable clarity, that luminousness, which make a photographic light to be matched in no other civilized country." A light that reveals and envelops. A light that produces harsh, yet not violent, contrasts.

And they found magnificent clouds, that bring the sky to the earth or float majestically over the earth as if in protection. They found the earthen adobe buildings a delight to photograph and the peoples of different cultures a challenge.

Interestingly, the epochs of these photographic discoveries parallel the growth of New Mexico. The era of exploration brought the large camera, capable of recording great detail and of encompassing the vastness of the land as well. The coming of the railroad in 1880 coincided exactly with the introduction of the hand camera and of film, with which tourists could take casual snapshots of scenes as exotic to them as a faraway foreign country. The choice of New Mexico by painters as a residence, and the founding of art colonies here, brought many a pictorial photographer to the area. Most recently, the establishment of a strong department of photography at the University of New Mexico is bringing to younger photographers fresh outlooks and techniques, together with an understanding of the creative traditions of the medium.

This book is a record of little-known work done in New Mexico by photographers whose names are now legendary, as well as unpublished work by photographers only recently brought to light. Thus it constitutes a contribution both to the general history of photography and to its specific development in the state of New Mexico. It is also a stimulating demonstration of the reaction of many gifted photographers to a common environment, a pictorial anthology of individual vision.

Beaumont Newhall

Preface

This is by no means a complete history of photography in New Mexico. Richard Rudisill's pioneering publication "Photographers of the New Mexico Territory 1854–1912," which is being corrected and greatly expanded, lists dozens of photographers not mentioned here. A great many photographers who have worked and lived in New Mexico over the last fifty years could have been included in this history. Space limitations dictated, however, that I stress those photographers who have made contributions of a certain aesthetic or communicative nature.

A number of history of photography graduate students assisted in compiling information and doing interviews for this publication. I am indebted to Amy Conger, Elizabeth King, Rebecca Morgan, and Daniel Bortko for this type of preliminary research. I also wish to express my thanks to the photographers who provided information about themselves and loaned their work for reproduction, and to Arthur Olivas of the Museum of New Mexico and Jerold Maddox of the Library of Congress for the help they gave.

The Early Photographers

Upon his first visit to New Mexico, Ansel Adams said, "This is the most completely beautiful place I have ever seen. A marvelous snowy range of mountains rises from a spacious emerald plain and this little Old World village [Taos] nestles close to the hills. Adobe—bells—color beyond imagination—and today, the heavens are filled with clouds."[1]

New Mexico is a land of nature's mysteries inhabited by a people that make of mystery something palpable and stirring. For these and other reasons, New Mexico has attracted more famous photographers in the past hundred and twenty years than any area in the West, except perhaps California. Gardner, O'Sullivan, Jackson, Curtis, Strand, Weston, Adams, Cartier-Bresson, Gilpin, Lange, Frank, Caponigro—these are the names of only a few of the distinguished photographers who have taken pictures in New Mexico. Some of these have spent only short periods of time in the area; others have taken up residence and become major figures in various communities.

The first highly skilled photographers to work in the area came to take a hard look at the lay of the land, and to record the kinds of vegetation and minerals that existed in the area. Many of those who came later, first to the Territory and later to the State, did so to record the Indians and the unique styles of adobe architecture built by them and by the Spanish Americans. The next arrivals often took as their subjects the beauty of the land and the Hispanic people. The coming of the railroad in 1880 successfully encouraged tourism, creating a market for mementos for those who made the long trip over the Santa Fe Railroad. Curiosity in the East, generated by reports of venturesome travelers and articles in popular journals, gave employment to dozens of photographers in New Mexico. The stereograph was in its second great period of popularity in the 1880s and 1890s. Thousands of these little dual images, which evoke a real sense of depth when seen in a viewer, were of New Mexico subjects. They were sold in large quantities to tourists and for the entertainment and enlightenment of armchair travelers.

During the Great Depression of the 1930s, New Mexico was extensively photographed by members of the Farm Security Administration team that was documenting the migration of people displaced by drought in Oklahoma and Texas and the special character of the state's many-faceted economy and social makeup. Since World War II photographers seeking a sanctuary from big-city life have come to New Mexico, responding to the region's unique qualities and the possibility of capturing Indian life on film.

The earliest surviving New Mexico photograph is a daguerreotype portrait of the prominent Hispano priest Padre Antonio José Martínez, who was born in Abiquiu but spent forty years as a leader in the Taos community. History is made very real when we study the face of this man, who helped to reduce ignorance by establishing the first coeducational school in the

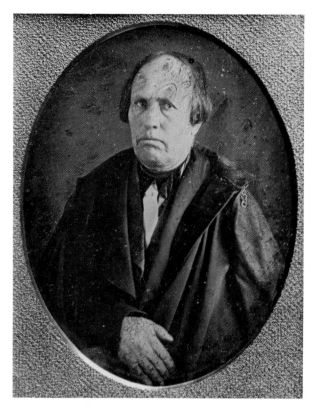

Unidentified photographer, *Padre Antonio José Martínez of Taos,* c. 1847. Daguerreotype. Loan from Ward Alan Minge to University of New Mexico Art Museum.

Where and how he learned daguerreotyping is not known, but in 1853 he opened a portrait studio. By 1856 Seligman had opened his own mercantile company in Santa Fe's plaza and apparently had given up photography.

J. G. Gaige, a traveling camerman en route from Arizona, was probably the next photographer to work in Santa Fe. He made daguerreotypes, ambrotypes, and paper photographs in the early 1860s in Santa Fe, and in 1865 signed a contract with the chief quartermaster of the New Mexico Military District to photograph all the posts in the district. He seems to have been active in 1866 at Fort Sumner, where the Navahos were held in captivity until 1868. The character of Gaige's pictures is not known, since no work has been positively identified as his.

Nicholas Brown, who had been a daguerreotypist and ambrotypist in St. Louis from 1857 to 1866, came to Santa Fe with his son, William Henry, and opened

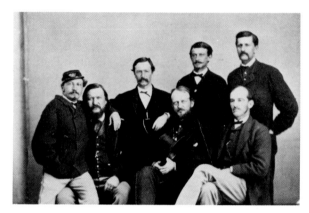

Nicholas Brown, *Group Portrait with Capt. Louis Felsenthal (3d from left),* Santa Fe, c. 1866–67. Modern silver print from negative in the Collection of the Museum of New Mexico, Santa Fe. Collection of University of New Mexico Art Museum.

Nicholas Brown, logotype on verso of above.

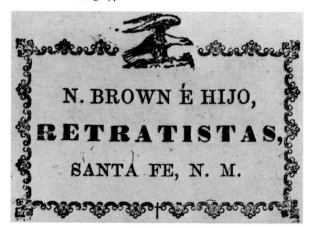

Southwest, operating a printing press, and publishing the newspaper *El Crepúsculo.* The portrait was made in Taos by an unknown cameraman in about 1847, the year in which Martínez was accused of fomenting an uprising of the region's Spanish people. For this he was defrocked in 1854 by the French-born archbishop, Jean Baptiste Lamy, of Santa Fe.

Itinerant portrait photographers were probably at work in Santa Fe and Taos soon after the American forces took over the territory in 1846 at the beginning of the Mexican War. One of them may have made the Padre Martínez daguerreotype. There is no indication that Mexican photographers were working in New Mexico before it was taken over by the United States. The first photographer we know by name was Siegmund Seligman, who came to Santa Fe in 1851 or 1852. He was one of the thousands of Germans who came to America after the failure of the revolution in Germany in 1848 and the consequent tightening of class barriers and decrease in business and social opportunities for liberals. Many of the immigrants from Germany moved to the Midwest, and a few made the long trek over the Santa Fe Trail to New Mexico. Seligman worked first as a clerk in the mercantile firm of Spiegelberg Bros.

a studio there in 1866. Brown traveled around a great deal from 1866 through 1868, visiting Fort Union and Albuquerque, and started a studio in Chihuahua, Mexico, before returning to Santa Fe and leaving the operation of the studio to his son, who ran it for two years before returning to Santa Fe. Nicholas Brown was active as a photographer of *cartes,* the very popular calling-card-size portraits. He also made *cartes* of scenes in Santa Fe for sale as souvenirs and, later, large paper prints, such as the stark view of the south side of the Palace of the Governors looking east (1868–69). The logo printed on the back of his *cartes* was sometimes in Spanish, N. Brown é Hijo, and sometimes in English, N. Brown and Son, an indication of his appeal to a wide audience in tricultural Santa Fe. Brown's pictures are not always distinguished artistically, but they are comparable to contemporary works of eastern studio photographers catering to popular tastes. Henry T. Heister may have preceded Nicholas Brown to Santa Fe. Brown probably bought out Heister, but no early Heister photographs have been identified as yet. Further research is needed on this point.

There is literary evidence that William A. Smith photographed in Santa Fe in 1866, in partnership with a man named Wertz. Smith came into New Mexico by the usual northeastern route, through Raton. Apparently he was photographing the Navaho Indians at Fort Sumner for the special Indian commissioner, Julius K. Graves, who was sent to New Mexico to investigate the treatment of the Navahos in captivity. So far no work has been located that can be positively connected with Smith and Wertz. Even vaguer is the evidence of a photographer named Corkin, who, according to William Smith's diary, was active in 1866 in Santa Fe.

2

The Great Surveys

After the Civil War there was renewed interest on the part of the government and private corporations in exploring the continent. Western expansion was fostered by the drive to complete transcontinental railroads and learn of the mineral riches in the Rocky Mountains. Alexander Gardner and Timothy O'Sullivan were the first prominent photographers to record extensively the distinctive characteristics of the virtually uncharted Southwest. Their perceptions had been honed by their work as field photographers during the Civil War, where they had taken relentlessly honest pictures to serve the serious purpose of informing people of the true nature of war. They were well aware of their responsibility to document the characteristics of the land, the types of rocks they encountered, and the vegetation, and to give some indication of the life of the Indians. When their work was eventually shown in the East, the clarity of their pictures showed all kinds of people the nature of the land in New Mexico and the Southwest. The general public gained a new awareness of the American identity, and specialists, such as geologists and soil experts, could readily detect in the photographs the likelihood of the presence of specific minerals, determine to a degree the fertility of the land, and get a clear idea of the difficulty of laying railroad tracks.

Gardner, the first of the two to come to New Mexico, was born in Scotland. He was brought to the United States to live in a communal settlement in Iowa that subsequently failed. In 1856 he was employed by the great photographer Mathew Brady because of his thorough knowledge of the then-revolutionary wet-collodion process. In the early years of the Civil War he was a portraitist and field photographer for Brady. Before the war was over he left his position as manager of Brady's Washington studio to set up his own portrait studio in the capital.

After the war, in the fall of 1867 and into 1868, Gardner, feeling the lure of the West, journeyed across Kansas. He followed the route of the Kansas Pacific Railroad, then being pushed westward toward a juncture with the main line of the Union Pacific, near the present eastern border of Colorado. He carried a stereo camera and 8-by-10-inch and 11-by-14-inch view cameras. In New Mexico he seems to have used only the 8-by-10-inch camera masked to make 6-by-8-inch negatives.

According to a report of Dr. William Bell, an Englishman who was serving as physician and photographer for a survey for the same railroad in the same year, the party with which Gardner traveled probably consisted of engineers (transitmen, topographers, levelers, and draughtsmen) as well as axmen, flagmen, cooks, and teamsters. A troop of thirty cavalrymen provided by the government afforded protection for the survey crews, for the Apaches were still hostile. The men and equipment were transported in wagons pulled by six mules. As many as forty horses were used to explore areas off the main route and to transport those who did not ride in the supply wagons. It was in one of the wagons or in the back of a buggy that Gardner would have had his photographic materials and set up his darktent.

The team Gardner was accompanying entered New Mexico at Raton Mountains, in the northeastern

Unidentified photographer, *Alexander Gardner's Dark Room Wagon in Kansas,* 1867. Silver print of albumen stereograph in the Collection of the Library of Congress. Collection of University of New Mexico Art Museum.

corner of the Territory. The group then proceeded through the 6,166-foot-high Cimarron Pass to Fort Union. Two routes were then surveyed. One was by way of Galisteo, where, the report states, "there is no timber fit for construction, although there is enough cedar and piñon for fuel." The other was east of Sandia Mountain through Tijeras Canyon, which they found well timbered. The two groups met at Albuquerque and proceeded west to Zuni by way of Laguna Pueblo. In 1868, upon the completion of this campaign, a portfolio entitled *Across the Continent on the Kansas Pacific Railroad* was published in Washington. It included 127 of Gardner's 6-by-8-inch photographs, at least 25 or 26 of them made in New Mexico. Among these were "No. 58, Las Vegas, New Mexico," "No. 61, Crossing of the Line of Tecolote Creek, New Mexico," and "No. 83, Ancient Pueblo Town of Zuni." Because the New Mexico photographs taken west of the Rio Grande, and those taken in Arizona and California along the 35th parallel, were of a territory where a projected survey road, rather than an already established route, was the focus, they covered many more subjects. In addition to appearing in the portfolio, Gardner's photographs, in a slightly reduced 3¾-by-5¼-inch format, were used to illustrate the *Report of Surveys Across the Continent in the Thirty-fifth and Thirty-second Parallels, for a Route Extending the Kansas Pacific Railway to the Pacific Ocean at San Francisco and San Diego,* by Gen. William

J. Palmer, published in 1869 in Philadelphia. Some of the photographs in this 1869 publication differed from those that had appeared in the 1868 portfolio. Made in New Mexico in late September and early October were such views as "Las Vegas Foothills," "Hot Springs of Vegas," "The Surveying Party at Agua Fria," "Tijeras Canon (*sic*)," "Placida of Mexican House, Los Lunas," "Cubero, N.M., Western Outpost of 35th Parallel," and "El Moro or Inscription Rock, Western New Mexico."

Timothy O'Sullivan was the next highly skilled photographer to work in New Mexico. O'Sullivan had come to New York as a child when his parents fled the famine that plagued Ireland in the 1840s. As a youngster, O'Sullivan apparently was employed at one of Mathew Brady's famous Broadway galleries to do odd jobs. This experience led him to photography as a profession; when Alexander Gardner was in charge of Brady's Washington gallery in the late 1850s, O'Sullivan joined him as an experienced cameraman. During the Civil War he frequently saw action as he roamed over the battlefields near Washington. In his semiofficial capacity as a war photographer he took hundreds of large views for Brady, showing the aftermath of the history-making events, since cameras and glass plates were too slow to catch the action of battles in progress.

The Civil War helped photographers to master the formidable problems posed by wet-collodion photography in the field. This reliable but cumbersome process, which was the favorite of all American field photographers, involved a knowledge of chemistry and optics, as well as perseverance and a hearty constitution. The glass plates used for negatives were heavy, easily broken, and messy to sensitize; also they required a portable darkroom (a "darktent," really) close at hand. Despite these difficulties, the wet-plate or collodion process produced sharp negatives from which an unlimited number of clear pictures could be made. The negatives were sensitized with a syruplike mixture in the darktent shortly before exposure. The picture was made while the negative was damp, and developed directly after leaving the camera. This meant that if a picture was not satisfactory it was known immediately after development, so while the tripod-mounted camera was still in place, another negative could be exposed. This assurance of technically successful pictures accounts for the striking number of good early photographs of the West. The difficulties of field photography, as well as the arduous journey to the West, made for great care on the part of the cameramen. Because they had had some art training before becoming photographers or had learned that well-composed pictures served scientists as well as

did dry documents, and sold to the public more readily, these men took care to produce attractive pictures. Generally photographers on U.S. government surveys of the West had the right to sell pictures to the public after their work had been made up into portfolios or pasted into printed reports for members of Congress or government agencies. Pictures were rarely enlarged, owing to the relative slowness of the albumen paper used to print negatives in the 1860s and 1870s and the expense involved in securing a nondistorting lens and a reliable light source. If you wanted an 8-x-11-inch picture you had to have a camera made to take this popular size of negative. It cannot be overemphasized that the size of the camera, as well as the size and weight of the glass for negatives and chemicals for sensitizing and development, had an influence on the character of the photographs produced in the two decades after the Civil War. Because of the time and money it took to make a good negative, great care was exercised when coating the plates, especially in the field, and making an exposure after traveling miles to find the best viewpoint. Expeditionary photographs were sharp and simply composed, with emphasis on the conveying of information. Rarely did a picturesque note creep in to indicate the photographer was stirred romantically by the lunar landscape or by rivers that had cut their way into the earth's crust. A terrain that would have brought out the flamboyant streak so prevalent in America's landscape painters in the 1860s and 1870s was seen and recorded in remarkably objective terms by Gardner and O'Sullivan.

A photographer of exceptional talent and one of the best wet-plate operators, O'Sullivan first came to the Southwest with Clarence King's U.S. Geological Expedition of the Fortieth Parallel in 1868. He concentrated on geological information in Nevada, Utah, and Colorado. In 1871, 1873, and 1875 he returned with Lt. George Wheeler's expedition, sent to survey the West and determine its suitability for development. A list of O'Sullivan's subjects in New Mexico gives us an idea of the territory he covered and the kind of photographs then thought to be useful for scientists, land developers, and railroad engineers.

O'Sullivan used an 8-x-11-inch camera in 1873 in New Mexico. His subjects included in *Geographical & Geological Explorations & Surveys West of the 100th Meridian under Lieut. George M. Wheeler—War Department, Corps of Engineers, U.S. Army* were

> Aboriginal Life among the Navajoe Indians (near Old Fort Defiance)
> Historic Spanish Record of the Conquest, South Side of Inscription Rock

> Ancient Ruins in the Canon de Chelle (in a Niche 50 Feet above Present Canon Bed)
> The Church of San Miguel (the Oldest in Santa Fe)
> Canon de Chelle (Walls of Grand Canon about 1200 Feet in Height)
> Section of South Side of Zuni Pueblo
> South Side of Inscription Rock
> Canon de Chelle (Walls of Canon about 1200 Feet in Height)
> Indian Pueblo, Zuni, View from the South
> Old Mission Church, Zuni Pueblo
> Section of South Side of Zuni Pueblo

Also in 1873 he made stereographs. Some of the subjects were

> Group of Zuni Indian "Braves," at their Pueblo
> War Chief of the Zuni Indians
> Ruins in Canon de Chelle
> Circle Wall, Canon de Chelle
> Explorers Column, Canon de Chelle
> Central Portion of Canon de Chelle
> Camp Beauty, Canon de Chelle
> Aboriginal Life among the Navaho Indians, Canon de Chelle. Squaws Weaving Blankets.
> Navaho Indian Squaw, and Child, at their Home, in Canon de Chelle
> Navaho Boys and Squaw, in front of the Quarters at Old Fort Defiance
> Navaho Brave and his Mother

In 1874, while with Lieutenant Wheeler's survey, he photographed in New Mexico with a stereo camera

> Pah-ge, a Ute Squaw, of the Kah-Poh-Teh Band, Northern New Mexico
> Ute Braves, of the Kah-Poh-Ten Band, Northern New Mexico, in "Full Dress"
> Jicarilla Apache Brave and Squaw, Lately Wedded
> Shee-Zah-Nan-Tan, Jicarilla Apache Brave in Characteristic Costume, Northern New Mexico
> Characteristic Ruin, of the Pueblo San Juan
> Lagunas Caballo, or Horse Lakes, 14 Miles, N. W. from Tierra Amarilla

The equal of O'Sullivan as a skilled landscapist but not so well known was John Hillers, who came to the United States from Germany. He started his western career in 1872 as an oarsman for Maj. John Wesley Powell's expedition along the Glen Canyon region of the Colorado River. When Powell's official photographer became ill, Hillers filled in for him; eventually he became the region's most famous ethnological photographer.

In the 1870s the government was conducting four separate surveys in the West. In 1879, Congress combined all four into the U.S. Geological Survey. Under this agency was formed the Bureau of Ethnology. John Wesley Powell was the first director of these agencies, and John Hillers was put in charge of photography for the Geological Survey. In late 1879 and into 1880 Hillers accompanied Col. James Stevenson to New Mexico and Arizona to explore and record the pueblos. He extensively photographed the sites, layouts, and details of the New Mexico pueblos along the Rio Grande and west to Zuni. The clarity of his pictures conveys in detail the physical character of the land and rocks that surrounded the Indians' houses. The pictures show the effect of weather on the earth roofs and walls of the buildings and tell us much about the construction

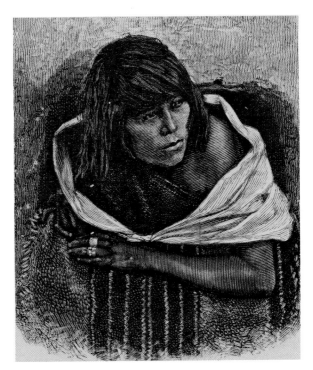

After John K. Hillers, *Zuni Woman at a Window*, from *Harper's Weekly*, Jan. 28, 1882. Wood engraving. Extended loan to University of New Mexico Art Museum.

After John K. Hillers, *Zuni Indians and Donkeys*, from *Harper's Weekly*, Jan. 28, 1882. Wood engraving. Extended loan to University of New Mexico Art Museum.

John K. Hillers, *Zuni Watching*, c. 1880. Albumen print. Gift to University of New Mexico Art Museum by Mrs. William S. Brewster.

John K. Hillers, *Zuni Transportation*, c. 1880. Albumen print. Extended loan to University of New Mexico Art Museum.

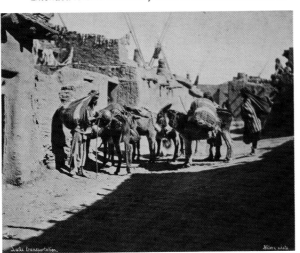
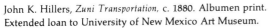

and organization of the living quarters and open passages between the various types of rooms. Even today Hillers's photographs throw light on perennial questions about the social structure of life among the Indians of the Southwest; they are also pleasing from a pictorial standpoint. His portraits of Indians posed before geometric Navaho blankets are as informative as his pictures of their architecture. He had a talent for selecting good locations for his camera so that the viewer of his pictures can grasp easily the settings of the pueblos; he used figures sensitively to indicate scale. Hillers's large prints and his stereographs are outstanding from both the technical and artistic standpoints. They were often reproduced by hand in the form of wood engravings, direct mechanical reproduction not being possible at that time, in the popular periodical *Harper's Weekly*.

The most famous landscape photographer in the Rocky Mountain region was William H. Jackson. He was American born and a veteran of the Civil War,

but was not involved with photography during that conflict. Jackson began his career in 1869 as a photographer in a studio in Omaha. Soon tiring of the stuffy life of a portraitist, he made a free-lance trip as a stereo photographer along the recently laid tracks of the Union Pacific Railroad. Soon he was hired by Professor F. V. Hayden to make photographs of the landscape in the Wyoming Area.

In 1874 Jackson photographed for Hayden's U.S. Government Survey aspects of Arizona, Utah, and New Mexico. He made some very impressive records with wet-plate negatives at Canyon de Chelly and Laguna Pueblo in New Mexico. The amount of equipment a field photographer needed when using the wet-collodion process was staggering. The following list of the items Jackson took with him in 1875 when he was with the Hayden surveys is typical of the array of chemicals, glass, and cameras used by the survey photographers.

Stereoscopic camera with one or more pairs of lenses
5 x 8 inch Camera box plus lens
11 x 14 inch Camera box plus lenses
Dark tent
2 Tripods
10 lbs. Collodion
36 oz. Silver nitrate
2 quarts Alcohol
10 lbs. Iron sulfate (developer)
Package of filters
1½ lbs. Potassium cyanide (fixer)
3 yds. Canton flannel
1 Box Rottenstone (cleaner for glass plates)
3 Negative boxes
6 oz. Nitric acid
1 quart Varnish
Developing and fixing trays
Dozen and a half bottles of various sizes
Scales and weights
Glass for negatives, 400 pieces

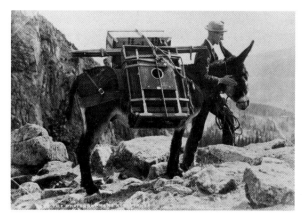

William H. Jackson, *The Photographer and Hypo*, c. 1887. Albumen print. Courtesy of Beaumont Newhall.

William H. Jackson, *Pueblo Laguna, N.M.*, c. 1880. Modern silver print. Courtesy of the Library of the State Historical Society of Colorado.

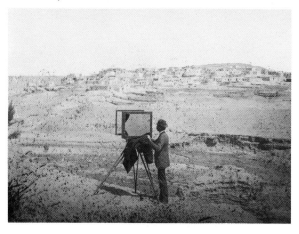

The Philadelphia Photographer enthusiastically reported in January 1875 that Jackson's pictures

from the regions of New Mexico and the Rio Grande comprise ruins, rivers, lakes, rocks, and mountains. Each picture seems to have been admirably chosen, and would form a subject for a painter. As specimens of photography, we think they excel anything in landscape work we have ever seen made in this country. Aside from the interest they possess in picturing scenery in our own country, of which, heretofore, but little has been known, they are most excellent artistic studies.[2]

On this campaign he used for the first time Anthony's Novel camera, which took 20-by-24-inch glass plates. This was the largest camera used in America up to that time. In 1877 Jackson continued survey work in the San Juan Basin and farther south. Starting from Santa Fe he proceeded southwest to Laguna and Acoma pueblos and then west to Zuni and Fort Defiance. Hoping to avoid carrying the weight of glass, chemicals, and darktent by using the recently introduced dry films, Jackson imported from England 400 8-by-10-inch "sensitive negative tissues." Unfortunately, this negative material failed to produce any images when developed, a tremendous disappointment after all the work that went into the trip, and an indication of why the reliable wet-collodion process continued to be used long after dry plates were available.

In 1881 Jackson returned to New Mexico and made some very pleasing views in Santa Fe and along the Rio Grande between Santa Fe and Taos; he took some formal and informal pictures of Pueblo Indians as well. A view of the badly deteriorated St. Michael's Church, the oldest in the United States, and a picture of one Diego and his burro at San Juan Pueblo were two of a number of pictures from 8-by-10-inch glass plates that were also sold as 16-by-21-inch pictures. This means they were rare

enlargements, made in Denver with the Solar camera, a primitive form of enlarger that used the sun's rays concentrated by a lens passing through the negative during an exposure of up to three or four hours, the albumen paper being very insensitive. The Solar camera had to be tracked with the sun as it moved across the sky during these long exposures, which often caused slight fuzziness in the images, because of poor lenses and wobbly mounting of the enlargers on studio rooftops.

Late in his life Jackson spent much of his time painting from photographs he had made earlier in his career. Probably on one of his 1880s trips to New Mexico he photographed an Indian standing in a carreta at Laguna Pueblo. His painting from this photograph included most of the details recorded by his camera. To increase the viewer's sense that the pueblo was inhabited, he added in the painting a young Indian carrying a baby, in the center of the composition, and a woman with a pot on her head, near the right edge. Because wet-collodion negatives were very sensitive to blue, skies were usually recorded in prints as cloudless and light tan in color. Jackson added clouds in his painting—clouds that probably floated above the scene when he set up his camera but did not register on his glass plate.

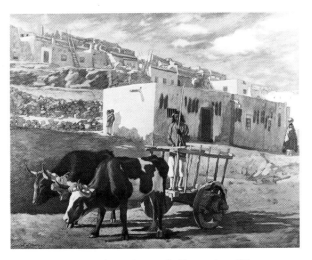

William H. Jackson, *Laguna Pueblo*, c. 1880. Oil on canvas. Courtesy of the Joslyn Art Museum, Omaha, Nebraska.

William H. Jackson, *The Old Carreta, Laguna, N.M.*, c. 1881. Modern silver print. Extended loan to University of New Mexico Art Museum.

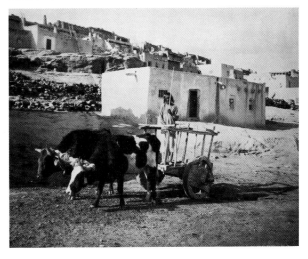

3

Pictures of New Mexico's Land and People

In 1878, Ben Wittick came to the Southwest. He was the first longtime resident photographer to specialize in large-camera, outdoor work as well as being a studio portraitist. Born in Pennsylvania, he was a Civil War veteran, and had campaigned against the Sioux. He began his career in New Mexico, as a photographer for the Atlantic and Pacific Railroad, a line that was to become part of the famous Atchison, Topeka & Santa Fe. Starting in March 1881 and continuing into 1882, he and R. W. Russell maintained the Blue Tent Studio in Albuquerque; just as the name implied, this was a tent, located near the newly opened railroad line. Wittick later opened a studio in Santa Fe. His major bases of operation, however, were Gallup and, later, Fort Wingate, located thirty-five miles northwest of Gallup in the western part of the New Mexico Territory. Like all of his contemporaries in the West, Wittick used a camera that was cumbersome to operate. A simple lens cap served, when taken off the big brass-barreled lens and then replaced, to regulate the exposures. The wet-plate process he began with was quite adequate for his purposes, as indicated by the extensive pictorial record he made of life in the Navajo enclave at Fort Wingate. Unlike Jackson, Wittick was not truly an artist in outlook. He was, however, a skilled, hardworking, and adventurous man who had a good eye for effective compositions. By taking on all kinds of jobs, he made a living documenting the Indians with his large and stereo camera, in both formal and informal situations. We are much indebted to him for his pictures of people and scenes of historic significance.

The Southwest was booming when Wittick arrived. Settlements were going up almost overnight, and ranching and commerce were beginning to flourish. Trading with the Indians and providing Kentucky whiskey, guns, hardware, and harness to settlers made many a man wealthy, and the railroads accelerated the pace. The railroad first reached New Mexico at Las Vegas, in the northeast portion of the Territory. There the A.T. & S.F. established a yard and shops. The next town to benefit greatly from the railroad was Albuquerque, through which the line was extended in 1880. The following year El Paso, a mere village across the Rio Grande from the Mexican city of Juárez, was opened to rail traffic. Wittick photographed oxcarts and buggies on the muddy and rutted streets of El Paso and Juárez in the 1880s. It was, however, his pictures of the Indians in the northern part of the New Mexico Territory that provided him with a livelihood, and that are today considered his most important contributions. He photographed them before elaborately painted backgrounds, which he combined with real boulders and cacti in his clapboard studio in Gallup, and used a portable background held up by branches when traveling through the Navaho country. The solemn-faced Indian men and women who stare out at us from Wittick's photographs rarely seem at ease before his camera; at times they look defiant. In this regard we should recall that the Navaho were pursued by the U.S. Army and forced to live in restricted areas in the 1860s to prevent them from interfering with the takeover of their traditional territory by the whites. Although Wittick's portraits

rarely convey more than a glimmer of the personality of his Indian sitters, his pictures are of great interest today simply because many of the Navaho and Apache leaders were photographed by him alone. His cabinet cards of such famous chiefs as Geronimo and Nachee sold well to the rapidly growing number of tourists who came to the Southwest.

Before he died of snakebite in 1903, in Fort Wingate, Wittick had photographed in El Paso, Juárez, Santa Fe, Albuquerque, and Gallup, and in the pueblos of Jemez, San Felipe, Santo Domingo, Zuni, Acoma, Taos, and Laguna. His posed and informal pictures of Indians are an invaluable record for anthropologists and historians and, in some cases, also provide aesthetic pleasure because of the way he documented the Indians in a charmingly informal grouping or caught the light and shadow that defined the low adobe structures' relationships to the earth.

At the same time as the A.T. & S.F. reached New Mexico, the Denver and Rio Grande Western Railroad entered New Mexico from Colorado; by 1885 it extended south to Santa Fe. Since 1849 there had been a regular stagecoach line between Santa Fe and Independence, Missouri, and by 1868 there was daily mail service for the East. But the railroads brought tourists, eager to see the Land of Enchantment and the famous Pueblo, Apache, and Navaho Indians. Hotels were built to accommodate all tastes. In 1880 the first Montezuma Hotel was completed near the northeastern New Mexico town of Las Vegas to serve millionaires from the East visiting the local hot springs. New hotels were built in Santa Fe and Albuquerque too. From these railroad stops, tours by horse-drawn stage were organized to Taos and other locations near picturesque scenery and Indians. Popular weekly magazines such as *Leslie's* and *Harper's* published pictures from photographs, in the form of wood engravings, of Indians and sights along the railroad and in Santa Fe, such as "The Oldest Inhabited House in the United States" and "A Typical Mexican House." This type of publicity attracted more and more tourists, who wanted mementos of their visit to New Mexico. Cabinet-size photographs, 5½ by 4 inches on a 6½-by-4½-inch mount, and stereographs were ideal for this purpose.

In 1880, the year the railroad came to Santa Fe, William Henry Brown, Nicholas Brown's son, formed a partnership with George C. Bennett in the old capital city. Owing to Brown's ill health, Bennett, in addition to two assistants, Genevus and John Burk(e), took most of the pictures made in the name of this firm. They made a large number of stereographs of Santa Fe, various Indian pueblos, and unusual landscapes. There is, for instance, a record of an order of 500 dozen in 1883 for the Palace Hotel.

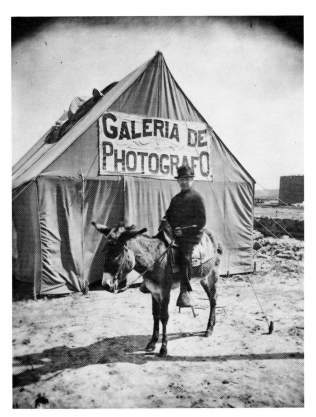

George Ben Wittick, *Blue Gallery, Albuquerque,* 1881. Modern silver print from a stereograph negative in the Collection of the Museum of New Mexico, Santa Fe. Collection of University of New Mexico Art Museum.

George Ben Wittick, *Self-Portrait with Camera,* c. 1878. Modern silver print from a stereograph negative in the Collection of the Museum of New Mexico, Santa Fe. Collection of University of New Mexico Art Museum.

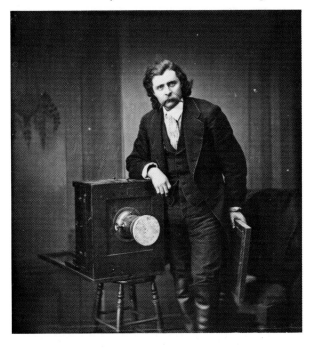

A partial list of William Henry Brown's catalogue of photographs for sale in 1884 is indicative of what was considered salable to tourists.[3]

STEREOSCOPIC AND LARGE VIEWS
—OF—
NEW MEXICO SCENERY.
PHOTOGRAPHED AND PUBLISHED
—BY—
W. HENRY BROWN
SANTA FE, NEW MEXICO.
WEST SIDE OF THE PLAZA. UP STAIRS.

Santa Fe Series
1. The Palace
2. Military Headquarters
3. The Plaza
5. Burro Alley, a common scene on this corner
6. Cathedral de San Francisco
8. View from Loma, showing Chapels, Cathedral, College
11. San Miguel Chapel, 300 years old, interior view
12. San Miguel Chapel, 300 years old
15. Group of Navajo Indians
16. San Miguel Chapel, rear view, and oldest House in City
20. Looking into a Plazita
21. St. Mary's Chapel
22. Santa Guadalupe Chapel
23. Gen'l view of City, Government Buildings in foreground
26. Indian Pottery, Navajo Blanket Background
27. A Group of Mexican houses on the Loma
28. Street Scene, "Rio Chiquito"
30. Bird's eye view north from College
31. Street Scene, "Nose Paint"
32. Gen'l view from river, showing St. Mary's and Cathedral
37. Santa Guadalupe Church, from river, 250 years old
38. The Centenarians, Jesus Reviera 100 years old, a Mex. Group
39. "El Horno," a Mexican oven
41. The Dirt Roofs
43. "Dos Cargas," manner in which fuel is brought to S.F.
44. Eastern Part of city from old Fort Marcy
47. The Mountains north-east from old Fort Marcy
49. Procession of Corpus Christi
50. Street Altar during Procession of Corpus Christi
51. Procession of Our Lady of the Rosary
53. The Plaza from Military Headquarters
55. Co. "Q" 49th Tenderfeet
56. Burros Laden with Corn-fodder and wood
57. Old San Francisco Church
58. San Francisco Street
59. The Archbishop's Garden

To judge by this list tourists were interested in the old Spanish earth buildings and the quaint, rutted streets, where dozens of burros carried firewood and corn fodder. Catholic church architecture was also an attraction, even though by the time these pictures were made there were also Protestant churches. Only one photograph showed Santa Fe's Mexican citizens, and only one was of Indians—identified as Navahos rather than Rio Grande Valley Pueblo Indians, by far the most prevalent kind to be seen in Santa Fe. Apparently no Anglos or their horse-drawn buggies or delivery vans were thought to be of interest to the tourists, who saw such things every day back East.

Tesuque Series
62. Mex. Plow, Old Noah's Patent, used by Tesuque Ind's
63. Mex. Carreata, or Cart, used by Ind's and Mex's of N.M.
64. Pueblo Tesuque Girls, carrying water
68. The Little Darlings, Pueblo Tesuque Indian Children
69. Group of Pueblo Tesuque Indians

Pecos Series
70. Ruined Gateway and Towers—W. entrance to Pueblo
71. General view of Ruins from the Church
73. The north Plaza
74. The old Pecos Church
76. Interior of the old Pecos Church

(*Taos series and misc.*)
78. The Indian Pueblo of Taos, N.M. North Pueblo

It is notable that no stereographs were offered of close-up portraits of Indians or Indians on horseback.

Los Cerrillos Series
82. Los Cerrillos, from near Cerro de Santa Cruz
84. View of Carbonateville from the South
87. "Hungry Gulch" and Miner's (*sic*) Cabins
89. Ruelina Camp and Shaft, Cerro de Santa Rosa in distance
91. Cerro del Oso from Chalchuitl Mountains
93. The Old Chalchuitl (Turquoise) Mine
94. "Poverty Hollow"

95. "Cock of the Walk" and "Mary" Shafts on Iowa Hill
96. "Marshall Bonanza" Shaft and Ore Sacks
97. Miners trenching for Lode, Archibigui in distance
98. "Homestake Shaft." "Millionares (sic) in it"
99. Working Tunnel Face on "Handy Andy"
100. A "Prospecting" Party
102. Santa Fe Mountains from Cerro de Santa Rosa

Anglos had made millions of dollars from mines in the West, which accounts for the interest in the Cerrillos series of stereographs of prospectors, their shacks, and the mineshafts.

San Juan Series
111. "The Camel" on the road to Pueblo of San Juan
112. Watch Tower and Sentinel on way to Pueblo of San Juan
115. Chapel at Santa Cruz on road to Pueblo of San Juan
118. Worshiping with fire-arms
119. The two parties of Dancers
120. The Runners
121. Group of young Bucks
122. Pueblo girls at the Acequia
123. The Rio Grande valley at Pueblo of San Juan

Santo Domingo Series
134. Carved doors of the old Church
135. The "Estufa" or Council Chamber
136. An Indian bridge across the Rio Grande

Cochiti Series
138. Potrero Viejo
139. El Cueva Pintada (The Painted Cave)
140. Statue of mountain Lions
143. Ruins of Cave dwellings in Rito de los Frijoles
147. Barrauco Blance (or El Tienditas)
148. "Matyaya-tihua" and family, of the clan of the Sage Bush
149. Jose Hilario Montoya, Our Guide

It should be borne in mind that, unless the viewer looks at stereographs in a lenticular holder made for this purpose, he gets no true idea of the effect of depth that they can achieve. Like all skillfully made stereographs, Brown's were composed so that views included near, middle, and far elements and thus took maximum advantage of the illusionistic character of stereographs. The Brown views are of unusually good quality from this standpoint.

Once opened to convenient tourism by the building of the railroads, the Southwest attracted visitors continuously from Colorado, the Midwest, and the East. New Mexico was billed in the 1880s and 1890s as a rewarding experience for sightseers and curiosity hunters. "It is," claimed one photographer's advertisement, "of another civilization, and one feels as in a foreign land." Santa Fe, the place most frequently visited had "the only palace in this republic," as well as "the crumbling Cathedral of San Miguel."

Statement on verso of card photograph by J. L. Clinton (see Plate 22).

This statement is typical of those attached to the backs of cabinet cards and stereographs. In this case the photographer was J. L. Clinton of Colorado Springs. A number of Colorado-based photographers took views of New Mexico for the Denver and Rio Grande Railroad or to be sold in hotels in Denver and Colorado Springs, both northern gateways to New Mexico Territory. W. G. Chamberlain of Denver and F. A. Nims and B. H. Gurnsey of Colorado Springs took quite a few stereographs in New Mexico. W. H. Jackson's stereos were also widely distributed from his Denver studio.

William H. Rau, a Philadelphia photographer, was one of the tourists attracted to New Mexico. He may have come to Santa Fe upon the recommendation of his father-in-law, William Bell, who took some very strong landscapes in the Colorado River area in 1872, while working for a U.S. government survey. Most likely he chose 1881 for his first visit because of the convenience of travel on the newly opened railroad. A frequent traveler in America, Europe, and the Near East, Rau was famous for his large landscapes. Four of his smaller photographs of the Indian Pueblo of San Juan, located twenty-five miles north of Santa Fe, have survived as albumen-print inserts in the *Philadel-*

phia Photographer of 1882. The report of Rau's trip to New Mexico and Colorado published in this journal gives us details of the plates he used, his lens, and other information rarely preserved in connection with specific photographs.[4] This in turn gives us an idea of the equipment used by other photographers of the period as wet plates gave way to the much more convenient dry plates. Rau came west in October and exposed almost 200 Keystone dry plates with a 6-inch Morrison lens on a 5-by-8-inch stand camera. His pictures were taken primarily for the purpose of making lantern slides, at the time a very popular means of showing photographs to an audience. Four different negatives by Rau of San Juan Pueblo were printed en masse on imported albumen "Pensé Eagle" paper for insertion in copies of the Philadelphia journal. In other words, a copy of the May issue of the magazine could have had any one of four different Rau pictures inserted with the report of his trip. Rau's pictures are quite straightforward and have no marked aesthetic quality, although he was known for the artistic character of his large landscapes.

In 1888 one of the most colorful photographers who ever worked in New Mexico arrived in the Territory, a man broken in body but very alive in spirit. This was the Harvard-educated writer-photographer-explorer Charles Lummis. He had begun his writing career in Chillicothe, Ohio, as a newspaperman but decided to learn about America by walking from Ohio to Los Angeles in 1884. He was made an editor of the *Los Angeles Times* after his heroic trek.

As city editor, Lummis not only supervised a small staff of writers but himself wrote often about events in southern California. Three years after he arrived in Los Angeles, the Apaches in Arizona renewed harassment of settlers. Colonel Otis, the owner of the *Times,* sent Lummis to report the progress of Gen. George Crook, who was responsible for putting down the new outbreak of violence. Lummis was delighted to be a part of this campaign, for he greatly loved life in the outdoors and the excitement of tracking and fighting the Apaches. Most of the Apaches soon surrendered, and Lummis was back at work at the *Times.* He worked over twenty hours a day writing stories and rewriting what his reporters brought in. Seemingly indefatigable, he finally had to leave the paper when he suffered a stroke that paralyzed the left side of his body. Despite the vigorous protests of his wife, Lummis would still stubbornly limp down to his office where, after a few hours work, the staff would have to carry him home. Finally he realized he had to have rest in a place where current events could not disturb him. Earlier in his life he had become a close friend of Don Manuel Chaves in New Mexico.

When Chaves heard of Lummis's illness, he invited him to return to what the writer called "the sunburnt mesas and ardent skies" of the Southwest. In February 1888, Lummis took a train from Los Angeles to Grants, New Mexico. There, despite his partial paralysis, he insisted on mounting a horse and riding thirty miles to the Chaves home. Rather than resting, Lummis did everything he could to exercise his body. Long rides on horseback and rabbit hunts on foot taught him to cope with the limitations imposed on him by his paralysis. Lummis returned to his wife in Los Angeles after his stay, but he suffered a relapse. He returned to his friend's place in central New Mexico and then, in 1888, moved to Isleta, the Indian pueblo on the Rio Grande just south of Albuquerque. His friendliness and obvious respect for the Indians as people made Lummis welcome at the pueblo in a period before there were hordes of tourists and anthropologists prying into the Indians' customs and overrunning their villages. Lummis fitted into the everyday life of the pueblo and made a conscientious effort to gain as much knowledge as possible of his hosts' language and traditions. Now twenty-nine years old, he was making a minimal living by writing humorous verse and short descriptive stories for publication and selling his photographs of the Indians or trading them for essential goods. His knowledge of the Indians increased daily, for he was an avid student of the meaning of their everyday life and ceremonies. He was allowed to witness, photograph, and join in the activities of the community as a helpful member rather than a visitor. As his health improved, he photographed more and more. He learned to develop unassisted at night the negatives he had made in or near Isleta.

Lummis soon took his camera and made trips west to Acoma, "the city in the sky," and to Laguna, a nearby pueblo. With his simple equipment, he made numerous photographs in both communities of the Indians dancing. By choosing moments when the men and women dancers were moving at a slow pace, he was able to catch clearly on his relatively slow dry plates the sense of flow of the dancers' movements as they turned to the rhythms of the chorus of male singers gathered about the drummers who set the beat for the dances. He also visited Zuni, in western New Mexico, and took pictures of the pueblo and the people.

Lummis seems to have made no attempt to control the activities of the Indians as he photographed them and their dwellings. This gives his pictures a sense of authenticity and actuality that is missing in some of the photographs made by more art-conscious photographers. He worked with a relatively small camera and made simple cyanotype prints from his

dry-plate negatives. This blue print process was chosen because it was inexpensive and because it allowed the photographer to coat his own paper and achieve a sense of hand craft when he used rough paper—a consideration of importance to a man dedicated to the virtues of crafts and the individuality that comes from creating things by hand. The process Lummis used did not require a light-tight darkroom or an elaborate array of chemicals. This suited him and, in the primitive setting at Isleta, he and his second wife printed thousands of 5-by-8-inch blue prints which sold for as little as five cents apiece. It should not be forgotten that Lummis was more an enthusiast than a careful, analytical photographer. His primary aim was to make a record of what interested him, to use photography to convey his genuine concern for the Indians and their way of life. Informal records of groups of Indians, as well as half- and full-figure portraits taken in the open air, make his pictures valuable even today from an ethnological standpoint, so accurate are they.

Most of Lummis's pictures of the Hispanic people are of the Penitentes. These items have great historical value, for there are few authentic pictures of the practices of these devout Catholics carrying out their reenactment of Christ's last days. It was while living with the Chaveses on his second trip to New Mexico that Lummis made his famous photographs of aspects of the Penitente ceremonies. The Penitentes were Spanish-American members of the Third Order of Saint Francis, a lay order that had taken over religious duties in New Mexico after 1821, when Mexico gained her freedom from Spain and all priests were banished by the Mexican government. (It should be recalled that New Mexico was part of this newly independent Mexico from 1821 until American forces took over the territory in 1846, when the United States and Mexico went to war.)

The Penitentes believed in flagellation as a means of expiating their sins and atoning for the treatment of Christ. During Lent, they reenacted Christ's agony as he carried the cross to Golgotha. The Penitente ceremonies required members of the order to carry huge crosses on their shoulders from one major shrine to another, each man flagellating himself. Finally, a type of crucifixion of one member took place. A man would lie down on and be tightly bound to a rough cross. When the cross was raised upright, due to loss of blood circulation caused by the tight ropes that bound his arms to the arms of the cross, the man would lose consciousness within a half-hour. The cross was then lowered to the ground and with its burden carried into the Order's morada, a chapel built just for the services of the members. There was considerable Catholic opposition to these

rites, for public penance had been banned by papal decree.

In the predominantly Protestant eastern part of the United States, the Penitentes had been the subject of sensationally recounted stories in periodicals. Therefore they took pains to carry out their rituals in private. The Penitentes were said to have shot at intruders who insisted on trying to witness their processions and crucifixions.

Lummis had been warned of the danger, and he brought with him his friend Ireneo Chaves, who wore a pistol and thus, in Lummis's words, "held back the evil-faced mob" by explaining "that if anyone attempted to hurt [Lummis] or the instruments, he would blow his head off."[5] On Good Friday Lummis set up his camera along the Penitentes' line of march. At first he was so far from the procession that photography was impractical. Even so, dark glances were cast his way, and there was muttering in the crowd. Lummis met with the leader of the group over drinks and persuaded him to halt the procession and permit pictures to be taken. The men carrying the great crosses were photographed, and then the crucifixion. Only a man of Lummis's extraordinary perseverance and dedication could have taken these photographs.

At the end of the summer of 1888, Lummis met Adolph Bandelier, the great archaeologist who had lived among the Indians in New Mexico for a number of years. The two men had much in common and soon planned to team up to explore some lesser known ruins. First they went to Cochiti Pueblo, where Bandelier had lived for two years. In preparation for this trip, Lummis spent his last cent on glass plates for his 5-by-8-inch-camera and his large camera. In 1890, near Cochiti, on the Jemez Plateau, the two explorers found cave dwellings in the porous rock cliffs that had been occupied by the modern Indians' ancestors. At Potrero de las Vacas they also discovered the ruins of a large pueblo, and they were the first white men to find the mountain lions of the Cochiti, two of the only zoomorphic sculptures north of Mexico. These were measured and described in detail by Bandelier and photographed by Lummis. His pictures of the lions are important as documents; those of the amphitheater of ancient cliff dwellings and the maze of now-roofless rooms on the canyon floor are striking pictures as well as telling documents.

Only a few years after Lummis made his pictures, the way of life of the Indians along the Rio Grande was changing considerably as the Santa Fe Railroad brought in more and more tourists. Lummis's photographs are very important documents, for they were taken before Indians, like actors, began to strike

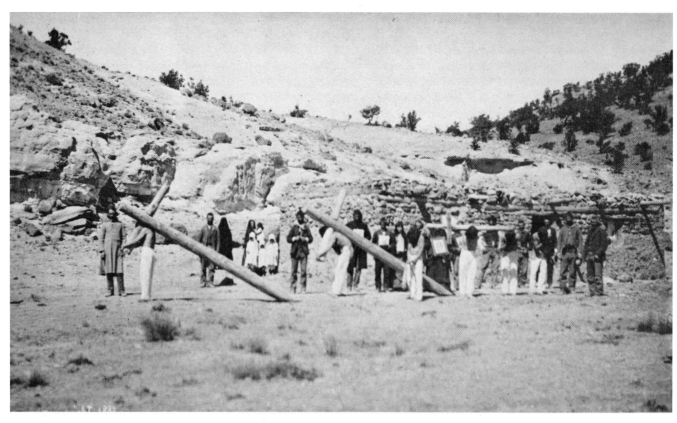

Charles Fletcher Lummis, *Penitente Procession*, 1888. Cyanotype. Extended loan to the University of New Mexico Art Museum.

Charles Fletcher Lummis, *Indian Dance*, 1888. Cyanotype. Extended loan to the University of New Mexico Art Museum.

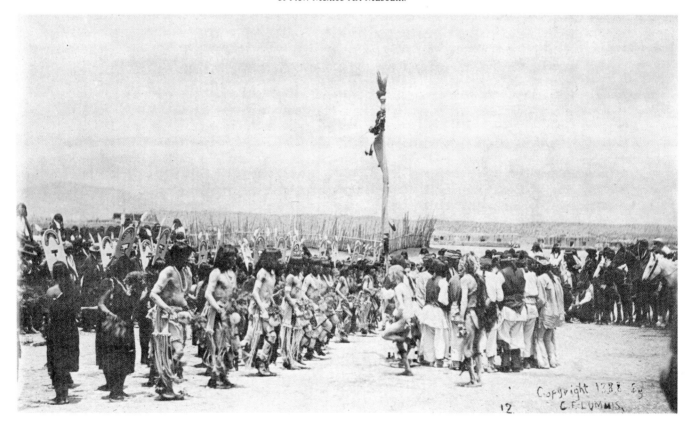

poses for the visitors or became shy as a result of the tourists' lack of respect for them as people.

Gardner, O'Sullivan, and Jackson were professional photographers and made their pictures of the Southwest to serve a practical purpose. Adam Clark Vroman, an amateur and friend of Charles Lummis, followed in their footsteps and produced some of the finest photographs ever made of New Mexico subjects. Vroman was born in La Salle, Illinois, and grew up in the Midwest. Shortly after his marriage in 1892, it became evident that his wife had tuberculosis and would need to live in a warm, dry climate. As a consequence, the Vromans moved in 1893 to Pasadena, California, but in spite of the change in climate, Mrs. Vroman died in 1894. Vroman remained in Pasadena, where he established a bookstore in which he also sold Kodak supplies, since he had an interest in photography. By the end of the century, when Vroman left his Pasadena bookstore to photograph in the Southwest, the dry plate had been perfected and the tourists were using hand cameras. At first Vroman was principally interested in landscape and architectural photography. With his glass plates, he documented California's crumbling missions and the grandeur of Yosemite Valley. In the late 1890s, he followed Lummis's trail across Arizona to New Mexico. The first New Mexican pueblo he visited was Zuni. Vroman probably went by train to Gallup, then south to Zuni by horse and wagon. Located on top of Thunder Mountain, Zuni was the first pueblo Coronado saw in 1540 in his search for the Seven Cities of Cibola. By the time Vroman came to Zuni, the Indians had established their pueblo slightly above the Zuni River at a new location, five miles from the site of their ancient dwellings. Only a few photographers had found their way to Zuni by the end of the last century, so, with a little patience, it was still possible to get the people to pose for the camera. Vroman seems to have had both patience and an eye for composition. He photographed the rain dancers, each carrying a gourd rattle, in a line before their four- and five-story terraced adobe houses. He made portraits of the Indian men in relaxed poses, including a pair gambling in the shade of a thick earth wall. One of his finest pictures is of a Zuni man seated in a low-ceilinged room with whitewashed walls and a great open fireplace. The light from an open door casts the man in relief against the plain wall. On the floor of the room in this beautifully executed picture are to be found typical Zuni pottery vessels and metates for the grinding of the corn, the basis of much of the Indians' diet. Natural light provided minimal illumination for his pictures, and Vroman may have resorted to setting off some form of magnesium flash powder or strips of magnesium foil to register as much detail on his negatives as possible. Without flash, the exposures inside would have had to be so long that movement by the Indians would have caused blurs, which are in fact very rare in Vroman's work. The shadows in many of his pictures, such as the one of women painting pottery in the corner of a room or the one showing the back of a Zuni weaver seated at her loom, could not have been made without artificial light, and, of course, there was no electricity at all in the pueblo. Vroman also photographed groups of Indians in the open. Women with pottery bowls on their heads and family groups posed on the flat mud roofs of their houses give us a clear idea of the colorful clothes the people wore.

The inconsiderate practices of the tourists made the Indians increasingly unhappy with photographers, and the Hopis at Oraibi Pueblo soon restricted the activities of cameramen at their Snake Dance. In 1902 and shortly thereafter they refused to allow any photographs of their ceremonial dances. Many of the New Mexico pueblos established similar prohibitions. Fortunately, most of Vroman's pictures were made before there were any limitations on what or where he could photograph. In 1895 he made his first trip to the Hopi area. He photographed the Indians at work inside and out of their living quarters. His picture of two Indian women, one resting against an interior adobe wall and the other grinding corn in the corner, has a natural feeling almost always lacking in earlier pictures of this kind. Vroman's special feeling for light and his way of organizing the elements in his pictures separates his work from that of the majority of visitors who photographed the Indians. Although many of the pictures, particularly portraits, were posed, his pictures still convey a feeling of life. His landscapes, especially those in which he included portions of the pueblos as they were etched against magnificent billowing clouds, evoke the characteristic appearance of the region during the summer and fall. Vroman's straightforward prints, often made on fine platinum paper, are rich both in tone and in aesthetic qualities without being self-consciously artistic.

In the last part of the nineteenth century more and more photographers visited New Mexico, and a few became lifelong residents. Among them was Henry Schmidt, who was born in Germany, came to the United States in 1878, and traveled west to Chloride, New Mexico, in 1882 as a surveyor. He decided to remain in this mining town in the central part of the Territory, where he worked both as an assayer and as a photographer. He made studio portraits and views from about 1890 to 1924 in the mining communities of Chloride, Lake Valley, Winston, and Tyrone. His

portraits of the Anglo and Mexican miners and their families, well executed but without particular distinction, are valuable records of a frontier mining town around the turn of the century.

Also living in central New Mexico was Joseph Smith, who came to the old Spanish town of Socorro in the early 1880s after learning photography in Chicago a few years earlier. He was an assistant manager of the Diamond D Cattle Company first; then, in nearby Kelly, he turned to mining. From 1885 to about 1898 he operated a photography studio in Socorro, where he made thousands of negatives and saved those made by other photographers. His pictures give us the particular visual quality of the region during an era when it was still a frontier. Memories fade and written records are subjective, but photographs document the true look of a community as well as the appearance of many of its inhabitants. While we cannot call such unaffected photographs fine art, we can put many of Smith's pictures in the category of folk art.

Dr. Arnold Genthe, a German-born scholar who became a major portraitist of the famous and fashionable, also photographed the southwestern landscape. Genthe came to San Francisco as a tutor in a wealthy German-American family. In California, he took up photography and made some remarkable candid pictures of the people in San Francisco's Chinatown at the turn of the century. In this same period, he made a trip to the Grand Canyon and east to New Mexico. He returned to the region twice more before 1926. The photographs he took at Laguna Pueblo, so far undated, are notable for their combination of a romantic outlook with the technique of candid photography. The inclusion in a carefully selected view of the pueblo of Indian children, caught by chance in a prominent location, exemplifies Genthe's sensitivity to formal considerations and his openness to a spontaneous element. This openness gives his pictures an unusual vitality.

Before continuing the history of photographers in New Mexico, it is important to indicate that many of the best pictures taken in the region were made by visitors. We have already mentioned survey photographers such as O'Sullivan, Jackson, and Hillers, the enterprising professional Gardner, and the talented amateur Vroman. There were also many visiting photographers working with cabinet-size and stereo photographs. Among the latter, one of the most prolific was William E. Hook. He operated all over the Rocky Mountain region, first in Manitou Springs, Colorado, during 1889 and 1890, and between 1891 and 1897 in Colorado Springs. In the 1880s, Franklin Nims, also from Colorado Springs, issued well-done stereographs of Santa Fe and the surrounding area.

Dana B. Chase was active in Santa Fe at the end of the century, producing cabinet-size views of the capital city which were usually sold on distinctive chocolate-colored mounts.

Stereographs and cabinet pictures of New Mexico were sold in fairly large quantities in the East as well as locally, to judge from the numbers that have been found along the eastern seaboard. In comparison, relatively few stereographs of Texas and Arizona were made, which indicates the degree of interest in New Mexico's Indians and in the unusual scenery found in the area, as well as the success of the Santa Fe Railroad's advertising.

One of the most popular photographers of Indians was Edward Curtis. While not a permanent resident of New Mexico, he spent a good deal of time in the region in 1903 and 1904, and again in the early 1920s, on trips from his home base in Seattle. Nowhere did he come closer to realizing his aim of photographing the Indians in a relatively natural state than in the New Mexico pueblos. He posed dozens of Indians for close-up portraits and made pictures of the men, women, and children going about their duties and carrying on their ceremonies. His pictures of the heavy-walled pueblos, soft in outline and irregular in silhouette, convey much about the climate and even about the temperament of the region's Indians. His very high quality portraits are attractive aesthetically, as well as being documents of ethnological interest. The genre scenes, which he usually posed, were often soft and sentimental. The landscapes and studies of pueblo architecture, while also romantic, give a clear sense of why this country has appealed to so many generations of visitors and caused many to become residents.

Theodore Roosevelt, in his foreword to *The North American Indians,* described Curtis as an artist and a trained observer, and characterized his work as "pictures, not merely photographs," with "far more than mere accuracy, because it is truthful."[6] Beginning in 1898, Curtis devoted part of each year to taking photographs and accumulating data in order, in his words, to "form a comprehensive and permanent record of all the important tribes of the United States and Alaska that still retain to a considerable degree their primitive customs and traditions."[7] For over twenty-five years, he conducted a series of arduous campaigns throughout the West to achieve his stated goal. As a field photographer he was resourceful, and as an observer, patient and thorough. His vision seems romantic today, but we should recall that when he set out on his visits to the Indians the term "Dying Redman" had much currency. The Indians must have respected him, for they posed to show how they had used bows and arrows,

and organized hunting parties for him to photograph. He often used a soft-focus lens, a device very much in favor among art photographers at the turn of the century. Nevertheless Curtis had an ethnologist's view of the Indians' life; he made portraits of young and old, recorded them at work and play, took details of their artifacts, and made general views of their habitats. In addition to his photographs, he made voluminous notes, and recorded the music of his subjects. In 1907, the first volume of his projected series was published. It was devoted to three Southwest tribes—the Apache, the Jicarilla, and the Navaho. His pictures of these people and their land are picturesque but only rarely blatantly sentimental. The Indians staged ceremonies and rites for him and old costumes were brought out to be recorded by his camera. The portraits were usually close-ups, with sharpness limited to the plane of the face; the hair was left out of focus, which, intentionally or not, created a sense of mystery in the case of the older Indians. Curtis's landscapes of the semiarid Navaho country are straightforward and reflect, with little concern for picturesqueness, the nature of life in the austere land as it was lived in widely scattered earth and log hogans or temporary, leaf-covered shelters over frames made of limbs. If slightly marred by theatrics, Curtis's photographs of the Southwest Indians—he photographed in almost every pueblo before 1925—are, on the whole, grave and solid representations of the people he so wished to memorialize.

W. Calvin Brown (apparently no kin to Nicholas or William Henry) came to Albuquerque in 1882 or a little earlier. He had a studio but traveled to Arizona making photographs of the Hopi and Mohave Indians in the early 1880s. In 1889 he sold his establishment to William Henry Cobb. Cobb, a graduate of Harvard College, had initially come to Albuquerque in 1880, probably, like so many other photographers, as part of a railroad survey team. He became interested in remaining in the West when he discovered he had tuberculosis. After his initial stay in New Mexico, he returned to the East but found the dampness of that part of the country affected his lungs, so he came back to the Southwest and settled in Albuquerque. He married Eddie Ross in 1891. Miss Ross was born in Leavenworth, Kansas. Her father was the U.S. senator who cast the key vote against the impeachment of President Andrew Johnson. She was one of the first women trained at the business school of the University of Kansas. New Mexico became her home in 1885, when her father was named territorial governor and she became his secretary. She was interested in photography and eventually became William Henry Cobb's retoucher.

After they were married, she rapidly took over the management of the studio as her husband's health deteriorated. The Cobb studio was engaged in general photographic work, taking portraits, views in Albuquerque and Santa Fe, and pictures of business houses, as well as photographing at fairs. The major value of the Cobbs' work is historical, for they photographed many ephemera not covered by other studios.

In the first years of the present century two photographers working in Albuquerque made a reputation with their Rembrandtesque studio portraits of Indians. They both arrived in Albuquerque in 1904. Karl Moon or, as he sometimes spelled his first name, Carl, may have arrived slightly earlier than William Pennington.

Pennington came from McKinney, Texas, where he had begun his career as a photographer's assistant. Having consumption, he sought the dry, clear air of New Mexico. With Benjamin Davis he opened a studio in Albuquerque. By 1908 Pennington had left New Mexico for Durango, Colorado, where his partner was L. C. Updike. During the period from 1908 to 1912 Pennington and Updike would take a six-horse wagon to the Four Corners area of the Navaho Reservation for periods of up to three months. They made portraits of the Navahos and pictures of them near their homes and at work with their flocks. Although their prints were sepia toned and sometimes printed with a deckled-edge frame around the pictures, the Pennington-Updike photographs (which carry only the former's name) were sharp in focus and not particularly sentimental. The studio portraits of the Indians are clear as to details in only a limited plane because the lens was used wide open. This caused the foreground and background to be indistinct, which created a certain feeling of romanticism and served to evoke former times when the Indians were supreme. Head and shoulder portraits of the Indian subjects in profile, gazing out of the picture in a heroic fashion, were common. At Pennington's studio in Durango, he made conventional portraits of the townspeople, many of which were tinted by his wife and daughter. These pictures are quite different from the Navaho genre scenes and formal romantic portraits of the Indians. The Indian portraits, too, were sometimes tinted to make them more salable. They were sold to tourists and were distributed in the East as evidence of the life-style and appearance of the exotic natives of the Southwest.

Moon was much more committed than Pennington to the romantic notion of recording the "Vanishing Race." Born in Wilmington, Ohio, Moon worked in the East six years learning to be a photographer

before he began photographing the New Mexico Indians in 1904. In 1905–6, he had a partner in his Railroad Avenue (now Central Avenue) studio, Thomas F. Keller, Jr., but only Moon, apparently, took the pictures of the Indians. He made a concerted effort to take out-of-doors genre scenes and formal studio portraits of the leaders of the pueblos along the Rio Grande and of those located at Acoma, Laguna, and Zuni from 1904 through 1914. In 1907, he made an agreement with Fred Harvey, whose company operated a series of restaurants catering to the flourishing railroad trade in the Southwest, to distribute his pictures. In 1911, he moved from Albuquerque to the Grand Canyon, where a studio and salesroom were built for his use near the local Fred Harvey establishment. During this period, Moon was also an official photographer for the Santa Fe Railroad, which used his pictures in travel advertisements. In 1914, he again became an independent photographer and, in the period that followed, devoted most of his time to painting. Many of his rather poor "paintings" actually consisted merely of color applied over his photographs. He also issued limited-edition sets of photographs of Indians selected from the thousands of pictures he had taken from 1903 to 1930. The majority of his prints were taken with a soft-focus lens or given a soft-focus treatment when enlarged. Evidence of retouching can be readily discerned. He photographed Indians at San Juan, Cochiti, Tesuque, San Felipe, Laguna, Isleta, Santa Clara, Acoma, San Ildefonso, Nambe, and Taos. He also worked extensively on the Navaho Reservation, taking informal pictures of the people, a few landscapes, and a large number of portraits against dark or plain backgrounds. A small number of his pictures are of Jicarilla Apache leaders. He also photographed Hopis, Havasupais, and other Arizona Indians and took a limited number of pictures of Osage Indians. In all, he photographed Indians from twenty-three tribes.

Moon seems to have worked most with the Taos Indians. His very soft, highly romantic, story-telling pictures are melodramatic in the extreme. Typically they show such subjects as standing, blanket-draped figures or a scantily clothed Indian playing a flute or making an arrow before a fake glowing fireplace. Moon's sentimental attitude could be summed up by the title he gave one of his pictures of two Nambe maidens, "Last Two Full Bloods of Nambe." The then-prevailing concept of the "Dying Redman" was exemplified by his selection of this title, as was his feeling about the inevitable miscegenation among various Indian tribes, Hispanic people, and Anglos. Such "mixing of blood" was considered very unfortunate by those who admired pure-blood horses, cattle,

and "natives." By the time Moon was photographing the Indians they were no longer a threat to frontier settlements, and their territories had been greatly limited by forced agreements. Sicknesses contracted from whites were decimating the Native Americans, and many people felt that they would die out. Moon's photographs were far from the objective records of Hillers and O'Sullivan. The Indians in his large, rough-textured, reddish-brown "art" photographs were dressed up in their traditional clothing and posed doing picturesque things, very much as actors would be, to convey stereotyped ideas of what Indians did or should do. Moon was pandering to the sentimentality and nostalgia of the time. Easterners who bought the pictures could idealize the past or create in their minds a kind of Zane Grey fiction reflecting their own quaint attitudes about the life lived by these first Americans.

Far from Moon's picturesque enlargements are some very well-executed photographs of Las Vegas, New Mexico, made in about 1885. These contact, albumen prints are exceedingly good action pictures of cowboy life on a ranch. James N. Furlong was the leading photographer in Las Vegas beginning in the early 1870s. He came to the Southwest from Massachusetts. During the period 1885–90, when the cattle-ranch photographs were made, he was in Texas and California in the cattle business. It seems likely that the picture chosen for reproduction of cowboys on the range by a Las Vegas (?) photographer is by Furlong. They tell us in objective terms much about the equipment and practices of cowboys before the West was completely fenced and life on the range restricted.

In addition to full-time and part-time professional photographers, some amateurs (other than Vroman) took pictures that deserve a place in the history of photography in New Mexico. Herbert F. Robinson, an engineer, took pictures of the Indians of New Mexico and, as one might expect of an engineer, many views of dams, landmarks, towns, and historic monuments. Born in Lexington, Illinois, Robinson was brought by his parents to Phoenix when he was just a baby. He grew up there and in 1898 was appointed adjutant general of the Arizona Territory. Four years later he moved to Albuquerque, when he was promoted to irrigation engineer for the United States Indian Bureau. In this position, he frequently had reason to visit the pueblos. To record what he witnessed of Indian life and ceremonies, he began to photograph with a roll-film hand camera.

Robinson did not usually concern himself with making artistic pictures, nor did he become a proficient technician. He sent his film for processing and printing to the Cobb Studio in Albuquerque,

rather than doing this work for himself. His pictures were made more in the spirit of taking pictorial notes than making complete statements. Nevertheless, he recorded aspects of Indian and Santa Fe life not thought significant by professional photographers and as a consequence, left a valuable record that helps to fill out our knowledge of life in New Mexico.

Another amateur New Mexico photographer, also an engineer, was Philip Embury Harroun. Trained as a hydraulic engineer at the University of California, Berkeley, he came to Santa Fe around 1881 and took up photography. Like Robinson, he photographed irrigation and bridge projects as well as the Indians. He often attempted to catch action that was difficult to frame squarely in his view finder and was beyond the capability of his camera's lens and shutter to record. His most important photographs, however, were those he made of Spanish ceremonies in Santa Fe, such as Corpus Christi Day.

A Santa Fe photographer of note in the field of archaeology was Jesse L. Nusbaum. He did not take particularly attractive pictures from an artistic standpoint, but this was not his aim. One of his assistants, T. Harmon Parkhurst, had a much better sense of what makes a picture—any picture—hold the viewer's attention as an aesthetic experience. Parkhurst was from Middletown, New York, and attended Syracuse University before coming to Santa Fe in about 1910. He was a member of an archaeological expedition in Frijoles Canyon, an area now part of Bandelier National Monument. When the Museum of New Mexico was founded, he joined the staff as a photographer. Around 1915 he opened a studio in Santa Fe on his own. The studio seems to have been primarily a base of operations, for he spent much of his time traveling about northern New Mexico photographing the Indians and landscapes. He

worked in a direct fashion with a 5-by-7-inch camera on a tripod. While maintaining his studio in Santa Fe and taking many pictures of the fronts of buildings in the city, he served as the official photographer of the Los Alamos Ranch School until it was turned into the atomic bomb development center. His contact prints were frequently plain, well-composed, and delightfully candid. For the tourist trade, he made enlargements that were softened in the process, to give them a romantic feeling, and were often tinted. The tinting was done by Quincy Tahoma and other Indian artists, but not very sensitively, and the results were rather garish pictures short on both information and artistic qualities. In some cases, Parkhurst made enlargements of huge dimensions—4 by 5 feet in a few cases. Intended for sale to tourists, to hang on the wall back home, these are soft and sentimental pictures of Indians posed in cliché situations. However, the photograph taken by Parkhurst in the mid 1930s that is reproduced here is atypical but irresistible. It is that rare thing, a genuinely humorous photograph of Indians dancing, a very common subject treated in an uncommon fashion.

Mention should be made of the fact that a number of the prominent painters in Taos in the early years of the art colony's popularity made photographs. These were usually to serve as studies or in lieu of detailed sketches of Indians in action at dances, such as Irving Couse's photographs of a "Hopi Flute Dance," and to verify details of a subject's dress or the position of a horse's legs. Joseph Sharp, even more than Couse, built up a considerable collection of photographs for these purposes. Because artists generally are sensitive to composition and dramatic moments, many of the pictures taken by Taos artists are of more than mere documentary value.

Irving Couse, *Study of an Indian*, c. 1910. Courtesy of the Fenn Gallery, Santa Fe.

Irving Couse, *Study of an Indian*, c. 1910. Courtesy of the Fenn Gallery, Santa Fe.

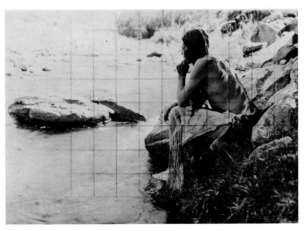

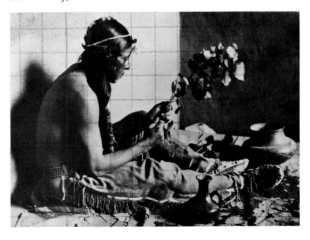

4

The Early Modern Photographers

In 1926, Paul Strand and his wife, Rebecca, came to New Mexico from New York via Texas. The purpose of the trip was to accompany to Galveston, Texas, Mrs. Strand's brother, who was suffering from tuberculosis and had to find a place to live with a less rigorous climate than New York. The three traveled to Texas by boat and then Strand and his wife continued west to Colorado. They visited Estes Park and then went south to Mesa Verde, in the southwestern corner of the state. Strand was attracted to rocks and dead, wind-bent evergreen trees as subjects. After about two weeks, the couple took the train to Santa Fe, went by bus to Taos Junction, and from there took a car into Taos. After a visit of ten days as a guest of Mabel Dodge Luhan, the Taos art patron, during which time, apparently, Strand took few photographs, they left for New York City.

In the summer of 1929, Rebecca Strand accompanied Georgia O'Keeffe on a visit to Taos, where the two women were the guests of Mabel Luhan. In the fall of 1929, Strand and his wife went to the Gaspé Peninsula on the eastern coast of Canada. With his 4-by-5-inch Graflex, he photographed the fishermen at work, their boats, the sea in its many moods, and the stretched out, fast-moving clouds so often found in the region.

In late July 1930, the Strands drove out to Taos from New York over long stretches of bumpy roads, many of them still unpaved. In Taos they rented an apartment at the Burt Harwood complex. After a week, Mabel Luhan offered them the use of one of the adobe casitas in her compound, where they stayed for five weeks. Strand did a good deal of photography that summer. He used both his 8-by-10-inch view camera and a 3¼-by-4¼-inch Graflex and rented a room above the Taos movie theater for a darkroom. He was enchanted by the majesty of the mountains and clouds and their relationships to the thick-walled earth houses and timber corrals. In the mountains north of Taos, he discovered the ghost towns, such as Elizabethtown. Places like this, now only weather-warped boardwalks and rough timber walls, were all that was left of towns that had served mines that were later abandoned. The Strand scholar Naomi Rosenblum was told by the photographer that his interest in old buildings, abandoned storefronts, and houses was based on an idea he got from the *Spoon River Anthology* to do a "village portrait."[8]

In 1931, the Strands returned to Taos, where Mrs. Luhan again put one of her little houses at their disposal. During his stay in 1930, Strand had not photographed the famous San Francisco Church in the old village of Ranchos de Taos, which lies a few miles south of Taos itself. While driving out to New Mexico on the second trip, he often thought of ways he would like to photograph this magnificent example of late eighteenth-century Spanish adobe architecture with its thick walls supported by massive engaged buttresses. As the Strands drove through Ranchos de Taos and passed by the church on their trip from Santa Fe to Taos, they saw that two basketball backboards had recently been installed directly in front of the apse of the church. Strand was most disturbed by the presence of these elements that would prevent him from taking the photographs he had thought about so often. He decided to see if

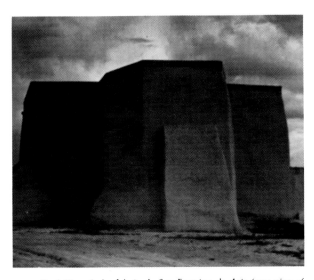

Paul Strand, *La Iglesia de San Francisco de Asis (rear view of Ranchos de Taos Church)*, 1931. Chlorobromide print. Gift of Mrs. Rebecca James to the University of New Mexico Art Museum.

the backboards could not be removed. Inquiries in the village about who was responsible for them were fruitless. Strand spoke no Spanish and the local people were somewhat standoffish when questioned in English. Strand then enlisted the aid of one of Mrs. Luhan's guests, the Mexican composer Carlos Chávez. With Strand he went to Ranchos and soon found that a young boy who lived near the church had installed the backboards. For a dollar the boy was persuaded to remove them. Strand was delighted and began his summer's work photographing this church.

In 1931, with the exception of a short trip to Colorado, Strand worked around Taos. He brought to New Mexico a 5-by-7-inch camera, which was somewhat more convenient to use than his larger stand camera, but he still found a good deal of work for his 8-by-10-inch view camera. After a productive summer, Strand returned to New York City in early September. The following summer the Strands returned once again to Taos as Mabel Luhan's guests. During this 1932 stay in New Mexico, Strand's ten-year marriage broke up when his wife became interested in William James, a wealthy rancher. To assuage his hurt and loneliness, Strand turned to Cornelia Thompson, an attractive young woman who was also going through a period of trauma. Mrs. Thompson drove Strand's Ford as they traveled through the countryside looking for places to take pictures. On one such trip, Strand made his first portrait of Cornelia Thompson. He had made a few portraits of Rebecca—and one of his friend John Marin, working on a watercolor hooked on a tripod

easel beside a rural road near Taos—and a picture of Barbara (Roberta) Hawk. Harold Jones, who has studied Strand's New Mexico work thoroughly, sees in the portraits of Mrs. Thompson a somberness that he attributes to a mutual feeling of melancholy. Strand chose a low camera position and a brooding sky for the head-and-shoulders picture of his friend. In addition, he took some less dramatic pictures of Mrs. Thompson, only slightly lower than at eye level, with an out-of-focus foliage background. These almost snapshotlike portraits were followed by a considerable number of informal likenesses of Mrs. Thompson's daughter, Nancy. These pictures were made in secret, for they were to be a birthday present from Nancy to her mother. From almost a hundred negatives, Strand made seventeen platinum prints of Nancy for presentation to Mrs. Thompson in a portfolio from "Mr. Paulito." Jones feels these pictures represent for Strand a new concept of arrangement, camera awareness, and environmental relationships. He has written that Strand used

> all the elements of texture, pattern and available lines to emphasize visual relationships with the image. The image becomes a total environment for the portrait, rather than the presentation of a face. The sense of the sitter in the context of his environment was a final step in Strand's approach to portraiture. The portraits of Nancy have the directness of a snapshot while the background functions in harmony with the sitter.[9]

These very personal portraits made up only a small part of Strand's work during the summer of 1932. He continued to devote most of his time to photograph-

Paul Strand, *Cornelia Thompson*, 1932. Present whereabouts unknown.

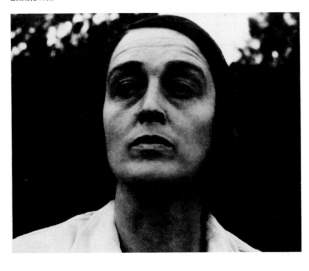

ing the landscape, with special attention to the relationships between the sky and the earth, and the sky and the adobe buildings. The Ranchos de Taos church provided him with the repertory of forms that made these relationships most meaningful. One of the most successful combinations of an adobe structure and a heavy, cloud-filled sky was his picture of a corner of the heavy-walled Ranchos church. It is seen in shadow, with a shaft of light raking across the front of the low, blocky, massed walls of the two simple structures located across the dirt street from the church. This picture relates form and content beautifully.

In New Mexico Strand resolved to take as his major theme the "spirit of place." In this regard, he found very stimulating the fast-moving storms that were accompanied in Taos by great grey clouds during the July and August rainy season. The dappling of the mountains as the clouds covered and then uncovered the sun was a subject he also found peculiar to the place and worthy of recording. He watched the sky from his house and learned to calculate how long it would take to reach a previously chosen location in his car so as to arrive in time to catch on film the clouds and the landscape in a suitably dramatic juxtaposition. As Calvin Tomkins has noted, people spoke of "Strand clouds," which meant heavy, lowering shapes holding rain and threat of storm.[10] These were the types of clouds, not what Strand called "Johnson & Johnson" clouds—that is, cottony clouds—that appeared in his pictures.

Strand said of New Mexico's skies:

> Here a new problem for me presented itself, that of trying to unify the complexity of broad landscape as opposed to the close-up of approachable and relatively small things. There are not only many photographs but also many paintings in which the sky and land have no relation to each other, and the picture goes to pieces. For the photographer, the solution of this problem lies in the quick seizure of those moments when formal relationships do exist between the moving shapes of sky and the sea or land. For this I turned to a Graflex and the snapshot.[11]

Strand exposed over 300 negatives during the summers of 1930 through 1932 in New Mexico. He photographed neither the Indians nor their pueblos. It was boarded-up ghost towns, horses, and wind-driven sand dunes that interested him, in addition to the adobe structures. His pictures of the abandoned mining towns and slumbering haciendas are somewhat similar to the work he did with his 4-x-5-inch

Graflex in the Gaspé. The Canadian cottages were occupied and well maintained, but the wind and rain had caused the wood to crack and erode in a fashion not unlike that found in the buildings in the ghost towns near Red River, New Mexico. In New Mexico, Strand moved in closer to the weathered wood and thereby called our attention to details that became symbols of the larger structures' battle with time and the elements. The earth buildings were also subject to erosion from the threatening rain clouds. They seem to personify the efforts of man to build out of the most basic element, the soil, protective housing for worship and shelter, with the full realization that the powers of nature can always overwhelm the staunchest efforts of man. He placed the squat, geometric forms of the adobe buildings in New Mexico against a background of towering clouds or shadowed mountains to give a sense of the unity of man with nature.

Dorothea Lange saw Strand in 1930 working with great intensity of purpose near Taos but did not meet him at that time. She recalled, "It was the first time I had observed a person in my own trade who took his work that way. He had private purposes he was pursuing. . . . All the photographers I'd known always were with a lot of other people, but somehow this was a lone man, a solitary."

In 1927 Albert Bender, the California art patron, brought Ansel Adams to Santa Fe. Adams responded immediately to the massive adobe buildings, the Indians, and the landscape between Santa Fe and Taos. During 1928, Adams returned and, to help pay for the trip, photographed for the architect John Gaw Meem his newest building, the downtown Santa Fe hotel La Fonda. The pictures are dramatic, reflecting Meem's use of adobelike massive walls and intentionally uneven parapets in the new structure, which was intended to look like an Indian pueblo.

Nancy Newhall has written, "For Adams in those days, Taos and Santa Fe were his Rome and his Paris."[12] In 1929 Adams returned, to work with Mary Austin on what was to be one of his greatest early projects, a group of photographs of Taos Pueblo. He wrote to Bender from Taos:

> We have finally decided on the subject of the Portfolio. It will be the Pueblo of Taos. Through Tony Luhan, the Governor of Taos was approached . . . in a week or so a Council Meeting was held, and the next morning I was granted permission to photograph the Pueblo. It is a stunning thing—the great pile of adobe five stories high, with the Taos Peaks rising in a tremendous way behind. With Mary Austin writing the text . . . I have a grand time to

come up with the pictures. But I am sure I can do it.[13]

In January 1931, Adams wrote to Bender, expressing satisfaction with his development, which had just led, in 1930, to the publication of *Taos Pueblo:* "From the first evening that I knew you, when I showed you some miserable prints in Berkeley, until now, when I have the completed Taos Book before me, I have figuratively had my breath taken away by trying to keep even with my evolution."[14] This beautifully produced work, published in a limited edition, included twelve of Adams's silver prints with a text by Mary Austin. Perhaps its greatest significance was Adams's response to making the photographs. In Taos, in 1930, he arrived at the decision to make photography his life work. He had been taking photographs since 1917 and had achieved satisfying recognition, but he had always thought that music would be his profession. His change in attitude came about soon after he arrived in Taos in 1930 as the guest of Mabel Dodge Luhan. Adams's prints up to this time, we should note, had been somewhat indistinct because of his use of a soft-focus lens to give his pictures what was generally considered to be an artistic character. Soon after he arrived in Taos, however, his stay was interrupted by a request from Mrs. Luhan to vacate his quarters in her hacienda. Unknown to Adams, it was her practice to dismiss a less prominent guest if necessary to make way for a newly arrived "lion."

There were few accommodations for rent in Taos in those days. Adams did not know where to turn but decided to seek out Paul Strand, whom he had met at Mrs. Luhan's home. He found the place the Strands had rented in town and knocked on the door. The photographer welcomed Adams and arranged for him to stay in the adjoining house. As darkness fell, Strand began developing some negatives he had just exposed. When Adams examined the fully developed and washed Strand negatives by lamplight, he was much impressed with their sharpness. After an extensive explanation by Strand of why he felt sharpness was a prime requisite for serious creative photography, Ansel decided on the spot to retire his soft-focus lens and use exclusively his Dagor and other sharp lenses.

After seeing Strand's work and talking about photography's potential as an expressive medium, Adams gave up his ideas of a musical career to devote his full energies to developing a personal style as a photographer. Taos therefore has always loomed large in his recollections.

Adams has another reason to remember New Mexico in 1930. While photographing Taos Pueblo in a sandstorm he suffered a ruptured appendix and almost died. Covered with ice packs, he was rushed 130 miles to a hospital in Albuquerque where a successful operation was performed.

Some of his early pictures of Yosemite had given him clues as to how he wanted to evoke his deepest feeling about nature's manifestations. In Taos he used his sense of drama not only to emphasize the relationship between the five-story stepped "apartment buildings" of Taos Pueblo and the nearby Sangre de Cristo Mountains, but also to make some stirring portraits. His striking portrait of Antonio Luhan, the Taos Indian who had married Mabel Dodge, conveys some of the mystery and self-sufficiency that had attracted this sophisticated thrice-married patron of the arts to Luhan on first sight.

Adams came back to photograph in New Mexico decade after decade, on over twenty expeditions. His most famous photograph, "Moonrise over Hernandez," was made in 1941 in New Mexico. As late as 1972 he was still finding New Mexico an interesting place to photograph and to create powerfully charged images of details of houses as well as imposing landscapes.

In the summer of 1925 Willard Morgan and his bride, Barbara, who were to become great friends of Adams, came to New Mexico from California. Willard taught her to use the 5-by-7-inch view camera. They photographed at Zuni and took some pictures of ghost towns. Barbara had been trained as a painter at UCLA and was teaching design and woodcut courses there when she married Willard Morgan, a writer-photographer by profession. He immediately indoctrinated her into photography but not until 1935 did she begin using the camera seriously for expressive purposes; it was at this time that she began her pioneering series of photographs of dancers in action. Her 1928 picture of Willard Morgan photographing with a Leica A at Bandelier National Monument was also taken with a Leica A. Morgan was trying out the early model Leica and its many precision lenses in various climatic conditions, for he had been employed by E. Leitz to write and lecture about this innovative camera soon after it was imported into the United States from Germany. This was the first time this extraordinarily versatile camera was used in the Southwest.

In the winter of 1930, Mabel Dodge Luhan, staying in Carmel, California, met Edward Weston. He took portraits of her and her husband, Antonio. In 1932, as a result of this encounter, Mrs. Luhan reproduced several of Weston's portraits in her book on D. H. Lawrence, *Lorenzo in Taos.* Included were one each of

Lawrence, Luhan, and the Carmel poet Robinson Jeffers. In 1931 Mrs. Luhan invited Weston to Taos. He accepted and, with his companion Sonya Noskowiak and his friend Willard Van Dyke, drove to New Mexico. In the fall of that year or the next, Weston made a second trip to New Mexico, this time with Merle Armitage, who designed and helped to publish the first book of Weston's work.

Weston drove up to the high country north of Taos, the location of the ranch Mrs. Luhan had given to Lawrence to provide an attractive and quiet place to work. Apparently Weston took only a few landscapes and no close-ups at this time. He and Armitage also drove through the nearby Jemez and Sangre de Cristo mountains, where Weston took more landscapes. Mabel Luhan reproduced six of these in her 1935 book, *Winter in Taos*.

In the spring of 1937 Weston was awarded a fellowship by the Guggenheim Foundation, the first photographer to be so honored. He was granted $2,000 to photograph from April 1, 1937, to the same date in 1938. Weston and Charis Wilson, whom he married in 1938, set off in a Ford to photograph California and the West. After a trial run to Death Valley, they drove across Arizona to New Mexico in November. After their arrival in Albuquerque via old U.S. Highway 66, then largely a gravel road, they continued east by mistake instead of turning north to Santa Fe. They found themselves in the town of Moriarty, where Weston exposed a single negative and then, discovering his error in navigation, turned north for the sixty-mile drive to Santa Fe. He and Charis stayed in Tesuque, near Santa Fe, with Gina and Ernest Knee, she a venturesome painter and he a skilled professional photographer whose pictures had appeared with Weston's in *Winter in Taos*. Winter was upon them now, and Weston found excitement in taking some snow-covered subjects near the Knees' house. He then set out to photograph the broader vistas of New Mexico near Santa Fe. In his Aspen Valley pictures he made effective use of the spare, repeated verticals of the white tree trunks of the aspens, set off by the dark hump of a nearby hillside in one instance. In another composition the white-covered ground canted up to an angle parallel to the picture's plane to create a lovely, flat pattern.

In 1940, recalling his New Mexico trip, Weston wrote,

> In Aspen Valley, high in the mountains back of Santa Fe, I found the clear views of these graceful trees I had been searching for. It was midwinter; the last few brown leaves clung to the topmost branches and the ground was coated with fine powdery snow. On a summit protected by higher surrounding mountains I discovered a grove of young aspens in a little clearing, with a dark, pine-covered hill for a background. No sooner had I set up my camera than the sun disappeared as if for good, and a gray blanket settled down over everything.[15]

In spite of this difficulty, Weston succeeded in photographing the aspens. After processing his recently taken negatives in Knee's darkroom, he took the road north to Taos. "Early Christmas morning," Charis wrote, "we drove up Taos Canyon, making first tracks in the fresh fall of powdery snow, Edward photographing dark little next-year's Christmas trees on the smooth white hills."[16] In Taos Charis and Edward stayed with Clyde Lockwood and her husband Ward, a respected member of the Taos art colony. Soon after they arrived, Weston was attracted to the flat roof of Lockwood's house and studio. The soft geometric organization of the parapets around the roof, a repetition of the vertical chimneys as they stuck up from the earth roof, served as a strong, simple foreground for the low adobe buildings in the middle ground and the snow-topped mountains capped by winter clouds in the background.

In a few days Weston and Charis headed back south. On the way from Santa Fe to Albuquerque he took a striking picture of the road as it crossed his field of vision to make a diagonal, receding form that dipped in the middle as it crossed a major arroyo. Of the trip south Charis wrote:

> Most New Mexico roads look as they they had been laid out with a ruler and pencil in a New York office; with apparent disregard for topographical features, they persistently follow the course that was once considered to be the shortest distance between two points. If the road meets a ridge of hills, instead of wandering off to find an easy grade, it shoots straight up this side, drops straight down the other. As we drove south to Albuquerque Edward made a negative of one of these long straight ribbons of highway. (When it was later published in the *New Mexico Magazine*, the editors showed their sense of delicacy by performing a Caesarean section on the print to remove the wrecked car in the foreground.)[17]

In Albuquerque they stayed with the painter Willard Nash. Behind Nash's simple adobe house Weston found an old garage littered with cast-off furniture and household debris. This material may just by chance have been made for Weston's eye, or he may have arranged it to suit his sense of design

and love of textures. In either case, he made this subject into a crisply sharp but enigmatic picture. Then he photographed Charis in the patio of Nash's house, asleep while sunbathing nude on a blanket beside a beehive-shaped Spanish oven, which echoed her curving forms beautifully.

From Albuquerque, Weston drove southwest to Deming and Lordsburg and then west into Arizona. Near the end of this trip, Weston sent Sonia Nosko-wiak a postcard on which he noted that he had made 160 negatives in New Mexico and Arizona.

Weston's next trip to New Mexico took place in 1941. On the eve of World War II, he had been commissioned to illustrate a deluxe edition of Walt Whitman's *Leaves of Grass*. The South and the East were to be the primary areas where he was to photograph. On his trip to the East, Weston took "New Mexico," a simple picture of vertical sema-phores played against the horizontally level railroad tracks and the slightly wavy edge of a long, low, flat mesa.

Dated also in 1941 and probably also made on this trip are a front view of the famous Santuario near Chimayo, New Mexico, and a picture of a sky crowned with clouds at all levels over a suggestion of rugged mountains. A vista was also taken over a stretch of flat land, broken in the middle of the com-position by mountains rising up at the edge of the plain, over which Weston caught slowly floating, almost stagy clouds.

These photographs, while quite recognizable as Weston's, do not show much development beyond the landscape work he had been doing for almost a decade. The effect of deep space and the clarity of vision one experiences in New Mexico are convinc-ingly conveyed by means of what could be called typical design solutions to creating visual excitement out of rather commonplace subjects. Weston's land-scapes must inevitably be compared to those of Strand, made only a few years earlier, of the same terrain and types of buildings. Weston was not so interested in the gray, haunting clouds. In fact he rather favored the heaped up, billowing cumulus variety that Strand spurned. Both photographers united the sky and earth in their pictures, but Weston's forms were chosen to flow one into another and to emphasize the unity and repetition of shapes. They both photographed in the abandoned mining town of Red River. In Weston's "Red River Church" it is the flow of the earth's contours behind the simple geometry of the unpainted church, seen full-face, that impresses one at first. The eye in such a picture is drawn to the pitched-roof wooden building, almost miniature in scale, that serves as an echo, just as the sunlit field is echoed in the dark-shadowed

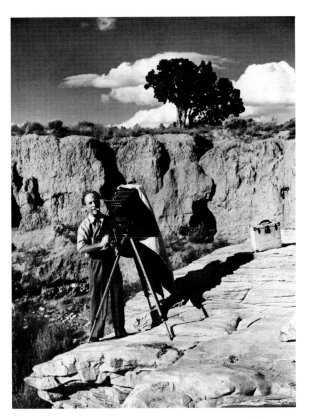

Ernest Knee, *Edward Weston at San Cristóbal*, 1941. Silver print. Collection of the University of New Mexico Art Museum.

mountain in the background. Weston treated the ovens and the living quarters at the Taos Pueblo similarly. He saw that the ovens repeat each other in shape and are countered by the geometric rec-tangles created by boxlike shadows. The sheer bulk of the earth walls out of which the stubs of vigas protrude at right angles to the thin upright elements is related to forms like the prominent dead tree trunks in the middle of the composition that at-tracted Weston's attention. In his New Mexico work, Strand, proud, moody, and often anguished, seemed to want to evoke a sense of meditation; Weston, a pleasant, thoughtful, and outgoing person, created a feeling of joyful celebration.

Willard Van Dyke, who accompanied Edward Weston to New Mexico in 1931, is a true westerner—born in Denver and a graduate of the University of California, Berkeley. From his high school days he was involved with photography. A pictorialist, John Paul Edwards, helped him to get started making money as a photographer. Despite his friendship with Edwards, who was known for his soft-focus pictures, Van Dyke sought out clear and sharply delineated geometric forms. The now-famous f-64 group was founded in his Oakland studio in 1931.

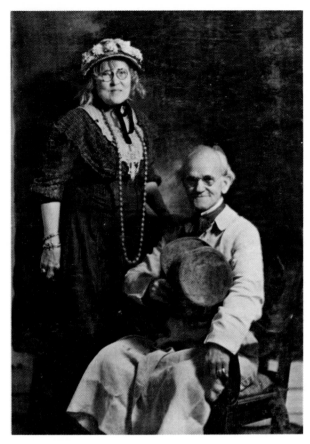

Will Connell, *Gerald and Ina Sizer Cassidy*, 1932. Silver print. Collection of the Museum of New Mexico, Santa Fe.

Like Edward Weston and Ansel Adams, also members of this group, he found New Mexico stimulating. In 1937 he returned to New Mexico with the photographer Peter Stackpole, who was on an assignment for *Life*. Most successful on that visit were Van Dyke's pictures of the Santuario near Chimayo and of Laguna Pueblo. The pictures he took in the state relate quite directly to his California work of the thirties. They are detailed overall and carefully composed in a classic fashion. In most of them, his stand camera was set up a considerable distance from the subject. He was very interested in photographing such clear-cut, massive forms as adobe ovens and examples of Hispanic as well as Indian architecture.

In June 1932, Will Connell paid a visit to Santa Fe and Taos. Connell had first studied pharmacy and then art. By the time he came to New Mexico he had become a well-regarded professional photographer and teacher in Los Angeles at the Art Center School. His first major show was in 1926, when his work was shown at the Los Angeles Public Library alongside that of Edward Weston. He had an especially wry sense of humor that came out in his dress-up portraits of artists and other creative people with

whom he was acquainted; on the bottom of the mounts for these portraits was the photographer's name and the words "Swell photographer." The prominent Santa Fe painter Gerald Cassidy gave a celebrity costume party in Santa Fe at which the guests came dressed as their ancestors might have appeared. Connell made deliberate wooden-posed portraits, in a tintype style, of many members of Santa Fe's art colony on this and other occasions. While in the city he also took a series of photographs of artists' homes and studios. From Santa Fe he went to Taos where he photographed members of the Taos Society of Artists in informal poses and took pictures of their homes.

In the 1930s probably the best resident photographer in New Mexico was Ernest Knee, who is still hard at work photographing and making prints from his thousands of negatives. This Canadian came, as so many came to the Southwest, to relieve the symptoms of tuberculosis. In 1929, he left his native country for Tucson, Arizona. In 1931 at a Tucson dude ranch he met Gina Schnaufer, an attractive, young painter who had been greatly influenced by the watercolors of John Marin. She invited Knee to go with her to Santa Fe and see the land Marin had painted the previous year. Knee and Schnaufer made the trip to Santa Fe and eventually married and settled there for almost ten years. Having largely recovered from his illness, Knee set out upon his arrival in New Mexico to be a professional photographer. He studied all the literature on photographic chemistry by the eminent Kodak chemist Dr. Kenneth Mees, and visited the Bell and Howell laboratory in Chicago.

In 1932, the painter Willard Nash introduced Knee to Edward Weston in Santa Fe. Like Weston, Knee used a large-format camera and carefully developed his negatives in soft working pyro. Their friendship was deepened when Weston came to Santa Fe in 1937 while photographing the West on his Guggenheim Fellowship. He used Knee's darkroom to develop his negatives and went with Knee to various sites in and around Santa Fe to photograph. Knee recalls that when setting up their tripods he noticed that his camera was often pointed 180 degrees from Weston's when they were attracted to the same general subject, an observation that tells us something about the difference between the two men's work.

In 1937, in recognition of the high quality of his work, Holger Cahill of the Work Projects Administration (WPA) selected one of Knee's photographs to represent art in New Mexico in an exhibition of American art circulated around the nation, a decision looked upon with great dismay by the painters of New Mexico. Knee's work was often reproduced in

magazines and books. Mabel Dodge Luhan reproduced some of his landscapes along with landscapes of New Mexico by Edward Weston in her book *Winter in Taos* (1935). *New Mexico: A Guide to the Colorful State,* compiled by workers of the Writers Program of the WPA and published in 1940, was also illustrated in part by Knee's photographs. A pleasant picture-book of his photographs of Santa Fe was published in 1942. The warm-toned gravure reproductions of his work in these latter two books emphasize this photographer's strong sense of composition, for this process tends to increase contrast in tones compared to the original prints. Part of this sense of design is the result of working with a large camera on a tripod and composing carefully on the ground glass, but it also reflects Knee's special sensitivity to adobe architecture and its relationship to the magnificent cumulus clouds that gather in the summer in the region, and to the canted landscape so peculiar to New Mexico.

5

The Farm Security Administration and Office of War Information Photographers

Under the direction of Roy Stryker, the Historical Section of the Farm Security Administration sent photographers to New Mexico in the 1930s to document the hardship conditions that existed in the state. Their role was to make known the suffering of what President Roosevelt called "the one-third of the nation which are ill-clothed, ill-housed, and ill-fed."

New Mexico and Arizona did not suffer so much as Oklahoma and Texas during the depression years. The great drought of the 1930s dried up the overcultivated fields of Oklahoma and Texas. Beef prices were so low and water so scarce that all but the most affluent farmers suffered. Farm workers had no jobs, and owners of small farms found they could not keep up payments on their mortgages. They very often simply abandoned the land and moved west.

Dorothea Lange, a former portrait photographer in San Francisco, photographed for the FSA the stream of ancient cars laden with people and household goods that moved across southern New Mexico roads on their journey to California from the drought-stricken area of Oklahoma and Texas. She had first photographed in New Mexico in 1931 and returned in 1935 to Albuquerque. There she married the University of California economics professor Paul Taylor, with whom she had been associated in 1934–35 in work with farm labor documentation for the California Rural Rehabilitation Administration. Her pictures in the mid 1930s caught the poignancy of the people's plight as their cars broke down and

they ran out of gas and money. She photographed their caravans and made pictures of individuals that clearly convey the erosion of the people's hopes. We can sense that her photographs were real, that they were a reaching out gesture to those unfortunate people.

Russell Lee, who worked in New Mexico a few years later for the FSA, had a degree in chemical engineering from Lehigh University and was married for many years to a painter. He had also studied art at the California School of Fine Arts before joining the FSA team. This background probably accounts for his ability to overcome technical problems as well as to place the elements in his photographs sensitively so as to produce pictures that were much more than mere documents.

In a three-week stay in New Mexico in 1940 Lee made some of his most moving pictures in a community called Pie Town. This town, located on U.S. Highway 60 at the Continental Divide near the Arizona border, had first been settled by a gold miner and his wife who had a filling station and also baked pies to sell to travelers. About two hundred families from Oklahoma homesteaded there during the depression on what had been grazing land that proved to be a good place to grow pinto beans. They had moved west when the topsoil on their farms had been scattered by fierce dust storms. Pie Town's social life centered around the community hall, which served also as a schoolhouse and church.

There were all-day community sings, and food was exchanged. Help was extended to newcomers, who often began living in dugouts and then gradually built frame houses with the help of neighbors. The rawness of the land, the simplicity of the life lived by the Oklahomans, and the occasional moments of pleasure that relieved the hard life in Pie Town were all recorded by Lee. He also worked in northern New Mexico, where the small farms owned by the Hispanic people had been divided for many generations among the children so that the plots had become uneconomical to operate as farms and barely provided food for domestic use. Lee photographed the people in the little towns such as Peñasco, Truchas, and Trampas. He documented his subjects with an acute social consciousness, but the bleakness, to be believed, he felt, had to be recorded clearly and frontally. The results are photographs that are strong and unsmiling but also evoke feelings of sympathy and have distinct artistic qualities.

Arthur Rothstein, a graduate of Columbia University who majored in physics and chemistry, became an FSA photographer in 1935. In 1936 he made his most famous single picture, a gritty view of a farmer and his two boys rushing toward the shelter of a low, roughly finished wooden shed for protection from a swirling Oklahoma dust storm. From Oklahoma, Rothstein came to New Mexico, where he photographed Taos Pueblo and did some work around Las Cruces. None of his New Mexico pictures match in intensity his Dust Bowl photographs. There are even picturesque elements in some of his Taos pictures.

Jack Delano, like Lee, had studied drawing and painting before becoming a photographer. In 1937, after graduating from the Pennsylvania Academy of the Fine Arts, he became a professional photographer; three years later he joined the FSA. In 1943, he photographed on assignment from the United States Office of War Information in New Mexico, concentrating on pictures of the Atchison, Topeka & Santa Fe Railroad locomotives, stations, yards, and shops. He was very active in Albuquerque at the large shop maintained there by the A.T. & S.F., in Gallup, and along the tracks in Clovis, Isleta, and Vaughn, New Mexico. His were directly recorded pictures full of information but without any special artistic character—just the type of pictures the government wanted for documentary purposes.

John Collier, the last FSA photographer to work in New Mexico, had spent his formative years in the San Francisco Bay area. There he attended the California School of Fine Arts with the intention of becoming a painter. He had known Dorothea Lange because he had studied mural painting with her first husband, Maynard Dixon. The high quality of her documentary work caused him to look upon photography as a livelihood that could also be used to acquaint people with social problems. He began work with the FSA in the summer of 1941 upon the recommendation of Lange. This was a period when pictures of war preparation were taking precedence over agricultural subjects. One of his assignments was in a Pennsylvania coal-mining area. There he perfected his use of synchronized flashbulbs while taking pictures of the miners at work. His use of flashbulbs stands out when his work is viewed along with pictures by other FSA photographers. In early 1943, Collier was sent to New Mexico to photograph by the Office of War Information, formerly the FSA. Despite the new name of the agency he did an FSA-type statement on the Hispanic people. His well-composed pictures reflect his training as a painter. His earlier assignment in the coal mines had given him experience with synchronized flashbulbs. He used this technique to light interiors in which there were people and to create a sense of drama in some of his pictures. There is usually an upbeat feeling to his work that separates it from many other FSA photographs. Strong faces that fill the full frame are common. These frequently were taken with a flashbulb or flashbulbs arranged to illuminate one side of a subject's face more than the other so as to create a feeling of roundness and record skin textures in detail. Collier's photographs, like Lee's, are very humanistic, and also strong as pictures, for he had a sensitivity to pleasing arrangements of bold shapes that were distinctive.

The writer-photographer Wright Morris worked briefly in New Mexico in 1940. His three now-famous books of text with photographs, largely of his native Nebraska, *The Inhabitants, The Home Place,* and *God's Country and My People,* had not then been completed. He had studied at Pomona College and stayed on in California writing for a number of years, then traveled in Europe. On a trip through New Mexico soon after he returned to this country, he photographed in Taos and as far south as Lordsburg. Using a large-format stand camera he photographed the Ranchos de Taos church as it had never been photographed before, from the northeast, with a rough plank fence prominent in the foreground. In the southern part of the state he photographed, among other subjects, a utility building along the railroad track. In this picture he neatly compared a palm tree with a rigidly upright iron smokestack. His carefully composed yet freshly seen images are straightforward as can be. He likes architecture and uses it as an indicator of people's lives by showing them in their daily architectural environment.

6

The Postwar Period

The dean of all the photographers in the Southwest today is Laura Gilpin. She is a native of the West and has a great fondness for the region as well as a true love and understanding of the Native Americans of the Southwest. Born in Colorado Springs, she attended boarding school in the East and, in 1917, graduated from the Clarence H. White School of photography in New York City after two years of study. There she perfected her technique and learned to make the beautifully subtle platinum prints for which she has become famous. In the 1920s, she returned to Colorado, where she was active as a portraitist and photographer of architecture. New Mexico's landscape and Indians were also her subjects in the twenties and thirties. After World War II, she moved to Santa Fe. The photographs in her book, *Rio Grande: River of Destiny*, made soon after the war, took her for three years on foot, on horseback, and in trucks and cars the length of this major river, which flows from Colorado into New Mexico and then divides Mexico from Texas, finally spilling into the Gulf of Mexico at Brownsville.

In 1941 her book of photographs of the Southwest, *The Pueblos: A Camera Chronicle*, was published. The following year she began a series of lengthy stays in the Navaho country that stretches eastward and westward from the New Mexico–Arizona border. For fifteen years she photographed these people, whom she grew to respect highly. That she had their trust is evident in her intimate portraits and studies of their ceremonies and everyday life. Her book *The Enduring Navaho*, incorporating these pictures, was published in 1968.

That she is a master of her craft can be readily understood when one considers the difficulties she had to overcome while photographing in the heat, dust, cold, and intense sunlight of the region. Both the beauty and the harshness of Indian life are indicated in her pictures. The Indians' adaptability and ruggedness are conveyed in such subjects as the temporary log huts and leaf-covered bough shelters Navahos make in summer as they move about the landscape to find grass and water for their flocks. Closeups of the men and women are important to her, for they show styles of jewelry and indicate dress and cultural practices. Gilpin almost always found a way to include in her portraits an indication of the setting in which the people being photographed live. With indomitable energy and a clear idea of what she wanted to record, Gilpin has made photographs that meet the needs of the scientists but also have compelling attraction for those who are interested in expressive pictures of the Indians.

Her informal pictures of members of the Santa Fe art colony, such as those she made of Randall Davey, Andrew Dasburg, and Cady Wells, catch in each instance a facet of the personality of the artist. She has a well-developed eye for strong designs not only in her portraits but also in her pictures of buildings and wood-crafted objects. This is apparent when we see her photographs of architecture and details of crosses in Spanish-American graveyards. Darkening the sky by means of a filter is a way for Gilpin to cause some parts of an adobe wall to stand out in relation to the others and thus to concentrate our attention on the part of a composition she feels is of

major import. A cluster of hand-hewn crosses makes a strong statement when she finds just the right spot from which to record them. No special tricks are used in her work, just unusually sensitive seeing whereby she makes of an ordinary subject a powerful picture and at the same time a meaningful symbol.

Gilpin is a real pro. She has made very good aerial photographs from a small, low-flying plane, served as a publicity photographer for the Boeing Airplane Company during World War II, shot pictures in dust storms, and photographed hundreds of paintings by New Mexico artists—no easy job to do well. She can coat her own platinum paper as well as formulate her own developers. Today she is an inspiration to younger photographers and continues to add to her vast archive of photographs of the people of New Mexico and the sun-seared southwestern landscape.

Henri Cartier-Bresson, the French master of the "decisive moment," that instant when form and content come together at the most psychologically powerful moment, has visited New Mexico on a number of occasions. His interest in the Indians is deep and he has spent a considerable amount of time getting acquainted with them and their way of life. He has rarely photographed them, for he feels that the very act of using his camera is an intrusion. In 1947, however, he photographed in Taos a non-Indian scene that is deeply moving without being sentimental. The picture he took at that time was later chosen to be reproduced in the classic book on his work, *The Decisive Moment,* published in 1952. The picture was described by the photographer as follows, "A landowner died. His body was taken out to the burial ground in a shiny black motor hearse. Members of the family rode in a stage-coach. Cowhands and ranch help came on horseback. During the funeral, this one old cowboy bowed his head at the graveside."[18]

The matter-of-fact report clarified the scene and endowed it with a dignity appropriate to the occasion. Cartier-Bresson here illustrated well the line of demarcation between sincere sensitivity to a situation and the treatment of that situation in a trite and plaintive fashion. His eye searched out the moment when there was symbolism in the gesture and stance of the man thinking of his departed friend.

John Candelario, born in Santa Fe, was one of the few New Mexico photographers, other than Ernest Knee, who took his cue from Edward Weston and the f-64 group. After attending Pasadena City College, he took up photography in 1938. In 1941, he began his New Mexico series. Soon thereafter his work began to be reproduced in a great many periodicals. His full-toned, carefully wrought pictures, made with a twin lens reflex, a 3¼-by-4½-inch press camera, or an

8-by-10-inch view camera, reflect his interest in his state's traditional subjects—the Indians, dramatic landscapes, and adobe architecture. At times he used a filter to make the skies very dark in his pictures, and thus to cause the light-drenched churches to stand out as if on a stage. Since the mid 1950s, Candelario has been involved with writing movie scripts and only does still photography now as a hobby.

Brett Weston, who had been trained as a photographer from the age of fifteen by his father, Edward, found New Mexico a stimulating place to photograph. He used an 11-by-14-inch view camera in New Mexico, as well as his usual 8-by-10-inch camera. His most notable New Mexico pictures were taken in 1945, 1947, and 1950 at White Sands, in the central part of the state. The rich brilliance of his prints matches the quality of the intense light itself as it reflects from the flowing powdered gypsum that makes up this bed of a former inland sea. The romanticism hinted at in so much of Weston's work came to the fore here, as he sought out clumps of yucca that seemed to take on the appearance of Indians in feather headdresses. The precision of his compositions is apparent when one measures the intervals between the low, vertical, spiny elements in his White Sands pictures and the arabesque lines made against the sky by the crisp edge of the tops of the sand dunes. A master of pleasing designs, Weston made the most of nature's patterns at White Sands, the undulating sea of sand stretched out before the nearby Black Mountains.

The New Mexico photographer who has had the greatest number of his pictures reproduced in color in beautifully printed books is Eliot Porter. Trained in biology and engineering at Harvard University, Porter then took a degree at Harvard Medical School. He was self-taught as a photographer. By 1933 he had decided to leave medical research and become a professional photographer. His was the last one-man exhibition of photographs at Alfred Stieglitz's An American Place gallery in New York City. This kind of high-level recognition has continued. More than ten books have been published of his lush color pictures of nature, animals, and birds. He has ranged from Iceland to Greece to the Galapagos Islands in the Pacific Ocean to find his subjects. In the Southwest he photographed Glen Canyon on the Colorado River before it was inundated by the waters backed up by the famous dam; he also recorded in handsome color pictures his first trip through the Grand Canyon. He has left his Tesuque home, which he established outside Santa Fe in 1946, to photograph all over the world, but he has also photographed New Mexico in color and in black and white. As Margaret

Weiss has said, "It is not accidental that Porter's work holds appeal for both art and science audiences. Blending a spirit of inquiry with a sense of wonder, his approach is born of a conviction that the proper study of man is nature—with its dynamism of orderly change and its full spectrum of animate and inanimate forms. What remains of the nature landscape deserves careful inventory and respectful treatment. Eliot Porter's lens is capable of both."[19]

Attracted by his friendship with Georgia O'Keeffe, and by a wish to return to America from France but to live in a part of the country that had some of the qualities of Europe, Todd Webb came to Santa Fe in 1961. Webb, who was from Michigan, began working in photography in 1939. He was a U.S. Navy photographer during World War II. After the war he was a member of Roy Stryker's Standard Oil Company group, which Stryker had organized somewhat as he had previously organized the FSA team of photographers. Webb was named a Guggenheim Fellow in 1955 and 1956. The work he had done in Europe had been early singled out by Edward Steichen for exhibition at the Museum of Modern Art, and he had been involved with photographing the frontier trails in the West before he came to New Mexico.

In New Mexico he photographed ghost towns and mining sites in a style in no way distinctive, emphasizing the repetition of forms and depending upon the appeal of sun-warped and weather-beaten wood, found often in entrances to the mines and in the miners' quickly built houses. Webb, as a friend, made hundreds of informal photographs of O'Keeffe. In a few instances he also took some still-life pictures of arrangements of sun-bleached bones that reflected O'Keeffe's use of these beautiful white forms in her carefully measured paintings. In the early 1970s Webb left New Mexico, selling most of his negatives to a New York dealer. He now lives in Maine.

One of the most influential photographers of modern times, the Swiss-born Robert Frank, took a number of pictures in New Mexico in 1955–56 during his famous transcontinental trip from New York to Los Angeles and back. Frank had been trained as a professional photographer in Zurich in the forties before he came to New York City in 1947. After nine years as an advertising and fashion photographer he decided to see what his adopted country was really like when he received a Guggenheim Fellowship that made an extended trip possible. He had already photographed in South America, England, France, and Spain. He saw America just as he did these places—as a foreigner—but he also, having worked in New York City for a number of years, had the insight of an ironic realist into the special character of the country's psyche. Reproduced in The Americans, Frank's major book, was a picture neither poignant nor depressing taken in New Mexico of a group of ranch hands standing around a fluorescent-lighted bar in Gallup. This offhand shot with a 35 mm camera conveys the macho character of the men at leisure in their clubhouse. It is as if the photographer was fascinated by what he saw and wanted to get on film a glimpse of the tough cowboys but was afraid to show himself, or at least show his camera, and so shot the picture from a seated position across from the bar, which created a canted, keyhole view surrounded by black. His stark picture of the Shamrock gas station in Santa Fe, in its grayness and neutral quality, has, like the Gallup picture, influenced many younger photographers, who see in them a coolness they appreciate.

Frank has said of his pictures, "There is one thing the photograph must contain, the humanity of the moment. This kind of photograph is realism. But realism is not enough—there has to be vision, and the two together can make a good photograph."[20]

Because they use a large-format camera and print their pictures to get a maximum amount of detail in the highlights and shadows and a long range of tones in their images, Wayne Gravning, Thomas Cooper, Richard Faller, and, to a degree, Arthur LaZar can be considered together. Their prints are more objects than reports of what was in front of their cameras. We can usually recognize the general type of material that has been photographed, but not the particular facets of the material, so mysterious have they made the raw material in their lush, dark prints. The art of transforming reality to the still, silver image is, for them, an intellectual act that involves a preconceived idea of what part of nature or, for that matter, man-made objects, can be made into a sign. They could work in their style and with their intent almost anywhere, but have chosen New Mexico. A few water-worn rocks, patches of snow, or a twisted tree trunk are sufficient to provide them with the raw material they turn into analogues of a grand kinship of man and the earth. No motion, no sound, no color, no smells are evoked in their paradise, where God's handiwork is found in even the smallest rock or twig. This view of transcendent reality, coupled with their study of Zen, makes of simple objects equivalents to states of mind that question the role man has assumed in the universe.

Cooper, Gravning, Faller, and LaZar have been directly influenced by Minor White, who taught a workshop in Albuquerque in 1966. White's interest in Zen and the concept of equivalents permeates their thinking. The Zone system and previsualiza-

tion, both taught as techniques by White, also played a role in shaping their work. White taught his students to be open to emanations and, when these emanations are felt, to grasp the essence of their message on film. This made possible in their photographs the evocation of a state of meditation similar in character and intensity to the initial emanations experienced firsthand.

Thomas Cooper was born in San Francisco and took his first degree at Humboldt State University in Arcata, California. Located in the damp Northern Pacific coastal belt, this area's fog and growth of ferns and evergreens, plus the prevalence on the beaches of sea-washed logs, which often appear at a distance to be medieval monsters, possibly set in motion a deep romantic strain in Cooper's mind. When he came to the University of New Mexico for graduate work, he found it difficult at first to adjust to the clarity of the light and the dry-bones quality of the rocks. Soon, however, he found a rock-filled arroyo and a trickle of water that met his needs for a motif that was in accord with his transcendent view of existence. He took a series of pictures that have about them a confidential tone that causes one to think of ancient mythology as found in Victorian poetry.

Wayne Gravning, a professional filmmaker at Sandia Laboratories in Albuquerque, often takes in a wider view of his subject than Cooper when evoking what he feels is the essence of the pantheistic experience. Richard Faller works with a similar philosophy. His, like the prints of the other "Zen philosopher" photographers, are beautiful in a classic sense. They are pleasurably elegant and, while precise, have a romantic, melodic quality of detachment from worldly cares. Arthur LaZar, like Cooper, was interested in philosophy and studied it formally at the University of Arizona. Not one to stay in the classroom long, he left to study photography privately with Minor White. LaZar was born and brought up in New Mexico. It was therefore natural for him to take pictures of buildings that convey something of the span of the area's history. He has been very successful in finding a vantage point for these pictures and a time of day that emphasized the special qualities of the structures so that they take on a character suitable to their age and heritage. LaZar has also photographed rocks and trees for a number of years. He is not especially concerned about geology or forestry but aims in such pictures to evoke some of the universal mystery of nature and its underlying order.

As far as possible from the Zen photographers is the work of Harvey Caplin. No history of photography could, however, be complete without taking into account the contributions made by commercial photographers, who have an eye for subjects that will make attractive and informative pictures for a variety of customers. Dick Kent or Joseph Laval could have been chosen, but Caplin seems to exemplify best this aspect of the history of photography in New Mexico. He has a vast archive of what in the trade are called stock photographs. Many of these were made just because the subject appealed to Caplin and he felt there would be market for them somewhere. This is quite different from being a studio or staff photographer and making pictures on assignment to serve a company, government agency, or some other agency that has a vested interest in what is taken and the manner of representation. Caplin has in mind what will sell, for that is how he makes his living, but only rarely does he make pictures that would serve a viewpoint that might be at odds with his own.

Caplin was born in Rochester, New York, and received a certificate of achievement from the forerunner of the Rochester Institute of Technology. He was trained in applied arts and only incidentally received instruction in photography. He began his career as a commercial artist but grew tired of leaning over a drafting table all day, so he took up photography. During World War II he was a photographer in the U.S. Air Force, doing publicity work and documenting plane crashes. In 1945 he became a professional photographer and located his studio in Old Town, Albuquerque.

By virtue of being a resident of New Mexico for over thirty-five years and making it his business to photograph all kinds of activities, he has built up an important collection of pictures of events that are now part of history. He has not only photographed the Indians and dramatic views of the architecture and landscapes, but has also documented many aspects of ranch life. Some of his pictures of cowboys at work on New Mexico ranches carrying on their traditional pursuits are of increasing value as documents, for cattle are now being handled in quite a different fashion than in the past. His pictures are easy to understand, well composed, and help to humanize the images of the large corporations that use them in advertisements.

In a period that spawned traveling writers like Jack Kerouac and Allen Ginsberg, it is not surprising to find photographers moving about the country. Robert Frank set the trend when he took the pictures that were published in *The Americans*. He probably influenced Lee Friedlander as much as anyone. Friedlander, in turn, served as a model for Paul Diamond. While wandering across and up and down the United States, both men took a number of photographs in New Mexico. They were not attracted

to the Indians or to the landscape, nor did they involve themselves with dislocations of the social system. Friedlander was born in Aberdeen, Washington, and studied commercial photography at the Art Center School in Los Angeles. He began his career doing all kinds of photography, including catalogue illustration for a mail-order company. Recognition of his fresh approach to our urban environment came early. In the sixties his creative work was shown in major exhibitions and frequently published in leading art and photography periodicals. Three Guggenheim Fellowships plus commercial assignments have made it possible for him to travel extensively.

Friedlander brought to photography a new kind of space and a way of particularizing the artifacts that make up the street environment in the commercial sectors of our communities. He sees the facades and out-of-the-way corners of towns, large and small, in a unique fashion. Banal objects like fences, telephone poles, public monuments, and street signs are turned into formal elements that divide, focus, and point, channeling our eyes and minds so that the commonplace takes on new meaning and visual excitement. Out of the disordered environment that has developed under our free enterprise system he shapes a new order, and he has ways of making us see in a different way the most ordinary objects. Under his sharp eye the discordant mixtures are united into neatly framed patterns. They show us what the camera can do when it comes to singling out for study things we would never stop a moment to examine or relate to one another.

Paul Diamond's wide-angle photographs of everyday subjects take on qualities that encourage us to use a strange designation like "surreal anthropology." Brooklyn born, Diamond was trained in graphic design at Pratt Institute and for a time was assistant to the artist Leonard Baskin. Like Baskin's, his vigor is evident and extends almost to a viciousness that can be seen as a portent of chaos. His willingness to dislocate continuously and thus symbolically suffer reminds us of the mendicant monks—they with staff and gourd of water, he with his camera begging the world to speak to him so that he can understand it better. His attitude links him with some aspects of existentialism. New Mexico to him is a land of great contrasts—shaman and scientist, skyscraper and Taos Pueblo—but it is the overlooked objects he combines in his pictures to puzzle us and evoke a questioning attitude about our relationship to all these "things."

Ralph Gibson is another wanderer. He lived in Santa Fe for six months in 1977 and has frequently photographed in the area while traveling from coast to coast. Born and raised in Los Angeles, trained in the navy to be a photographer, at one time early in his career and very late in hers Dorothea Lange's printer, and later an assistant of Robert Frank, Gibson today has a fine eye for puzzling reality. He uses to apt advantage his knowledge of contemporary art canons and sees pictorial witticisms in ordinary subjects. His New Mexico photographs show Gibson at his best. He uses photography to work out his complex and often pungent feeling about the free life he leads on the road to London and Paris by way of America's university communities, where he plugs briefly into the academic world between flights to the centers of the international avant-garde. His pictures touch reality only at selected points. He delights in the tricks recognition plays on us after we have looked at an image for a few moments. Under the guise of surrealism, Gibson also reveals his interest in sex as a major subject. While his pictures are difficult to decode, the clues reside in autobiographical allusions coupled with a distinct sense of mystery that derives more from film than from still photography traditions.

The 1960s and 1970s

In 1963, photography in New Mexico began to change rapidly. A program was begun that year in the Department of Art at the University of New Mexico, in Albuquerque, that has developed into one of the strongest programs in the world devoted to venturesome photography as a means of artistic expression. Photography had been taught at the university by the painter and ex-Navy photographer Les Haas, who was for many years chairman of the department. Photography was also taught in the context of the graphic arts program by William Thonson. These courses, however, did not add up to a complete program that had been thought out in its entirety and based on philosophical aims. New courses instituted in 1963 were designed to acquaint students from throughout the university, as well as those enrolled in the Department of Art, with creative photography as a means of self-expression on a par with painting, sculpture, and printmaking. The program was based on a thorough knowledge of the history and criticism of creative photography and the concepts of modern art. It was designed to open students to an understanding of the responsibilities of a creative person and what was expected from one who seriously practiced photography as an art and means of philosophic communication.

After two years of testing at the undergraduate level, the teachers in this program, Wayne Lazorik, Richard Rudisill, and Van Deren Coke, decided that the ideas were sound and the next move could be made. This was the establishment of a two-step graduate program that would parallel the graduate program in the other studio fields offered by the Department of Art. An M.A. and an M.F.A. were established. The M.A., a two-year degree with emphasis on the development of a student's personal style and philosophy, was step one. With this degree completed, some students were invited to take the M.F.A., a doctoral-level degree emphasizing a more extensive knowledge of the history of photography and a deeper awareness of the student's creative aims. From the beginning, it was envisioned that graduates of these programs would become teachers in colleges and universities as well as carrying on their work as practicing artists. Many students who were selected for the graduate programs had been outstanding as undergraduates in such fields as literature, anthropology, history, and art history. It was felt that training in these disciplines would better equip students to handle the philosophic aspects of the photography program. It was not necessary to have had extensive undergraduate training in photography to enter the program, for it was felt that the techniques of photography would be learned as the student needed them to carry out his or her aims. By analogy and drawing upon ideas being explored by contemporary writers, painters, filmmakers, and others engaged in creative fields, students were encouraged to explore techniques that could best express their feelings about themselves and about the world at large. Students have been attracted to this program from all over the United

States as well as from Canada and England. Their responses to New Mexico's light, space, and people have been innovative and very imaginative.

One of the outstanding early graduate students in photography, Cavalliere Ketchum grew up in Arizona. He came to the University of New Mexico in 1964 and stayed for five years before finishing his M.F.A. and taking a teaching appointment in photography at the University of Wisconsin–Madison. Ketchum, being half Spanish, had learned as a youngster a kind of provincial Spanish that served him well during the most important project he undertook while living in Albuquerque. This project, the basis of his dissertation, was to photograph the town and people of Manzano, located in the Manzano Mountains, south of Albuquerque. This little Spanish town had been founded early in the nineteenth century as an agricultural community. The distinctive apple orchards (*manzano* is Spanish for apple tree) had flourished for a hundred years but because of negligence and old age had gradually died or failed to bear fruit. Poor crops had become the rule rather than the exception in the area. Many of the farmers came to Albuquerque to find work or moved as far away as Los Angeles when they could no longer make a living by farming. A core of staid old-timers always remained to give the community stability, but there were also some colorful youngsters and even a few adults who ran afoul of the law and spent time in the penitentiary before returning to the community. It was to photograph this range of people that Ketchum rented an old house in Manzano and spent weekends and vacations in the town. He got to know all the families intimately and was a favorite of the children, who followed him about as he photographed the countryside, homes, and outbuildings, as well as the people, in and out of their homes.

Ketchum's special rapport with the people is immediately evident in his photographs. He gently directed or encouraged them to take up poses that made it possible to include in a single picture symbols of the life led in the community. Traditions of worship, work, and play are strong in such villages, and they are conveyed in Ketchum's photographs. Sensitively he incorporated in his pictures the icons that sustain the old as well as the young. A typical picture showed a young girl sitting by a TV set tuned to a romantic film. On top of the set are her dolls, and photographs of members of the family—living, deceased, or away from Manzano—and on the walls, pictures of Christ and the saints dear to her family. In Ketchum's pictures of the buildings we often see the effect of age on the adobe walls, patched in places with old tin signs that have, in time, rusted together. Among signs of neglect and poverty, bright-

eyed, agile youngsters play age-old games and act out new ideas they have picked up from television. Ketchum's overview of life in Manzano links objective content and human emotions with a sense of formal clarity that makes the content of his pictures easier to grasp.

The faculty of the photography program has grown as the number of students has increased. Some faculty members have become involved with new interpretations of New Mexico. They are seeing the people more frankly, reacting to the new architecture that is rapidly taking its place alongside adobe buildings, and experimenting with new ideas about "the West" as a concept.

Thomas Barrow is one of the faculty members who has created the spirit that is so exciting young photographers. In his photographs made in New Mexico he has managed to challenge the power of the camera's reality by qualifying the nature of that reality in his work. Barrow was trained at the Kansas City Art Institute and Chicago's Institute of Design, which probably accounts in part for his particular sensitivity to design. For instance, by introducing a ragged line in his "Cancellation" pictures he determines the way we see space. With this device he creates a flat grid that is like a web made of cracks in a piece of window glass. The marks divide the picture space both in depth and in plane. Ordinary subjects are enlivened by a psychological battle between the man-made marks and the lens-recorded plethora of information in the picture. The tensions set up by the lines, which he draws with a sharp instrument into his negative, in part cancel our normal response to the subjects. The lines become analogous to the sheer energy conveyed by the slashing brushstroke of a skilled Abstract Expressionist painter. Barrow is referring in such pictures to different modes of mark making. His hand-made marks sometimes parallel elements he has caught with his camera, like the crossbars of a scaffolding, or counter upright geometric forms, such as telephone poles or the support structure of giant roadside billboards. By his marks he forces us to look at and respond to subjects that are outside the traditions of emotional stimulus or have values that have rarely been given serious attention by artists.

Anne Noggle, another faculty member, is a former flyer in the U.S. Air Force. She was born in Evanston, Illinois, but has lived in New Mexico for many years. She took both her undergraduate work in art history and her M.A. in the practice of photography at the University of New Mexico, where she now teaches part-time. She has an intuitive understanding of the women of means and taste who enable the arts to flourish in Santa Fe by supporting musicians, the

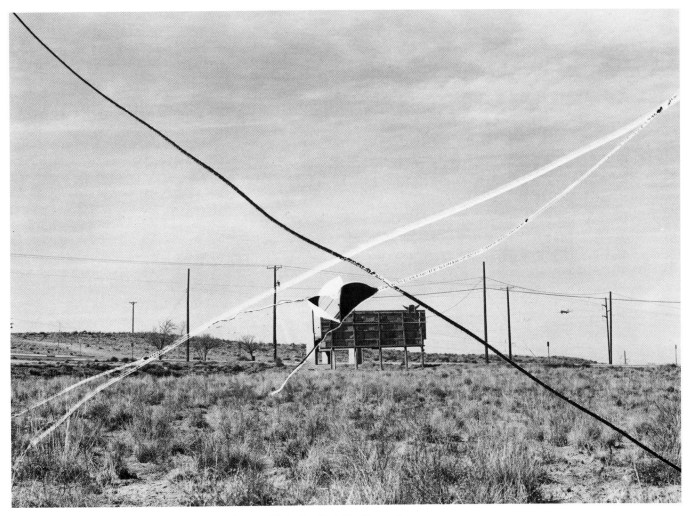

Thomas Barrow, *Untitled* (from the series "Cancellations—Flight Field"), 1974. Silver print.
Loan from the artist to the University of New Mexico Art Museum.

opera, younger artists, photographers, and poets. Sometimes eccentric and always charming in a stimulating way, these women are often like character actors out of a play. Noggle catches them with their masks down, when their true selves are revealed for a moment. Her accomplishment is not so much that she has an eye for the true self revealed but that she reveals her subjects' strengths rather than weaknesses, even if the strengths are not always appealing. Brutally honest in self-portraits, she sees no reason not to be honest in photographing others she knows well. By using a semi-wide-angle lens or a special panoramic 140-degree camera, she involves us directly in her frank disclosures that give a strong hint of what goes on behind the facades of Santa Fe society. While her work has a documentary quality, it also has psychological overtones that are related to the dream state. This combination gives her pictures a double hold on our imagination.

Betty Hahn of the University of New Mexico's photography faculty is known for her skilled use of a variety of photographic processes. Gum bichromate printing, stitching into her photographs printed on cloth, manipulated offset photographic imagery, collages over photographs, and photo silk screening in color of her camera-made pictures are only a few directions she has explored. Her unorthodox use of the bold contours of popular imagery as subjects for her photographs has resulted in fresh and vivid pictures about the West. She is not speaking tongue in cheek when she implies in her pictures that truth is symbolized in simple cinematic myths. Hahn was trained conventionally at both the undergraduate and graduate levels at Indiana University in design, photography, and art history, and it was a big step for her to create new ways to look at commonplace icons. She has nevertheless taken over and made her own the pop symbol of the Lone Ranger and Tonto,

mounted on their faithful steeds, conferring about the best direction to take to catch the villain of the moment. She retells the familiar story in a series of lighthearted variations on the theme. Her imaginative display of photographic techniques provides us with humor and recreates the suspense we experienced when we first watched these heroes ride across the screen. Today her romantic images take on new meanings as we see the West with new eyes.

Ray Metzker, who, like Barrow, was trained in photography at the Institute of Design and who is now a member of the faculty of the Philadelphia College of Art, taught the practice of photography at the University of New Mexico for two years in the early 1970s. While in New Mexico he also made pictures of aspects of the city of Albuquerque. He responded strongly to the textured walls of houses and commercial buildings and the deep, black shadows that cast the walls into relief. By printing his pictures with greatly exaggerated contrast, he called attention to design and construction characteristics he discovered in his camera's finder when light and shadow articulated spaces and textures. He emphasized the geometry of such subjects with particular attention to the differences, as forms, of trees and bushes compared to man-made shapes. In addition to directing our attention to these matters, his pictures also convey a strange sense of foreboding that has to do with our imagining that mysterious things take place in spaces concealed by deep, dark pools of black.

The university's program has attracted a good many photographers to Albuquerque in recent years, but Santa Fe's charm continues to exercise an influence. A half-dozen or so well-regarded photographers have chosen to live there. Two of the Santa Fe photographers who have made some striking pictures in New Mexico are William Clift and Paul Caponigro.

Clift's scrupulously crafted landscapes of New Mexico would not serve the analytical interests of a geographer. They do affirm for the poet in us all the enchantment of New Mexico's mountain ranges, so often interspersed with sloping plains and flat-topped mesas. Clift is the inheritor of his teacher Paul Caponigro's love of dramatic lighting, which gives the land a feeling of mystery owing to the spectacular light effects during the brief rainy season and late in the afternoon when the clouds gather. Clift has not become numb, as have many young photographers, to the effects of giant clouds hanging over the land and creating unusual shapes of fast-changing combinations of light and shade. His beautiful prints convey a sense of awe in the presence of nature. To this end he makes good use of the phenomenon of seeing faraway mountains and mesas as if they were much closer than they are, which is due to the clear, thin air that prevails in the Southwest.

In 1975 and 1976 Clift changed his subject for a time. He was engaged in photographing New Mexico courthouses for the American County Courthouse U.S. Bicentennial Project, sponsored by the Joseph E. Seagram and Sons Company. He photographed twelve New Mexico courthouses for this project, drawing upon his earlier experience as a commercial photographer of architecture, and benefiting greatly from what he had learned while photographing in detail the old Boston city hall. His pictures of the courthouses, like his landscapes, are especially sharp, wtih great attention paid to giving a sense of the environment from unexpected and therefore stimulating viewpoints.

Clift's explanation of his reasons for coming to New Mexico and of why he finds it a stimulating place to photograph speak for many photographers who have chosen to make New Mexico their home. "The northern New Mexico landscape," he says, "is marked by a sense of space, oceanic light, dryness, and austerity. The bareness and openness of the land are similar for me to the honesty and openness possible in human beings. These are the reasons I came and they are the reasons I stay."

Paul Caponigro moved to New Mexico after his former student William Clift had established himself in Santa Fe. Caponigro had been inspired, like a number of others who live in New Mexico, by Minor White's idealism and poetic reaction to nature. He first saw the West in 1953 when he was sent to San Francisco as a soldier during the Korean War. The following year the army sent him to Yuma, Arizona, where he took every opportunity to see Arizona and made trips as far north as Utah. He found the Southwest very different from his native eastern Massachusetts. It was an unending landscape, a free landscape inhabited by free people. He felt himself one with the landscape—a new, almost mystical experience. We sense even now in many of Caponigro's baroque landscapes a feeling of the smallness of man in the universe and a sense of wonder at the manifestations of nature. His pictures are at once realistic and picturesque, in the full sense of the latter's meaning. We feel the earnestness with which he approaches the problem of encompassing on a single piece of film his responses to the breadth of the land. His experience as a skilled musician carries him beyond satisfaction with conventional means of evoking the dramatic content he feels. Caponigro's subtly handsome prints reflect his feeling that harmony in tones, proportion of forms, and elegant simplicity can align our thoughts with God or at least

with the ebb and flow of expanded consciousness. His very accessible pictures convey with new insight the grandeur of the New Mexican landscape as a manifestation of the mysteries of nature.

Santa Fe photographer Edward Ranney is best known for his sensitive pictures of Maya and Inca architecture in Mexico and Peru. Ranney, who was born in Chicago and graduated from Yale University, had his first extensive experience with pre-Hispanic culture in 1964–65 when he was a Fulbright Fellow in Cuzco, Peru. There he studied anthropology and began seriously to photograph. He has recently been staking out a photographic claim in New Mexico. Unlike some photographers who dramatize the country, he does not equivocate when it comes to making landscapes. His pictures of the ruins of the Southwest in their austere setting are finely printed to take maximum advantage of the full range of tones in the carefully exposed and developed large negatives he produces. The word "beautiful" is often on the lips of viewers of his prints but they are not romantic evocations of the past. Ranney's pictures clarify in emotional terms the data his lens recorded so that we appreciate the structural logic and rhythms of ingeniously built clusters of rooms or high-nave churches. His pictures of the ruins relate the past and the present in objective terms. The structures built by the early cliff dwellers and the later Christianized Indians hundreds of years ago are today open to the wind and rain and yet they still reflect their noble purposes in Ranney's direct and rational images.

Danny Lyon, a recent resident of New Mexico, was born and raised in New York City but came to photography while taking a degree in history at the University of Chicago. After having published photographic essays on Chicago youth gangs, bike riders, the destruction of old buildings in lower Manhattan, and Texas prison life, he came to New Mexico in 1970. He established his home outside the old town of Bernalillo on the Rio Grande. Here he has made a film about his neighbors, and edited other films. He has also made some impressive still photographs of the living world around him which mirror his anxieties about social injustices. Like much of his work, the New Mexico pictures are carefully structured responses to people at work or play which tell much about the character of the subjects' lives.

Like Lyon, Robert d'Alessandro works freely with a 35 millimeter camera. He teaches at Brooklyn College, but he spends summers in New Mexico, photographing and working on a house he is building in Placitas, the old Spanish town at the northern end of the Sandia Mountains. Known for his off-hand pictures of people, which point up the underlying structure of society, he has been impressed by the life-style of his summer neighbors, who embody many of the attitudes of the post–Viet Nam war generation. Their western pioneering spirit appeals to the imagination of this Bronx-born easterner. The young couple in the picture reproduced here are slowly building a simple house, rock on rock, from the ground up, using the foundation of an old Spanish ruin. D'Alessandro has caught both the facts and the flavor of the counterculture that is being integrated into New Mexico society all up and down the Rio Grande.

Very few photographers in New Mexico have set out to document in artistic terms a limited group of people prominent in the state. Scientists abound in New Mexico, and prominent businessmen are important to the state's economy, but no one has systematically photographed these members of society. Thomas Zudick, a professional motion picture photographer for Sandia Laboratories in Albuquerque, decided to do something about this situation. He has chosen to make interpretive portraits of New Mexico's artists. At the suggestion of the prominent painter Raymond Jonson, he began in his spare time to make portraits of recognized painters, photographers, craftsmen, and performing artists. These people, as a rule, are interesting to deal with, and Zudick has done an impressive job of conveying the spirit as well as the appearance of his colorful subjects.

Meridel Rubenstein has carried the idea of interpretive portraits to another level. Before coming to New Mexico she attended Sarah Lawrence College and then took a postgraduate seminar in photography with Minor White at the Massachusetts Institute of Technology, but she did not become a rocks-and-water photographer like so many of White's followers. She next took an M.A. and M.F.A. in photography at the University of New Mexico. For the past five years she has used her camera skillfully to photograph dozens of New Mexico Indians, Chicanos, and Anglos. What concerns her is not subject matter as something out of which pictures are made, but the creation of images that convey her humanistic concerns. In her portraits she includes symbols that define something special which she senses in each of her subjects. In some of her pictures she combined two negatives in a single frame. This gives her a greater range of symbolic expression as she links background with likeness to evoke a subject's personality and perhaps a state of mind. It also allows Rubenstein to follow her inclination to employ both fact and fantasy when expressing her responses to her subjects.

Nicholas Nixon was another of the outstanding

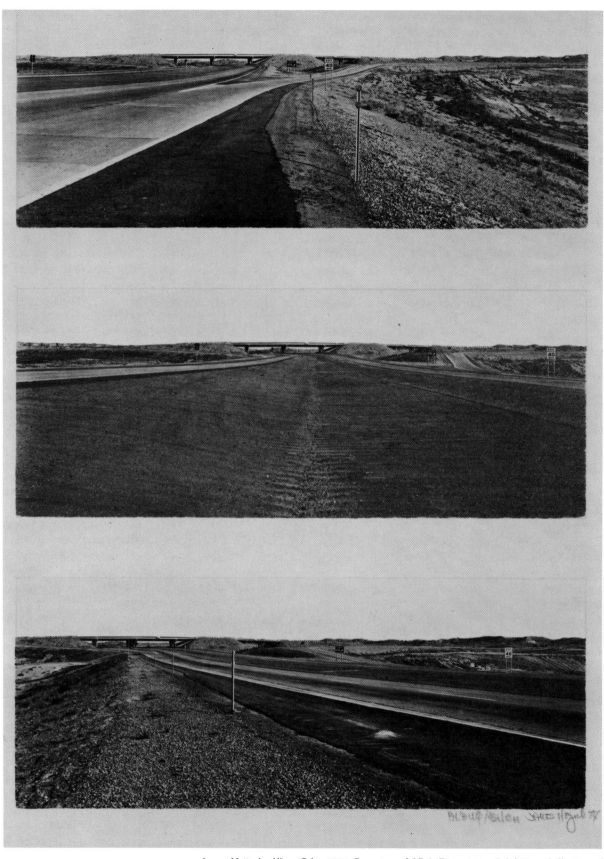

James Hajicek, *Albuq./Belen*, 1974. Cyanotype. M.F.A. Dissertation Exhibition, Collection of University of New Mexico Art Museum.

graduate students who took an M.F.A. at the University of New Mexico in the mid 1970s. A native of Michigan and a graduate of the University of Michigan, Nixon saw the time he spent in New Mexico as a period of research and confirmation of ideas he was firming up in his mind. He mastered the painstaking techniques needed to get the most details from the negatives exposed in his 8-by-10-inch camera. He sought to convey in his pictures the nature of substances by presenting them in as clear a fashion as possible. It has never been his intention to convert emotional responses to his subjects into pictures. He seeks to treat knowledge gained from his photographs as an end in itself. As he does so he poses as an anonymous observer but his stylizations are personal and give his work a definite identifying quality. There is a harmony of forms in his razor-sharp compositions, but this is to give a keener edge to the data recorded by his lens. What gives Nixon's work its special character is the tension between the readily recognizable subjects recorded by his camera and the mystery of the super clarity of his photographs, a clarity often at odds with firsthand experience. Occasionally, Nixon's latent wit triumphs over the chilly air of assurance he brings to his personal viewpoint, and he creates a delightful pictorial riddle. This is exemplified in his Santa Fe picture of a cluster of adobe buildings painted on a wall, behind which enigmatically rise the towers of the pseudo-French cathedral. This image speaks of the many incongruities that existed in the city's past and prevail even today.

James Hajicek, who teaches at Arizona State University, came from Kansas City and was trained at the Kansas City Art Institute before taking his M.F.A. at the University of New Mexico. Having a special sensitivity to design and an interest in systems, it was natural that he should have turned to the old blue print process to work out his ideas about space and resonant repetition of forms. Hajicek's new-fashioned use of the process suited his cool attitude toward the geometry of geography in a land where the horizon was the most persistent fact with which he had to cope when making pictures. His combinations of horizontal bands of the earth's surfaces with the changes in the elements that altered the flatness of the land link him with such contemporaries as Frank Stella and Donald Judd, artists of the 1960s who tackled problems of geometry and serial minimal structures. Hajicek's matter-of-fact information about construction sites and mechanical equipment breaking the flat skyline are seen as if from a car riding through the Southwest. They have nothing to do with travel, however, and are neither romantic nor visionary. Hajicek does have an interest in

well-engineered roads and their relationship to nature's own geometry as large-scale evidences of man's need to design well for practical purposes. This interest he turns into an art of formal interrelationships.

An Englishman, Kenneth Baird, who photographed in New Mexico in 1977–78, saw the sky in quite different terms. He sought a solution to a problem that has concerned photographers ever since they tried to capture on their negatives the sky and the vast, uninterrupted spaces of New Mexico. Baird was a professional photographer and teacher of photography in Manchester, England, before coming to the University of New Mexico to take an M.A. degree. The problem he solved was what to do as a picture maker about the skies that so dominate New Mexico's landscape. Baird's answer was to turn his square format up 45 degrees, causing his landscapes to stand on the point rather than in the conventional rectangular shape where the sides are parallel to the sides and bottom of the mat. In that way he could record a great stretch of foreground and middleground and suggest the extent of the country's space and its relationship to the sky by including only a small triangular portion of the sky at the top of his pictures. He set up in this way an arrangement that invites viewers into the space pictured without the danger of overwhelming them with the sheer magnitude of the towering atmosphere that often hangs full of clouds in New Mexico. By thus controlling the scale of what in poetic terms can be seen as the great dome of the heavens, Baird was able to concentrate in his pictures on the subtle changes in the earth's surface that have been made by man and nature.

Joe Deal, now teaching at the University of California, Riverside, was, like Hajicek, trained in design at the Kansas City Art Institute before taking an M.A. and M.F.A at the University of New Mexico. While in Albuquerque he photographed extensively the new housing under construction at the foot of the Manzano Mountains on the eastern edge of Albuquerque. Deal carefully organized the geometric forms inherent in his subject into more complex configurations, related in many ways to an old-fashioned cubist treatment of forms that have been flattened and overlapped at odd angles. That is, Deal shoots down and is able to make effective use of the varieties of shapes of the flat roofs as they relate to driveways or streets. Without, perhaps, meaning to do so, Deal also makes reference to the type of life people live in these upper-middle-class dwellings. We see how they build walls to separate themselves from their neighbors. The pattern of patios and swimming pools for outdoor living is apparent, as is the affluence of the owners of such houses. This can

be determined by the size of their two- and three-car garages, outside of which are parked their mobile vacation homes and boat-laden trailers. A response to forms and a wish to explore design possibilities attracted Deal to the subject initially, but the social statement that was a secondary interest becomes more important with the passage of time.

Graduate student Kevin Wrigley has followed Deal's lead. He has taken as his subject the process whereby virgin grassland on the slope northeast of Albuquerque is being encroached upon by single-family dwellings. Wrigley uses an 8-by-10-inch camera which produces under his skilled management exceedingly clear negatives with a wide range of tones. These needle-sharp negatives, in turn, make it possible to produce very detailed prints in which he has used a rich range of tones to convey a sense of light. The ultrarealities he creates in this fashion are as true as photographs can be—so much so that we feel an uneasiness in the presence of this disclosure of the system being used to provide quarters for people. Soon, however, this response gives way to an admiration for the way Wrigley has organized, as though on a blueprint, the various parts being assembled into houses. The system seems relentless and beyond the control of the city planners, architects, builders, and even the consumers. His prints are striking examples of how the photograph is able to represent "reality." The lack of natural color in his pictures removes them just enough from the real things so that we are forced for a brief moment to savor the sensation of seeing the future unfolded before us as if by a time machine in Wrigley's detailed records of man's need for shelter versus natural spaces.

Frank Gohlke lives in Minnesota, but he has come to New Mexico to photograph. He studied photography with Paul Caponigro before Caponigro came to live in Santa Fe. Above all Gohlke is an ordering photographer. That is, he sees the world with eyes conditioned by the arrangement of shapes on the ground glass of his square-format camera, a shape he particularly favors. There is a calm, static quality to the square which he used to advantage in much of his work. His concern is to establish a state of equilibrium in his pictures. In Albuquerque, he found objects clarified, as a result of the clear mountain air, to the point that the extent of space was deceptive. The normal near-far relationships of even the closest objects were confusing to the eye. Gohlke took advantage of this experience and produced some strong and intellectually stimulating pictures of the most conventional and even unattractive subjects.

James Dobbins and Richard Barish, both of whom have received M.A.'s and are working on their M.F.A.'s at the University of New Mexico, belong to a new breed of photographers. Their imagery is cool and impersonal. The subjects they choose are without symbolic connotations and are often no more than an excuse for dealing with light and space in the detached manner of engineers. Dobbins came to the University of New Mexico from Evergreen State College in Washington and Barish from the University of Chicago. Their backgrounds are quite different, so it could be said that their attitudes toward picture making come out of the time they have lived in New Mexico, a time that has matured them as people and given them a new outlook on photography as a means of expressing this outlook. They have found a new use for the photograph. For them it need no longer be of any particular thing to be important. Their work indicates that the fallacies and canons of traditionalists and conservatives are being recognized and challenged. The distinction between art and reality, between virtual space and illusionistic space, is being defined again by Dobbins, Barish, and others like them, using the most straightforward of approaches to photography.

Related in its concern for ambiguous spatial representations is the work of Tom Patton, a Californian who came to the University of New Mexico to take an M.A. after finishing his B.F.A. at the San Francisco Art Institute. He uses the camera's lens to create out of the most ordinary subject a puzzling encounter with objects that clearly exist but exist in a space that fluctuates. He achieves this effect by avoiding lines that would lead to a sense of spatial recession and chooses subjects that have no emotional connotation. His pictures represent a final phase of naturalism in straight photography.

Dobbins, Barish, Patton, and a number of their friends have not capriciously turned away from beauty, but their work is not about very much that one can discuss in traditional terms. These photographers can make exciting white or pearly gray tones that avoid the effects of sharp, bristly separation of deep darks and brilliant whites. Grain can be as much a part of their imagery as the evocation of what was before their cameras, or they may use the most subtle range of tones. Tones or grain are used to convey a sense of the materials of photography. The triteness of the physical subjects they record reflects their lack of interest in laying bare social ills or being eyewitnesses to beautiful natural phenomena of light and spaciousness, subjects so often captured on film by earlier photographers and painters. Their coolness is at first just *sensed*. Then we realize they have moved from the sensual to the cerebral—or perhaps the term *sensual* has been redefined, now referring not to that

which is voluptuous and soft but to things and experiences that are hard, as in *hard*-edge painting or *hard* rock music.

Thomas Barrow and Betty Hahn, as we have seen, have frankly manipulated the photographic image to give their pictures a wider range of interpretations. Altering the photographic image by hand is a complex act. The confusion it causes is stimulating in itself, but it is not done for this purpose alone. It is done to deal with contradictions in the relationships of one space to another and differences of textures and colors. The novelty and peculiarity of it all is being fast assimilated; the look of a mixed-media print is no longer strange to us. We can now look at such combinations of abstraction and representation with critical detachment.

Rick Dingus, who did his undergraduate work at the University of California, Santa Barbara, before taking an M.A. and working on his M.F.A. at UNM, explores the power of parts of photographs. He finds the haunting qualities of a few grains of photographic reality assert themselves even when they are linked with lively, repeated marks made by a silvery Prisma-color pencil. His pictures of mounds of earth and hillsides are undoubtedly photographs, but they are so unusual that they are instantly provocative. Dingus's split-focus imagery of contraries does not look like any other. His pictures are as detached and cool as the straightforward prints of Dobbins, Barish, and Patton but pose quite different questions. They mirror the precision and impersonality of the photograph and at the same time incorporate a spirited human presence and all that it implies. Dingus's pictures encourage us to see anew the irrepressible powers of the photograph, however they are processed and presented.

Places where students, mature photographers, and the public can gather to see and discuss photographs are necessary if photography is to flourish as a means of artistic expression. At a number of galleries in Albuquerque, Santa Fe, and Taos photographs have been shown regularly for over fifteen years. Ann Dietz's Quivira Gallery has been holding photographic exhibitions since 1965. Mrs. Dietz began in an adobe gallery in Corrales, the old Spanish town on the edge of Albuquerque, and later established her bookshop and gallery a block south of the University of New Mexico in Albuquerque. She has shown the work of prominent photographers such as Minor White, Van Deren Coke, Eugene Meatyard, Laura Gilpin, James Alinder, Eliot Porter, Walter Chappell, and historic material such as *Camera Work* gravures, plus the work of dozens of younger photographers. Her bookshop has specialized in photography publications, which has made her establishment a natural gathering place for those interested in photography.

In 1969 Elie Scott, an accomplished amateur photographer, established the f-22 Gallery in Santa Fe. Mrs. Scott died in an automobile accident in 1977, and the gallery was closed. During the eight-year history of the gallery, about twelve shows were organized each year. Among the exhibitions were those devoted to the work of James Alinder and Laura Gilpin, but Mrs. Scott's primary aim was to introduce younger photographers, including a number of University of New Mexico graduate students, to the public.

A number of art galleries show photography along with other examples of graphic art. The White Oak in Albuquerque, Elaine Horwitch, Hill's, and the Santa Fe Gallery of Photography in Santa Fe, and Maggie Kress's in Taos are notable in this regard.

Exhibitions of photographs such as "Laura Gilpin, Todd Webb, and Eliot Porter" were held from time to time at the Museum of New Mexico in Santa Fe. From 1970 to 1976, Anne Noggle served as curator of photography at the museum. The beginning of a collection was formed—today there are over 1,000 prints—and major exhibitions were held. Chief among these were "Women of Photography: An Historical Survey," "Laura Gilpin, a Retrospective of Photographs," The Coke Collection, "Found Moments Transformed: Work by Alice Wells," "New Mexico—New York," "Duane Michals—William Clift," and "Wynn Bullock Retrospective."

The Art Museum of the University of New Mexico opened in 1963. From the beginning, photography has been exhibited each year. Among the outstanding shows of international import have been the "Eliot Porter Retrospective," "Florence Henri, Consuela Kanaga, and Walter Peterhans," "Voyage of the Eye: A Fifty-Year Retrospective of the Work of Brett Weston," and theme shows such as "Peculiar to Photography," in which the University of New Mexico graduate students focused on definitions of those characteristics unique to the medium, and "Light and Substance," which called attention to the interest of photographers in adding elements such as texture or color to the surface of their prints and the simultaneous interest of other photographers in light as a pictorial agent, without regard necessarily to what the light may have been reflected from. Out of each of these exhibitions, prints were purchased for the art museum's rapidly growing collection. The collection assembled at the Art Museum is very broad in scope, ranging from work of the early 1840s by Fox Talbot to prints made within the last year. Examples have been acquired of the work of most well-regarded nineteenth and twentieth-century

photographers. A large collection of contemporary work has also been assembled. By seeing photographic prints firsthand and repeatedly, students can attempt to truly understand and evaluate them. In addition to maintaining a permanent photographic exhibition, the museum borrows prints representing all contemporary movements from photographers or from other museums, so that work of all kinds can be seen regularly.

There is no end to a history. Although it is considered unwise to predict the future from the past, some things do seem evident. In New Mexico photography of the time-honored subjects will undoubtedly continue, carried along buoyantly by a growing romanticism and enthusiasm for the sheer beauty of the place.

More and more, owing particularly to the University of New Mexico program, venturesome photographers will explore ways to use the camera to create visual enigmas. They will be the ones who surprise us as they fuse contraries into new and provoking visual experiences. This has become the aim of many innovative creative photographers in New Mexico and the world at large.

Plates

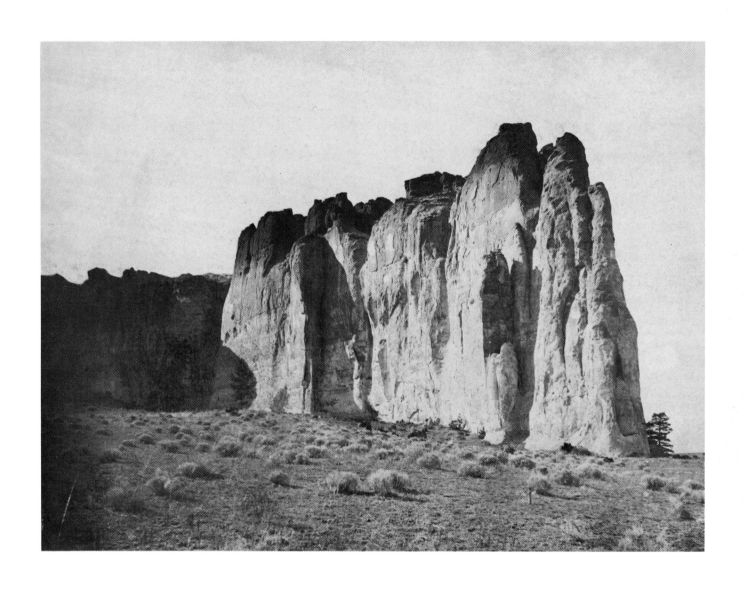

1. Alexander Gardner, *Across the Continent on the Union Pacific Railway, E.D.* (El Moro, Inscription Rock), 1867. Albumen print. Extended loan to University of New Mexico Art Museum.

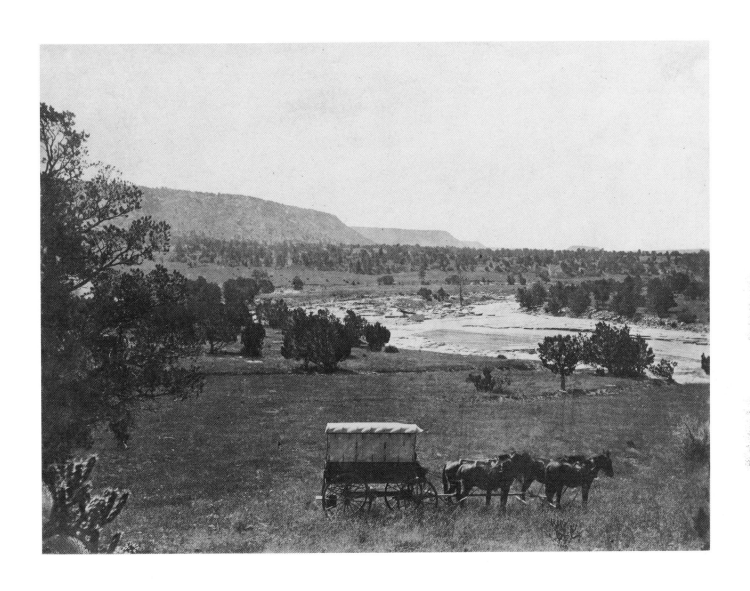

2. Alexander Gardner, *Across the Continent on the Union Pacific Railway, E.D.* (Rio Grande del Norte), 1867. Albumen print. Extended loan to University of New Mexico Art Museum.

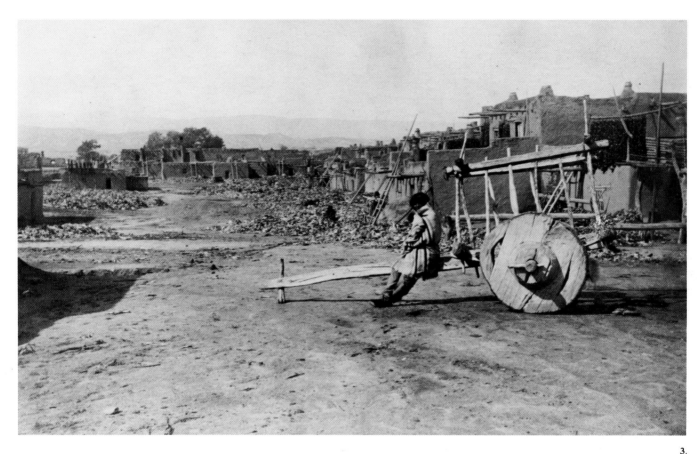

3.

3. William H. Rau, *Carretta: Pueblo San Juan,* 1881. Modern silver print from the *Philadelphia Photographer.*

4. *William Henry Brown, Santa Fe and Vicinity: A Mexican Residence,* c. 1880. Albumen stereograph. Extended loan to University of New Mexico Art Museum.

5. William Henry Brown, *Pueblo Tesuque Series: Mexican Carreata, or Cart Used by Indians and Mexicans of New Mexico,* c. 1880. Albumen stereograph. Extended loan to University of New Mexico Art Museum.

4.

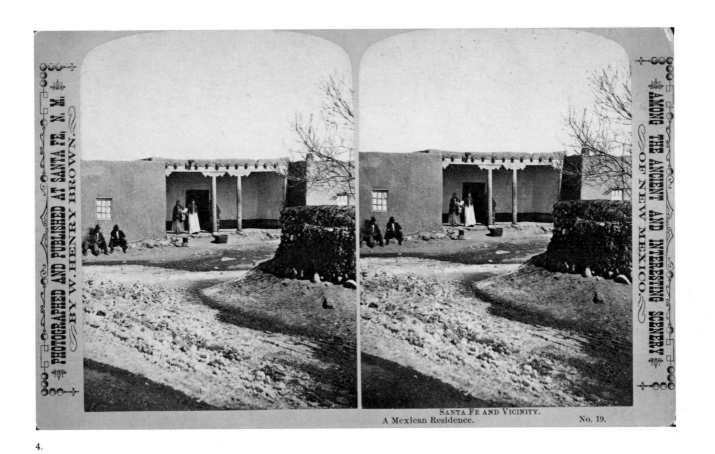

SANTA FE AND VICINITY.
A Mexican Residence. No. 19.

5.

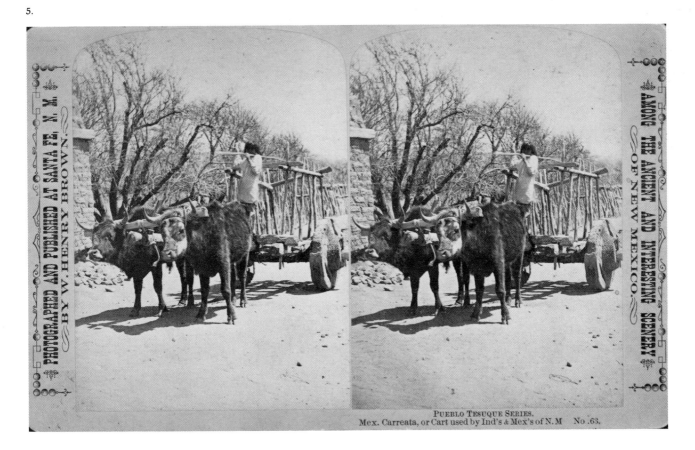

PUEBLO TESUQUE SERIES.
Mex. Carreata, or Cart used by Ind's & Mex's of N.M No .63.

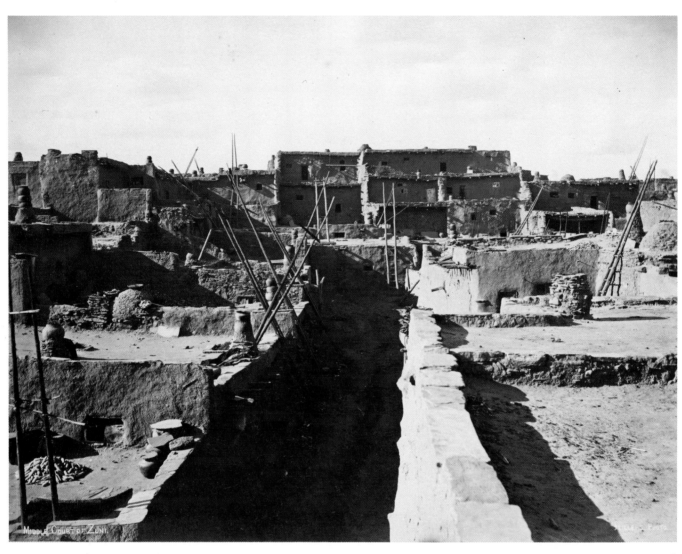

6.

6. J. K. Hillers, *Middle Court of Zuni*, c. 1880. Albumen print. Gift of Eleanor and Van Deren Coke.

7. J. K. Hillers, *Hedida, a Navajo Woman*, c. 1880. Albumen print. Gift to University of New Mexico Art Museum by Mrs. William S. Brewster.

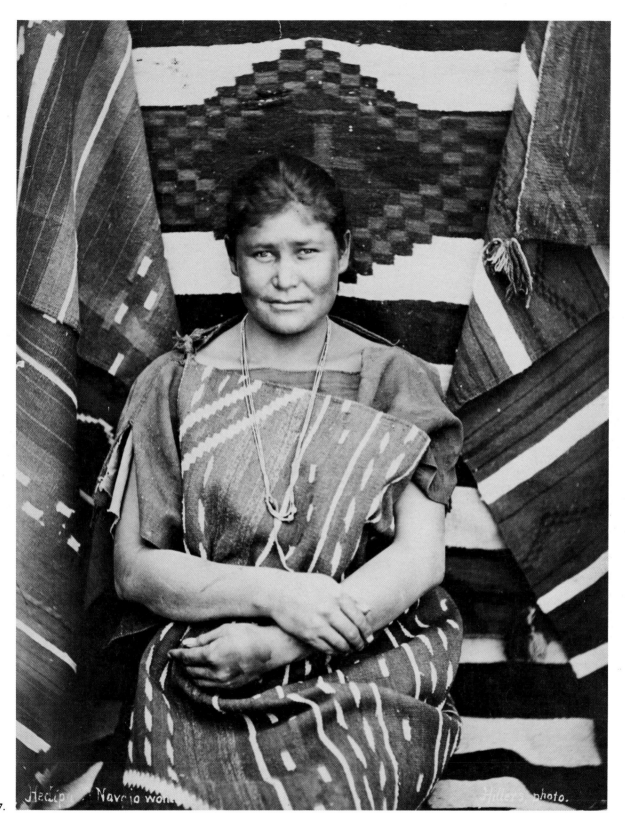

7. Haclipa. Navajo woman. Hillers photo.

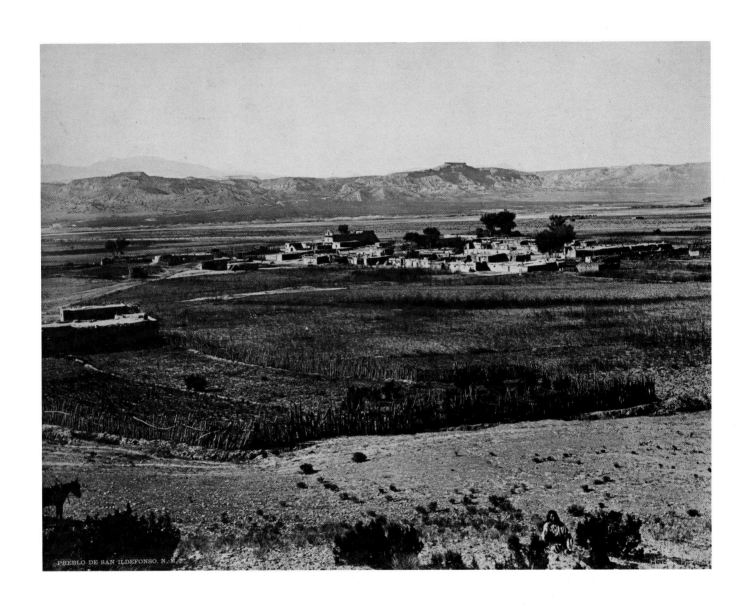

PUEBLO DE SAN ILDEFONSO, N. M.

8. J. K. Hillers, *Pueblo de San Ildefonso, New Mexico*, c. 1880. Albumen print. Extended loan to University of New Mexico Art Museum.

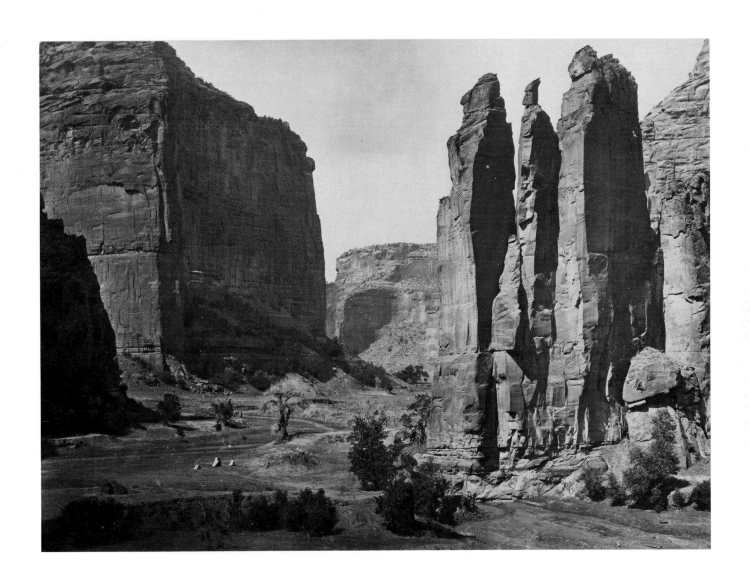

9. Timothy H. O'Sullivan, *Cañon de Chelle, Walls of the Grand Cañon*, 1873. Albumen print.
Extended loan to University of New Mexico Art Museum.

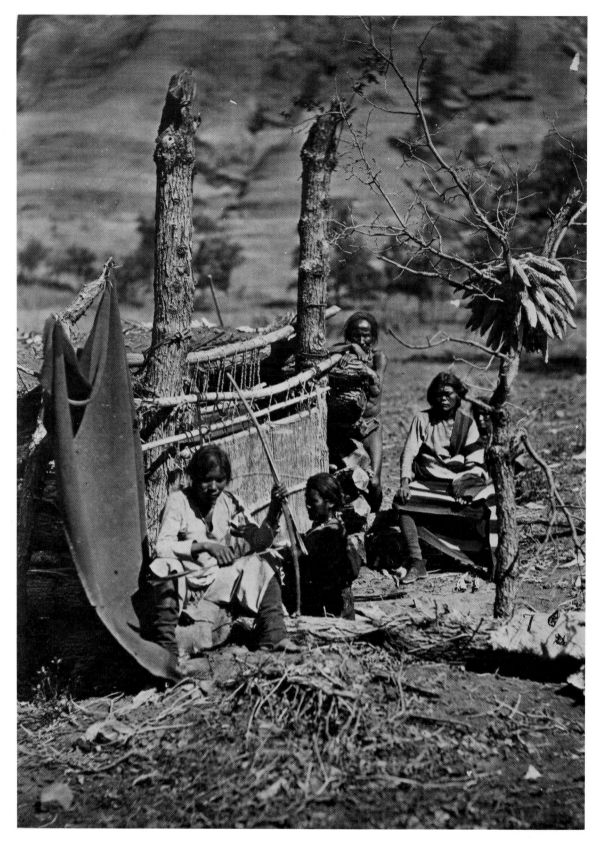

10.

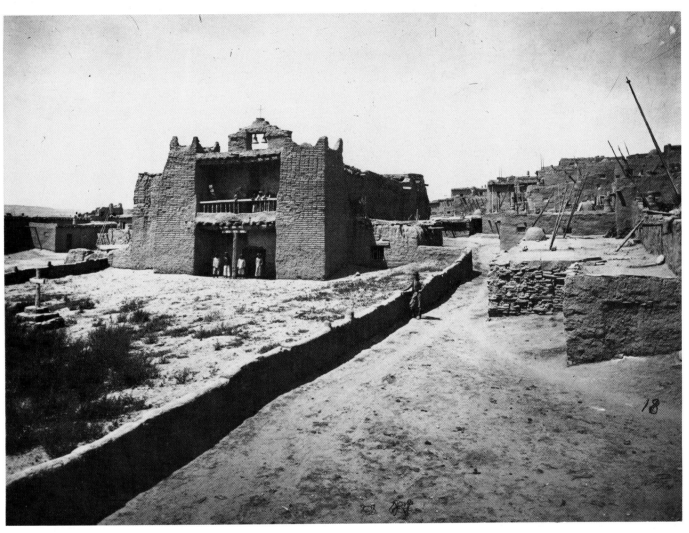

11.

10. Timothy H. O'Sullivan, *Aboriginal Life among the Navajoe Indians near Old Fort Defiance, New Mexico,* 1873. Albumen print. Extended loan to University of New Mexico Art Museum.

11. Timothy H. O'Sullivan, *Old Mission Church, Zuni Pueblo, New Mexico: View from the Plaza,* 1873. Albumen print. Extended loan to University of New Mexico Art Museum.

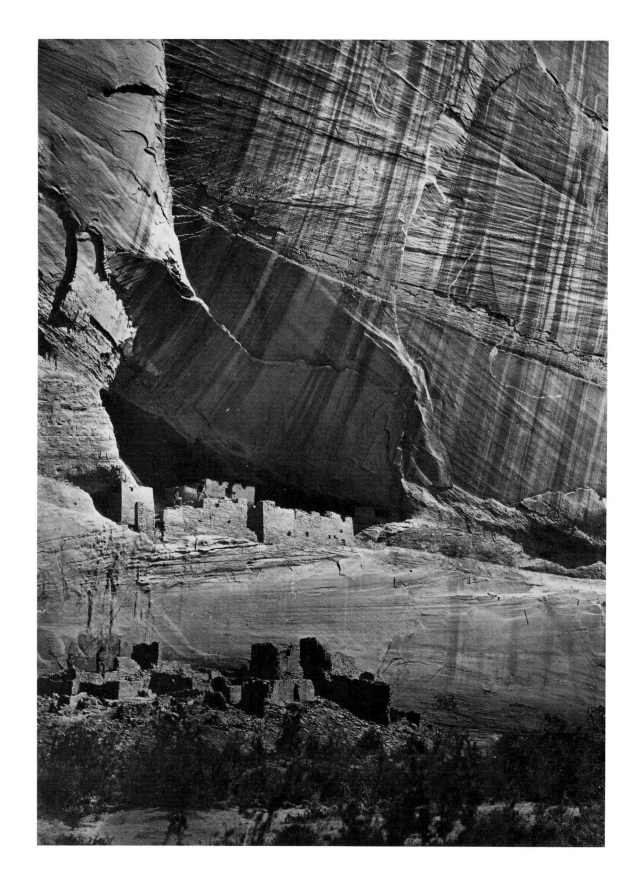

12. Timothy H. O'Sullivan, *Ancient Ruins in the Cañon de Chelle, New Mexico,* 1873. Albumen
print. Extended loan to University of New Mexico Art Museum.

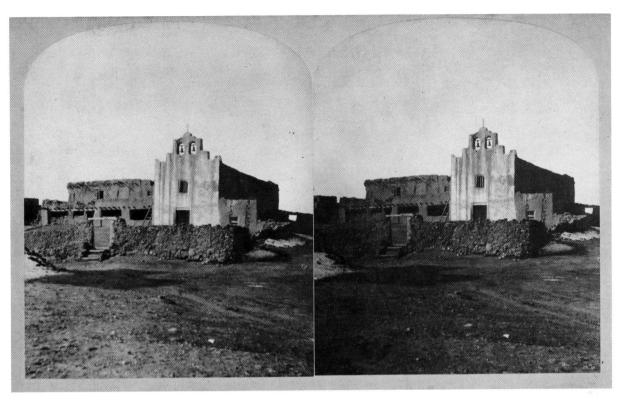

13a. Franklin A. Nims, *The Pueblo Indians: Old Church, Laguna,* c. 1890. Albumen stereograph. Extended loan to University of New Mexico Art Museum.

13b. W. Calvin Brown (negative by Sanders), *Church at Laguna, New Mexico,* c. 1885. Albumen cabinet print. Extended loan to University of New Mexico Art Museum.

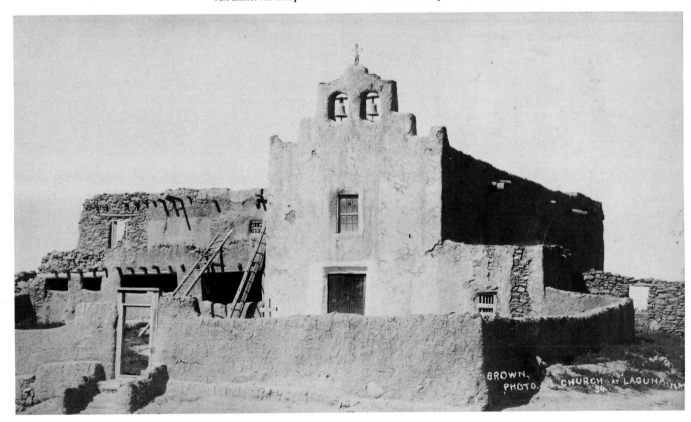

14. William Henry Brown, *San Francisco St, Looking East* (Santa Fe), n.d. Albumen stereograph. Extended loan to University of New Mexico Art Museum.

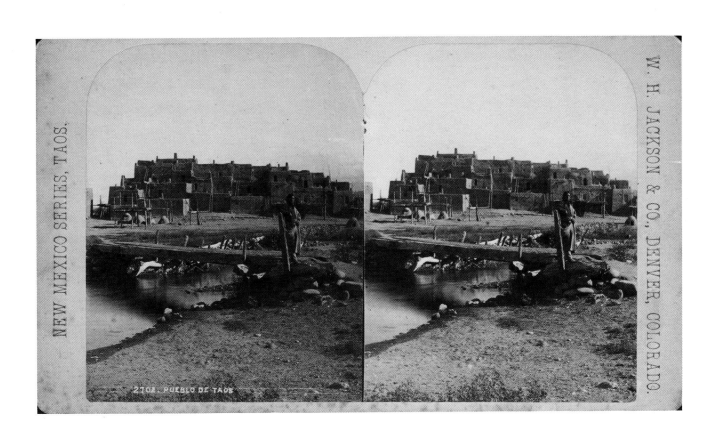

15. William Henry Jackson, *Pueblo de Taos*, c. 1880. Albumen stereograph. Extended loan to University of New Mexico Art Museum.

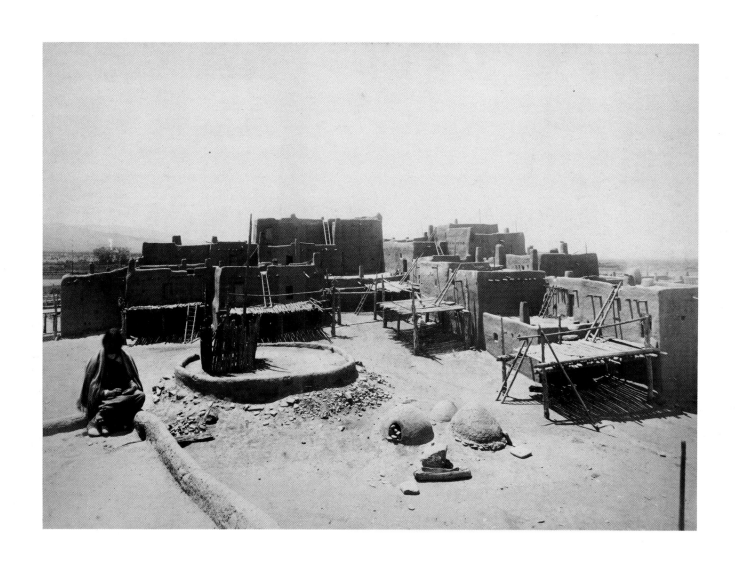

16. William Henry Jackson, *Pueblo de Taos,* c. 1880. Albumen print. Extended loan to University of New Mexico Art Museum.

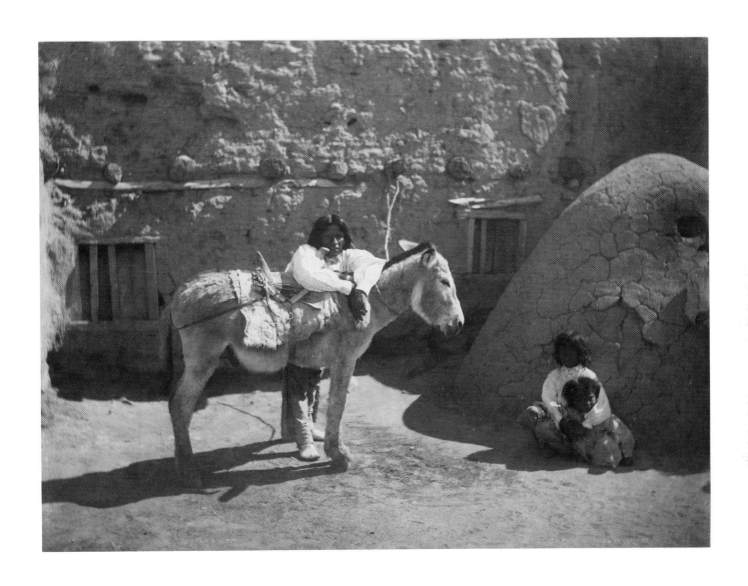

17. William Henry Jackson, *Pueblo Indian and Burro*, c. 1880–90. Albumen print. Extended loan to University of New Mexico Art Museum.

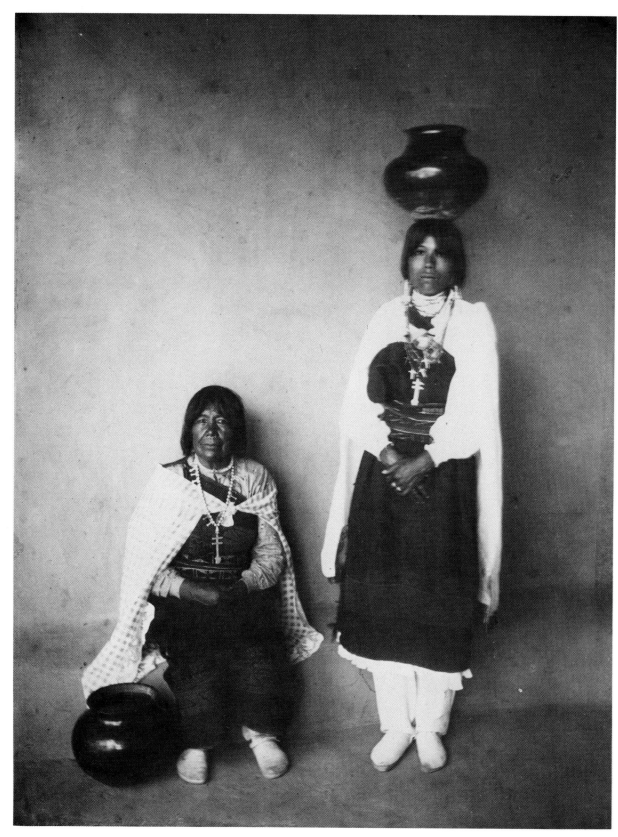

18.

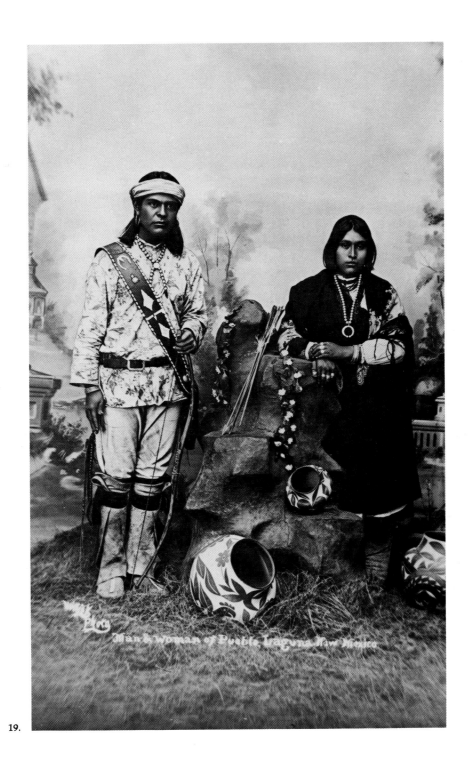

19.

18. William Henry Jackson, *Maria and Benina, Pueblo Women*, c. 1880. Albumen print. Gift of Eleanor and Van Deren Coke.

19. George Ben Wittick, *Man and Woman of Pueblo Laguna, New Mexico*, c. 1885. Modern silver print. Collection of University of New Mexico Art Museum.

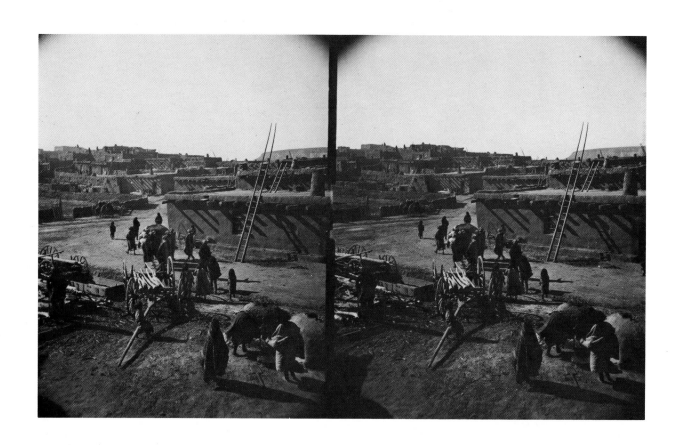

20. George Ben Wittick, *A View in Zuni Pueblo,* c. 1880. Modern silver print from a stereograph negative. Collection of University of New Mexico Art Museum. Negative from Collection of Museum of New Mexico, Santa Fe.

21. George Ben Wittick, *View in Pueblo Zuni, New Mexico*, c. 1890. Albumen print. Extended loan to University of New Mexico Art Museum.

22.

23.

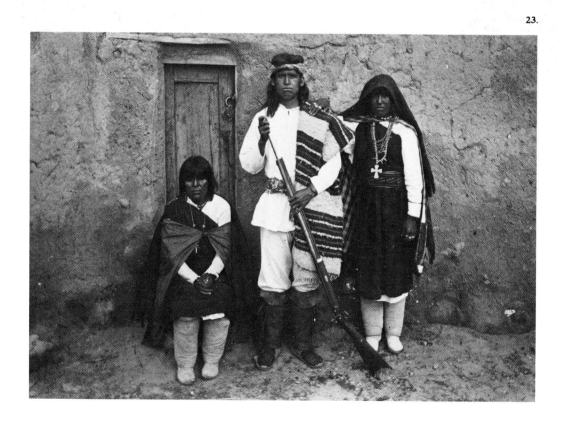

22. J. L. Clinton, *Adobe House and Burros,* c. 1890. Albumen cabinet print. University of New Mexico Libraries Collection.

23. William Henry Brown, *The Governor of Cochiti and His Family,* 1881–82. Albumen cabinet print. Extended loan to University of New Mexico Art Museum.

24. Dana B. Chase, *Signor Peso, Chief of Scouts Who Captured Geronimo,* c. 1889. Albumen cabinet print. University of New Mexico Libraries Collection.

24.

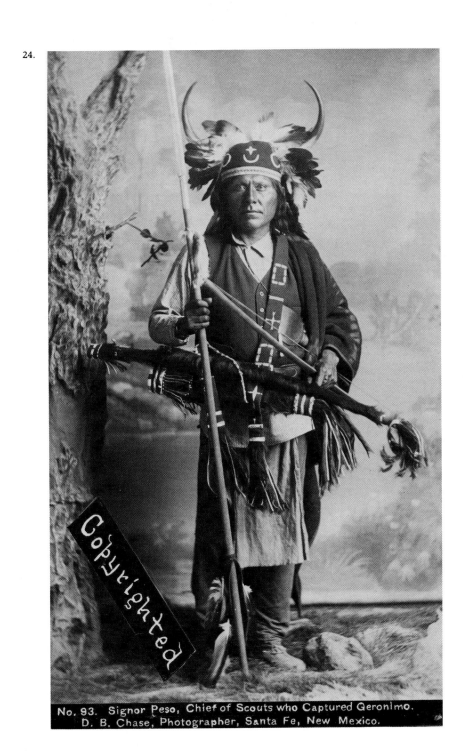

No. 93. Signor Peso, Chief of Scouts who Captured Geronimo.
D. B. Chase, Photographer, Santa Fe, New Mexico.

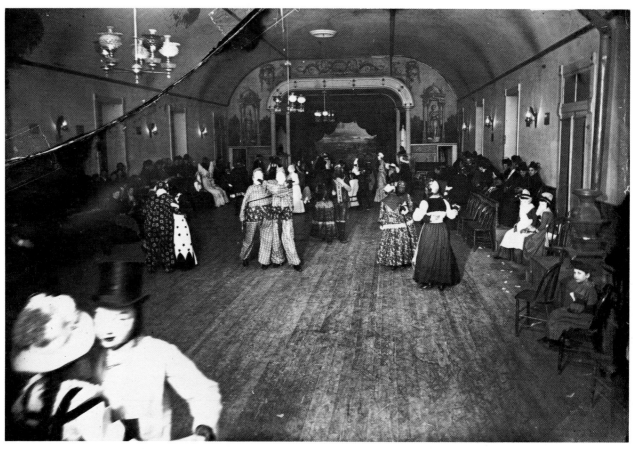

25.

25. Joseph Edward Smith, *Garcia Opera House, Socorro,* 1887. Modern silver print. Courtesy of Edward M. Smith.

26. Henry A. Schmidt, *Clown* (from the *Schmidt Album*), c. 1909. Print on printing-out paper by Daniel J. Bortko, 1977. Collection of University of New Mexico Art Museum. Negative in University of New Mexico Libraries Collection.

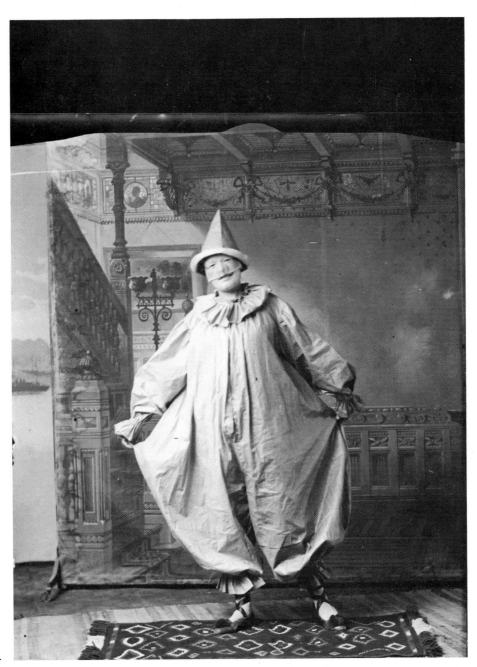

26.

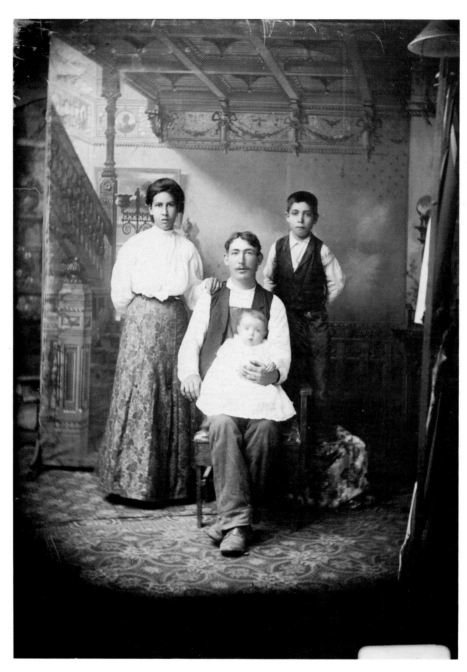

27.

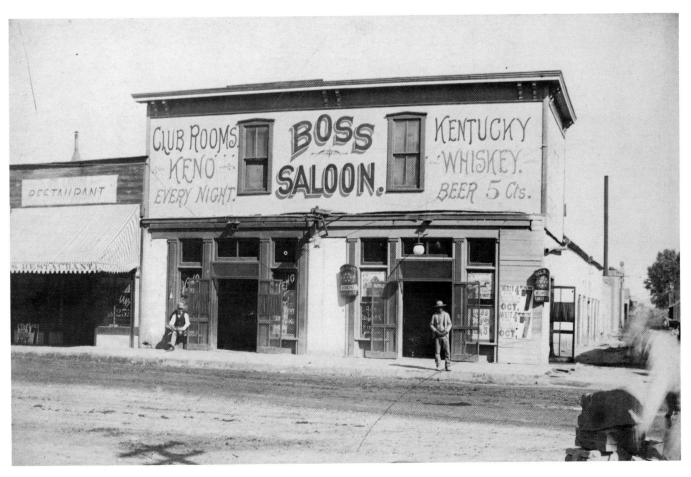

28.

27. Henry A. Schmidt, *Martin Miranda and Family* (from the *Schmidt Album*), c. 1909. Print on printing out paper by Daniel J. Bortko, 1977. Collection of University of New Mexico Art Museum. Negative in University of New Mexico Libraries Collection.

28. Eddie Ross Cobb & William Henry Cobb, *Boss Saloon and Concert Hall, On Central between 1st and 2nd, Albuquerque, New Mexico,* 1897. Albumen print. University of New Mexico Libraries Collection.

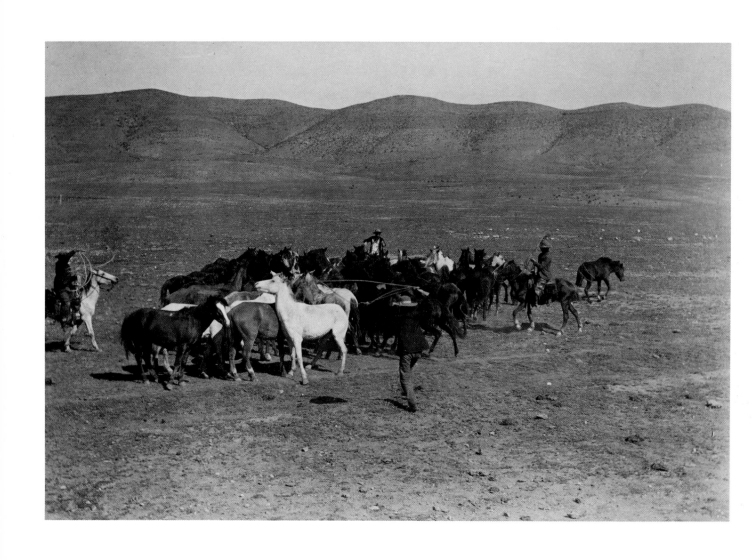

29. Attributed to James N. Furlong, *Catching Horses in the Morning*, c. 1887. Albumen print.
Extended loan to University of New Mexico Art Museum.

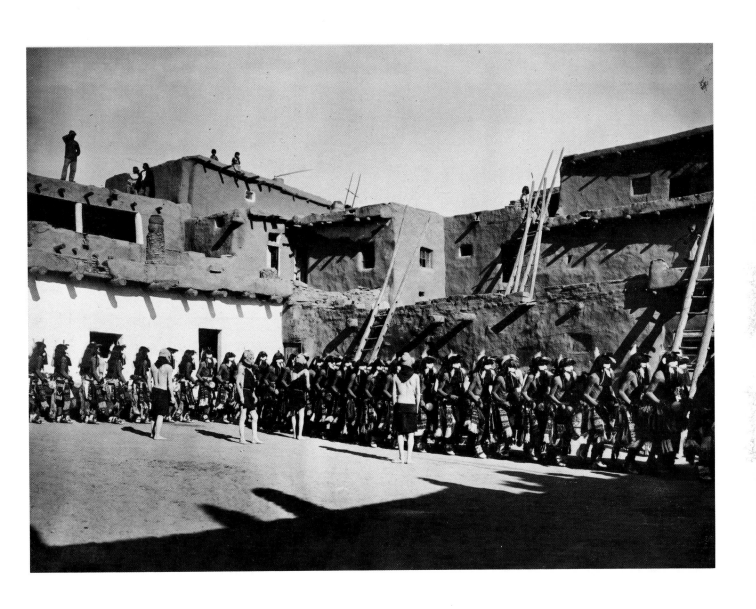

30. Adam Clark Vroman, *Rain Dance With Clowns*, 1899. Chlorobromide print by William Webb, 1972. Gift of William Webb to University of New Mexico Art Museum.

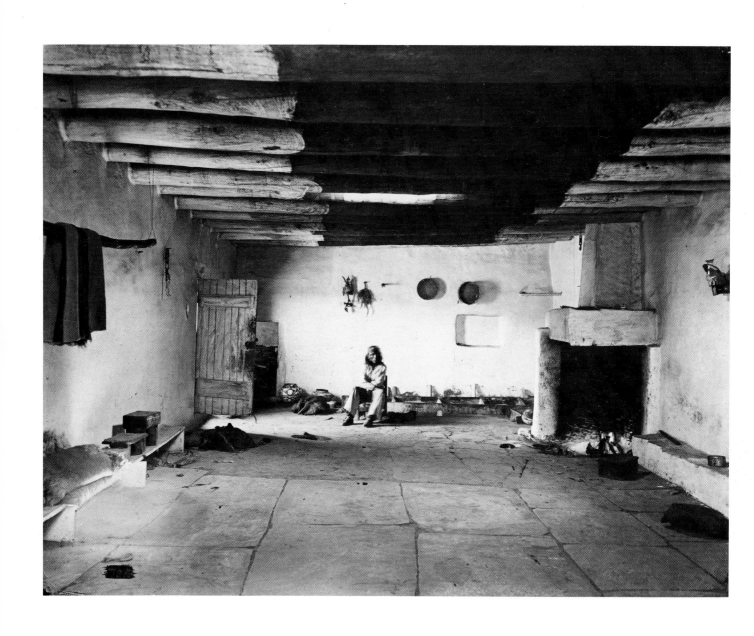

31. Adam Clark Vroman, *Zuni Interior,* 1897. Chlorobromide print by William Webb, 1972. Gift of William Webb to University of New Mexico Art Museum.

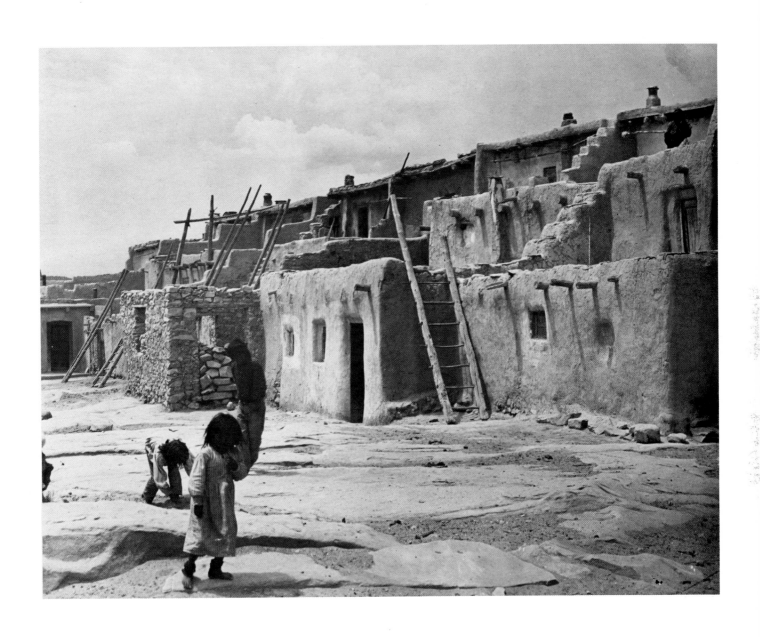

32. Arnold Genthe, *Untitled* (children and Pueblo houses), 1899 or 1926. Silver print from Library of Congress. Collection of University of New Mexico Art Museum.

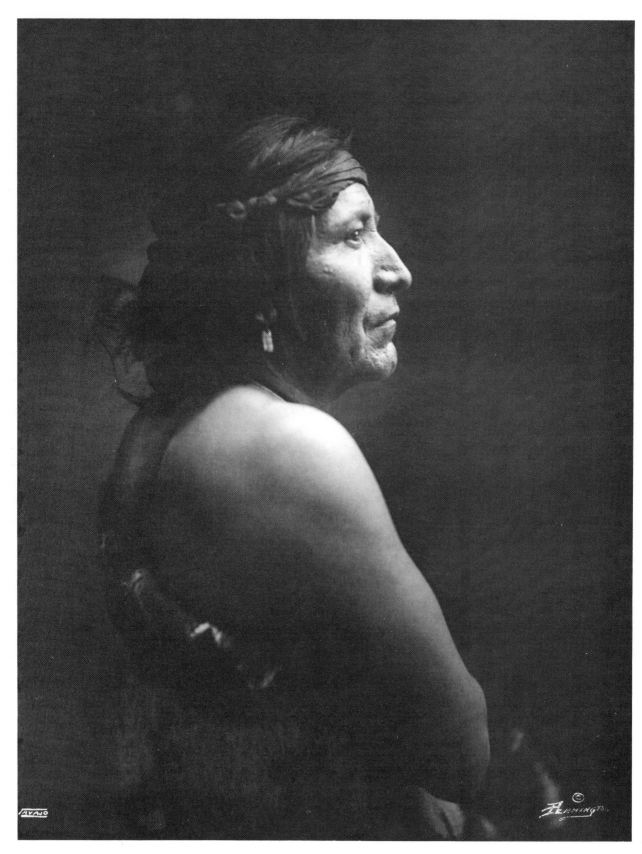

NAVAJO

33.

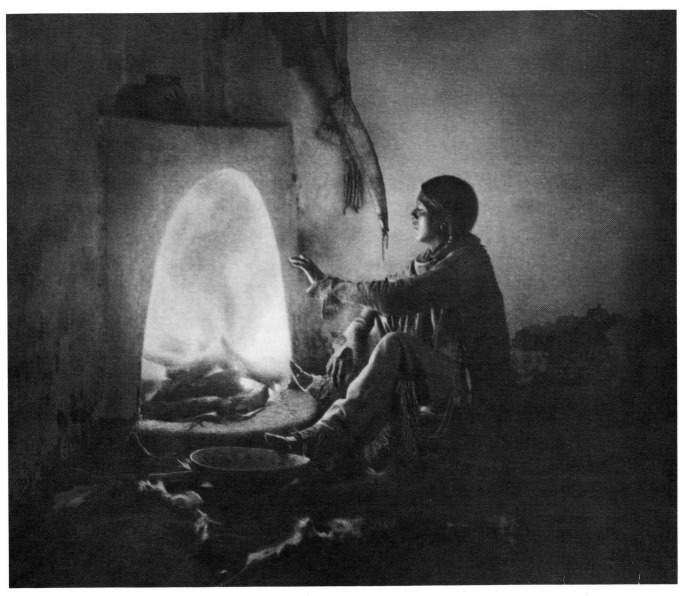

34.

33. William Pennington, *Navajo Portrait,* c. 1911. Gelatine bromide print. Collection of University of New Mexico Art Museum.

34. Karl E. Moon, *Indian Seated in Front of Fire,* c. 1907. Bromide print. Collections of the University of New Mexico Libraries and Gift of Mrs. Betty Cassidy Williams in memory of her mother, Mrs. Louise Lowber Cassidy.

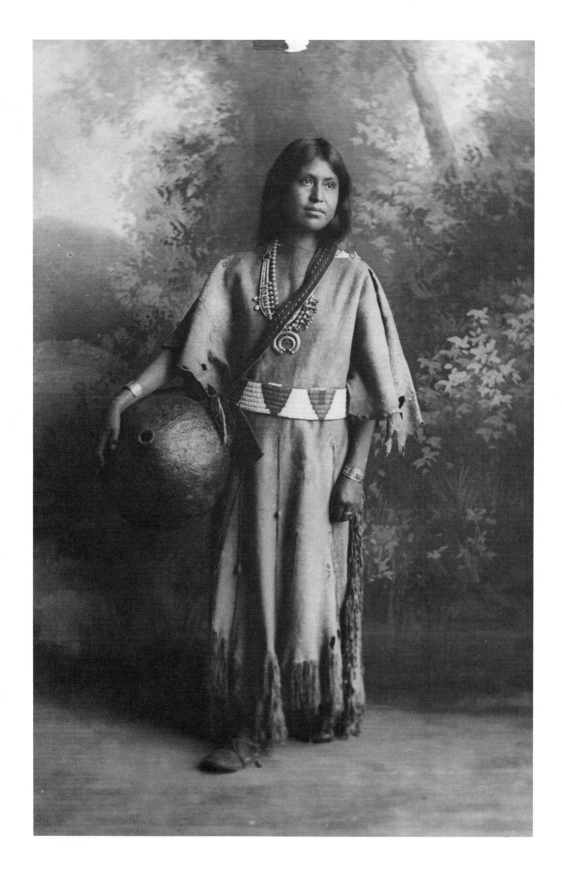

35. Karl E. Moon, *Isleta Indian Woman*, c. 1905. Bromide print. Collections of the University of New Mexico Libraries and Gift of Mrs. Betty Cassidy Williams in memory of her mother, Mrs. Louise Lowber Cassidy.

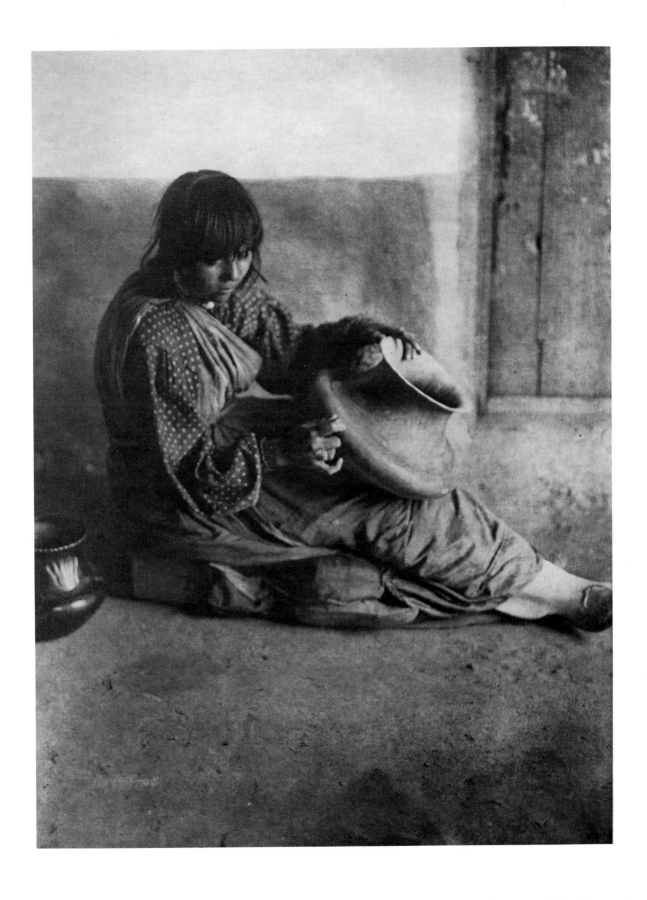

36. Edward S. Curtis, *The Potter—Santa Clara*, c. 1904. Photogravure. Gift of Beaumont Newhall to University of New Mexico Art Museum.

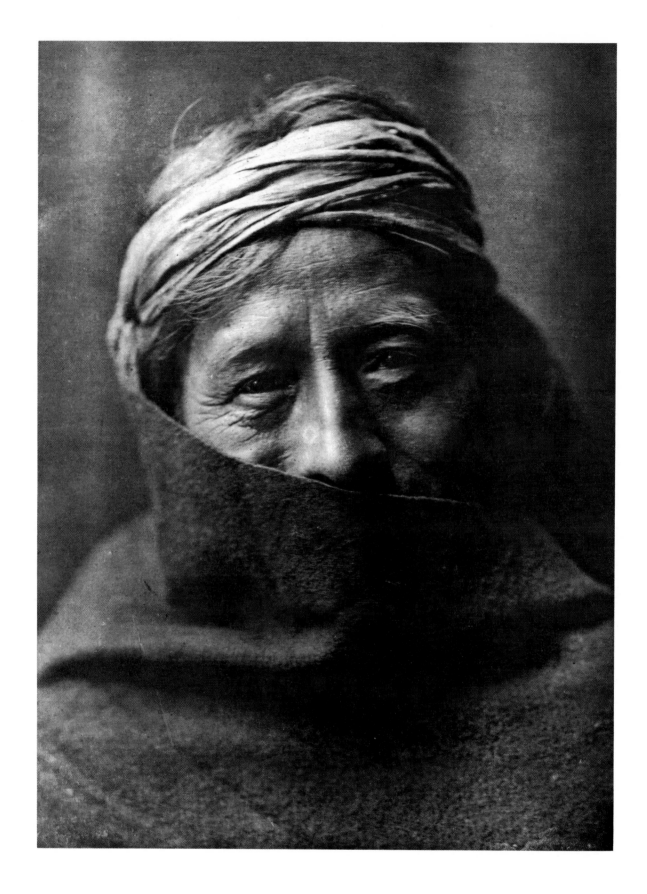

37. Edward S. Curtis, *Waíhusiwa, a Zuni Kyáqīmâssi*, c. 1902. Photogravure. Gift of
Beaumont Newhall to University of New Mexico Art Museum.

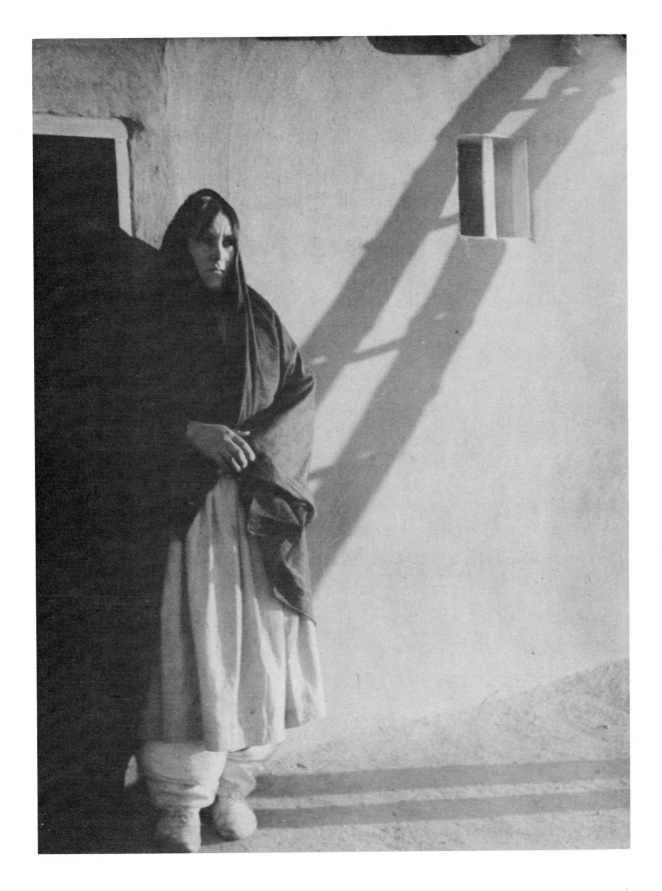

38. Laura Gilpin, *Taos Indian Woman,* 1923. Platinum print. Collection of University of New Mexico Art Museum.

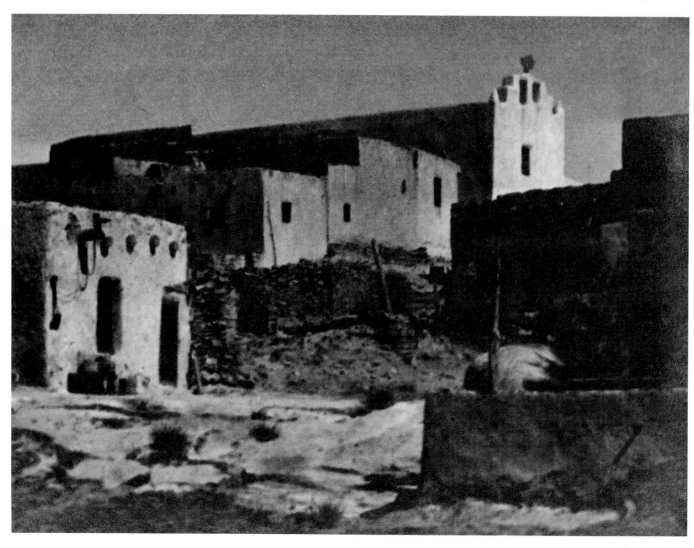

39.

39. Ansel Adams, *Pueblo Laguna, New Mexico,* c. 1929. Parmelian print. Extended loan to University of New Mexico Art Museum.

40. Ansel Adams, *Interior, Penitente Morada,* c. 1929. Silver print. Gift of the artist to University of New Mexico Art Museum.

40.

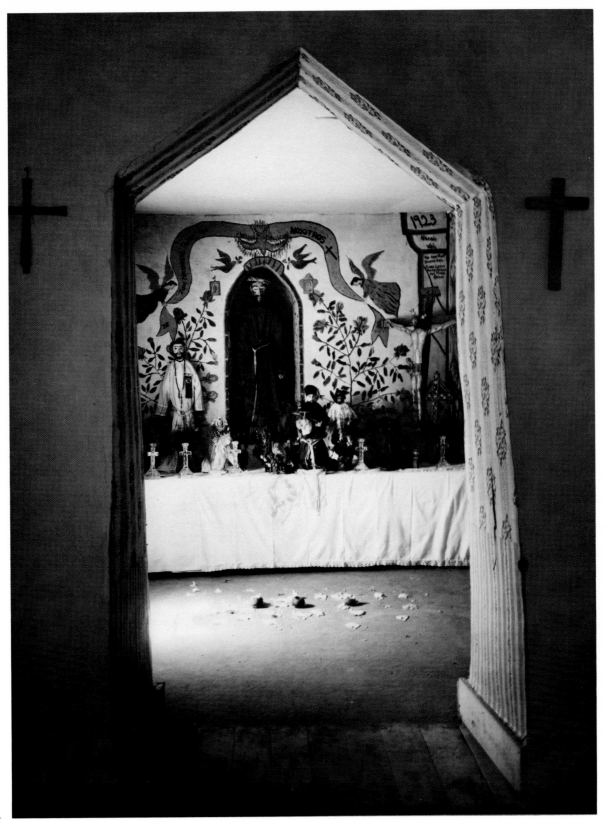

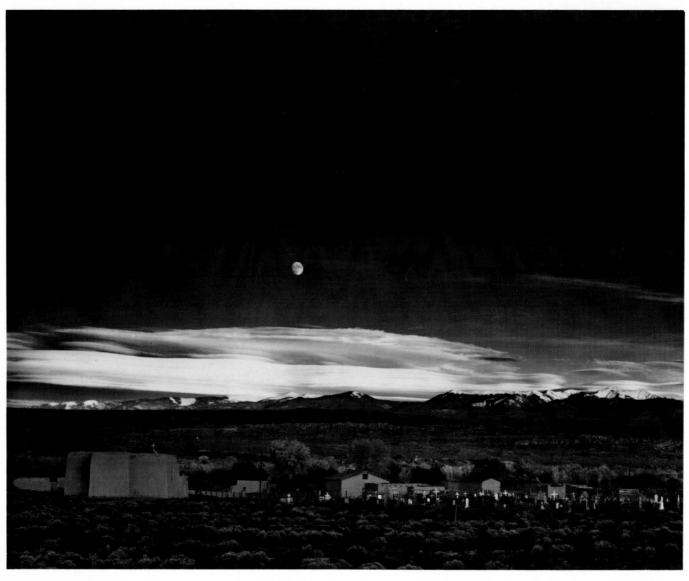

41.

41. Ansel Adams, *Moonrise, Hernandez, New Mexico,* 1941. Silver print. Collection of University of New Mexico Art Museum.

42. Paul Strand, *Buttress, Ranchos de Taos Church, New Mexico,* 1931. Silver print. Courtesy of the First National Bank in Albuquerque.

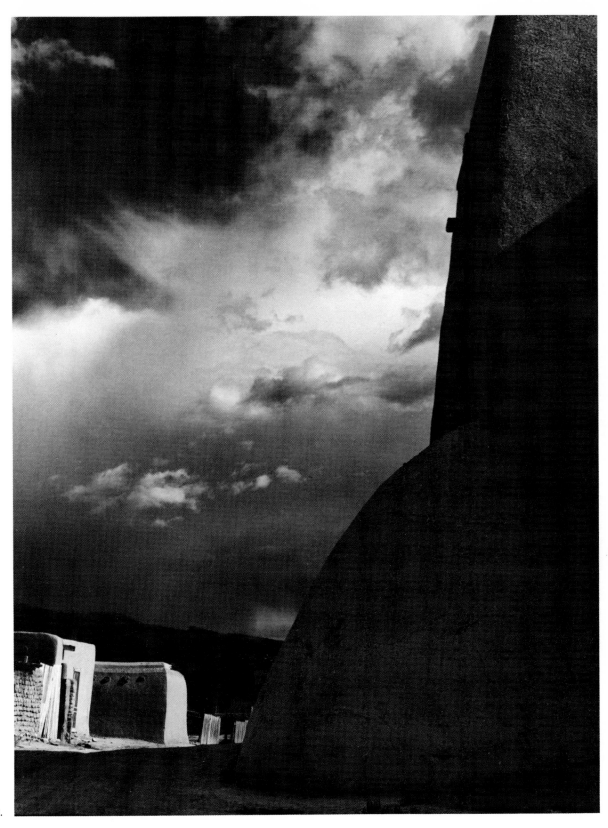

42.

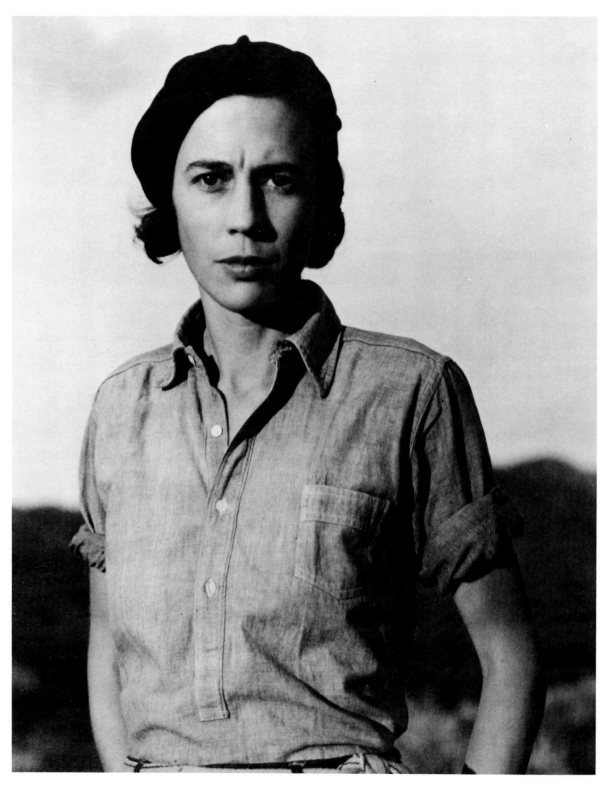

43.

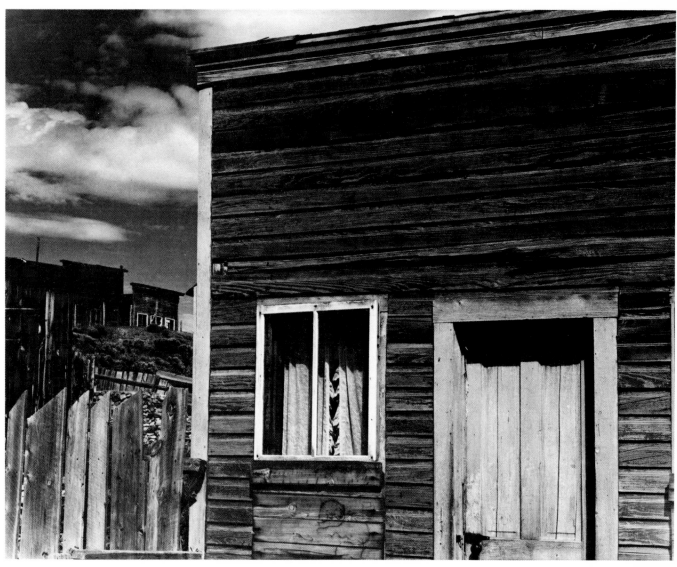

44.

43. Paul Strand, *Roberta Hawk, Taos, New Mexico,* 1931. Platinum print. Courtesy of Center for Creative Photography, University of Arizona, Tucson.

44. Paul Strand, *Ghost Town, New Mexico,* 1931. Silver print. Courtesy of the First National Bank in Albuquerque.

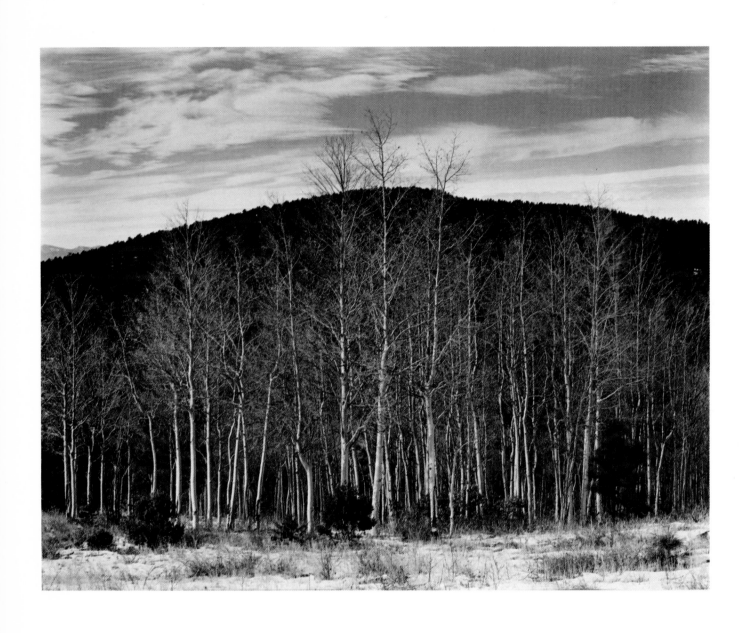

45. Edward Weston, *Aspen Valley,* 1937. Silver print by Brett Weston. Extended loan to University of New Mexico Art Museum.

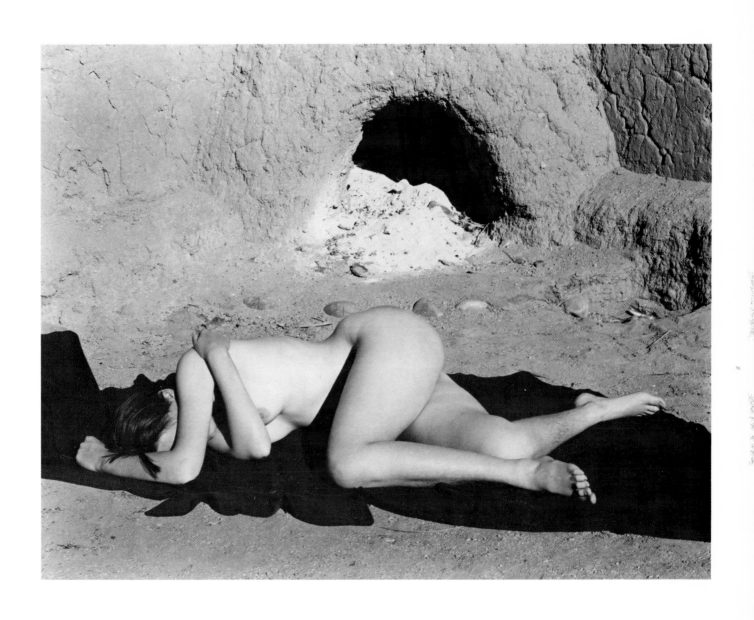

46. Edward Weston, *Nude in Albuquerque*, 1937. Silver print by Brett Weston. Extended loan to University of New Mexico Art Museum.

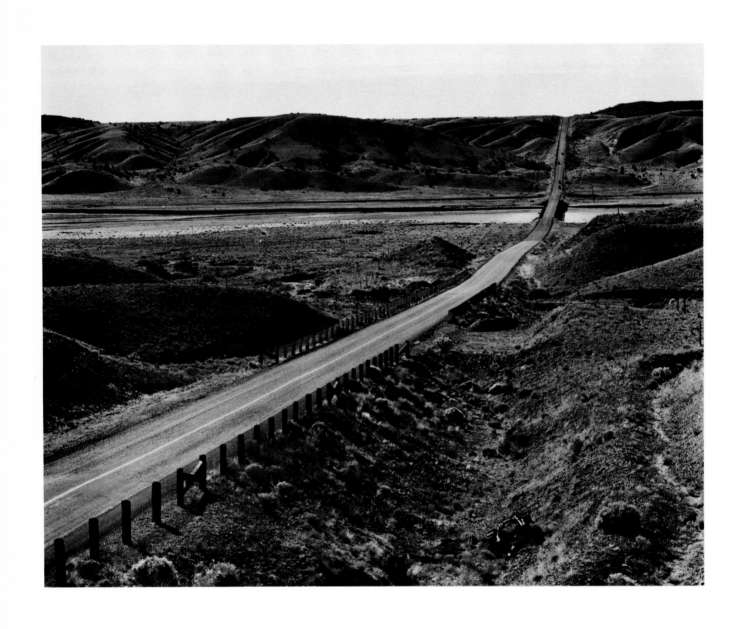

47. Edward Weston, *Santa Fe–Albuquerque Highway*, 1937. Silver print by Brett Weston.
Extended loan to University of New Mexico Art Museum.

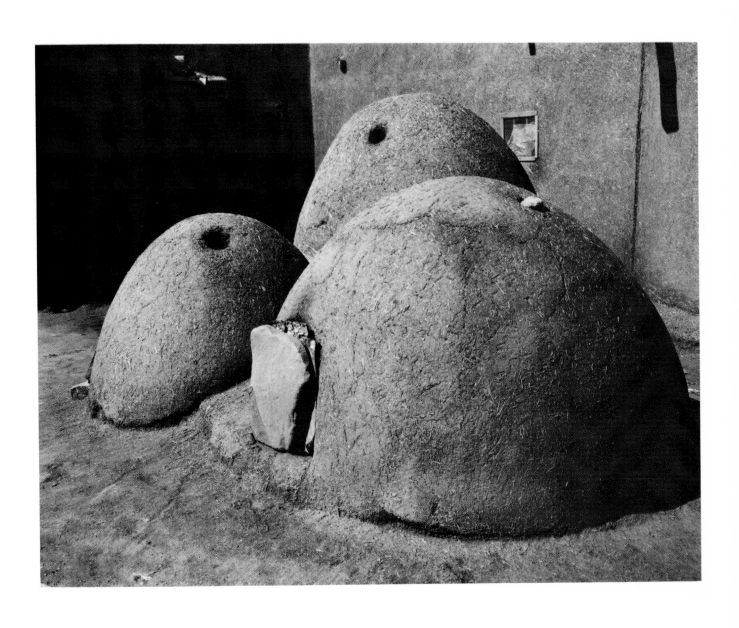

48. Willard Van Dyck, *Ovens, Taos, New Mexico*, 1931. Silver print. Collection of University of New Mexico Art Museum.

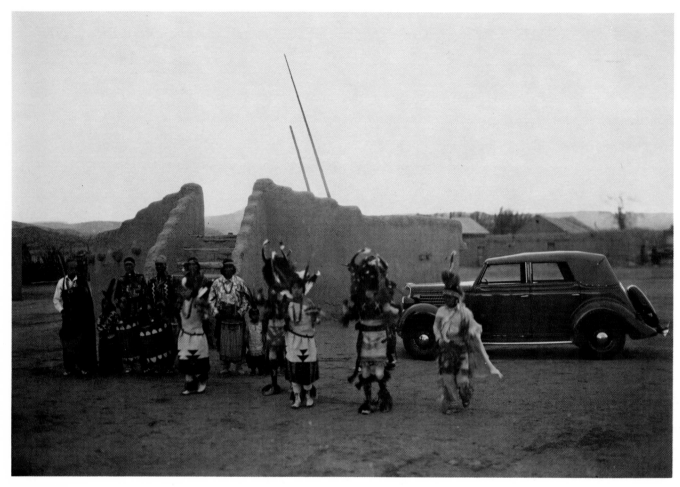

49.

49. T. Harmon Parkhurst, *Buffalo Dance, San Ildefonso Pueblo,* c. 1935. Modern silver print from a negative in the Collection of the Museum of New Mexico, Santa Fe. Collection of University of New Mexico Art Museum.

50. Philip Harroun, *Procession of La Conquistadora, San Francisco Street, Santa Fe,* 1897. Modern silver print from a negative in the Collection of the Museum of New Mexico, Santa Fe. Collection of University of New Mexico Art Museum.

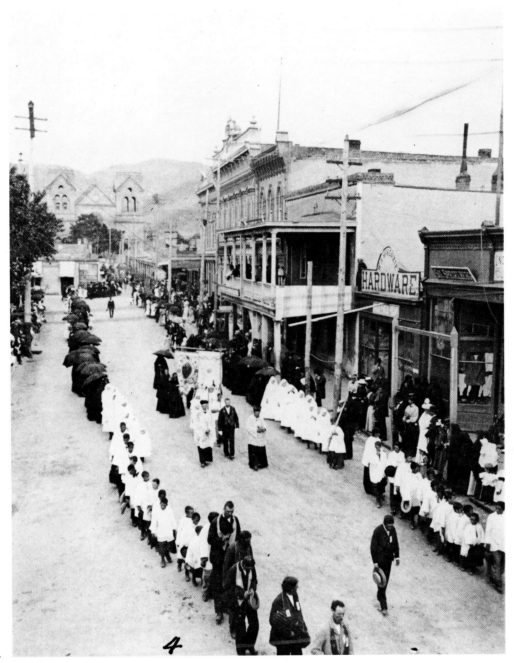

50.

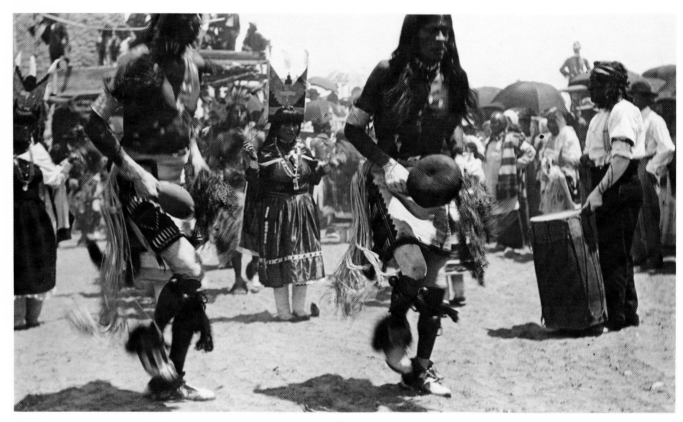

51.

51. H. F. Robinson, *Corn Dance, Santa Clara Pueblo*, c. 1915. Modern silver print from a negative in the Collection of the Museum of New Mexico, Santa Fe. Collection of University of New Mexico Art Museum.

52. Barbara Morgan, *Willard Morgan with Model A Leica, Bandelier National Monument, New Mexico*, 1928. Silver print. Extended loan to University of New Mexico Art Museum.

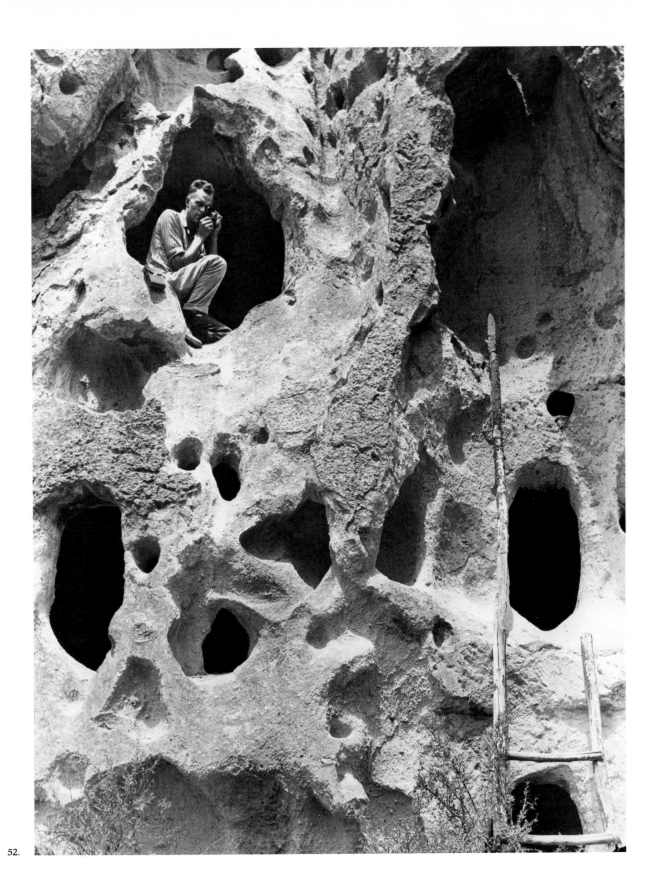

52.

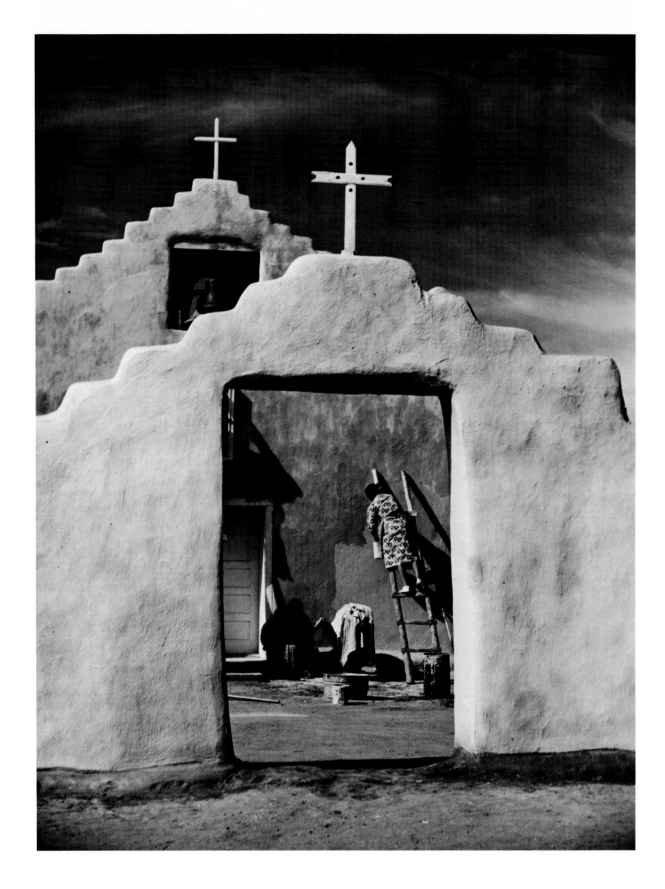

53. Ernest Knee, *Taos Pueblo*, 1941. Silver print. Greater University of New Mexico Fund Grant, Collection of University of New Mexico Art Museum.

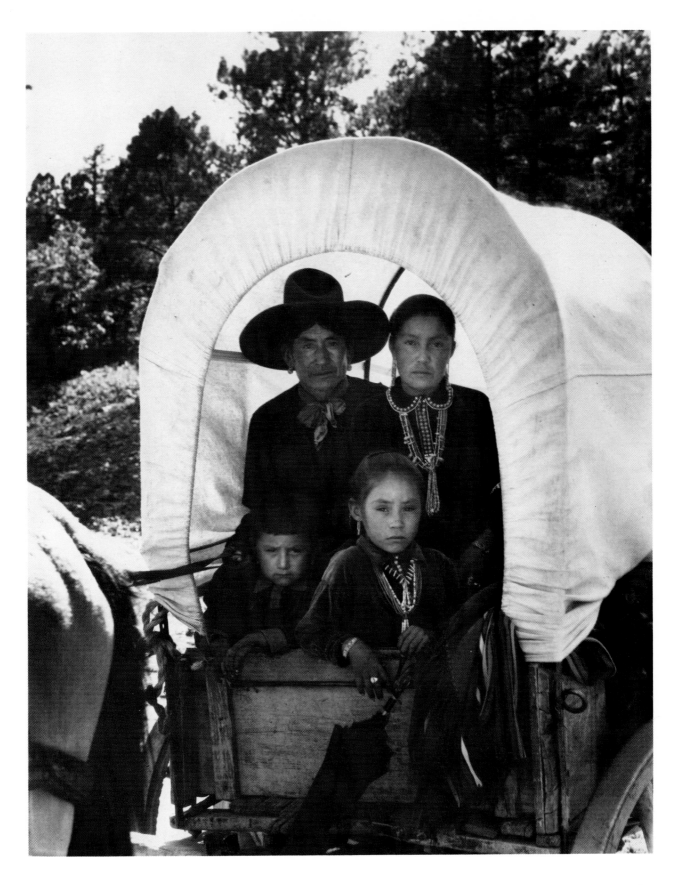

54. Laura Gilpin, *Navaho Covered Wagon*, 1934. Silver print. Courtesy of the Museum of New Mexico, Santa Fe.

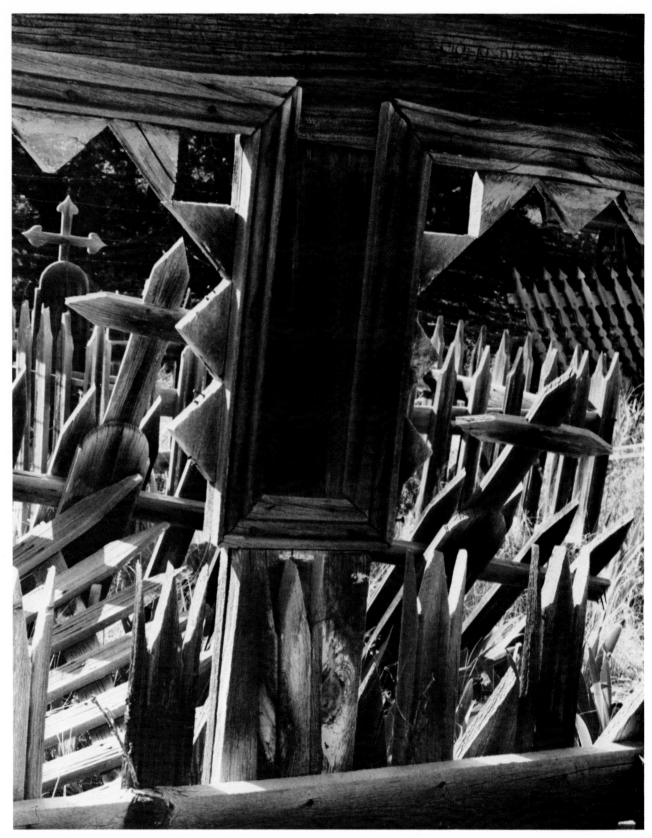

55.

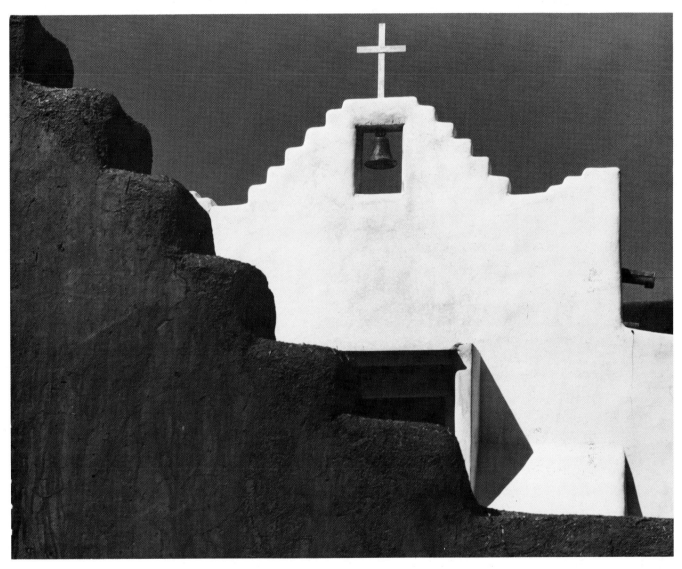

56.

55. Laura Gilpin, *Camposanto El Valle, New Mexico,* 1961. Silver print. Anonymous gift to University of New Mexico Art Museum.

56. Laura Gilpin, *Church at Picuris, New Mexico,* 1962. Silver print. Anonymous gift to University of New Mexico Art Museum.

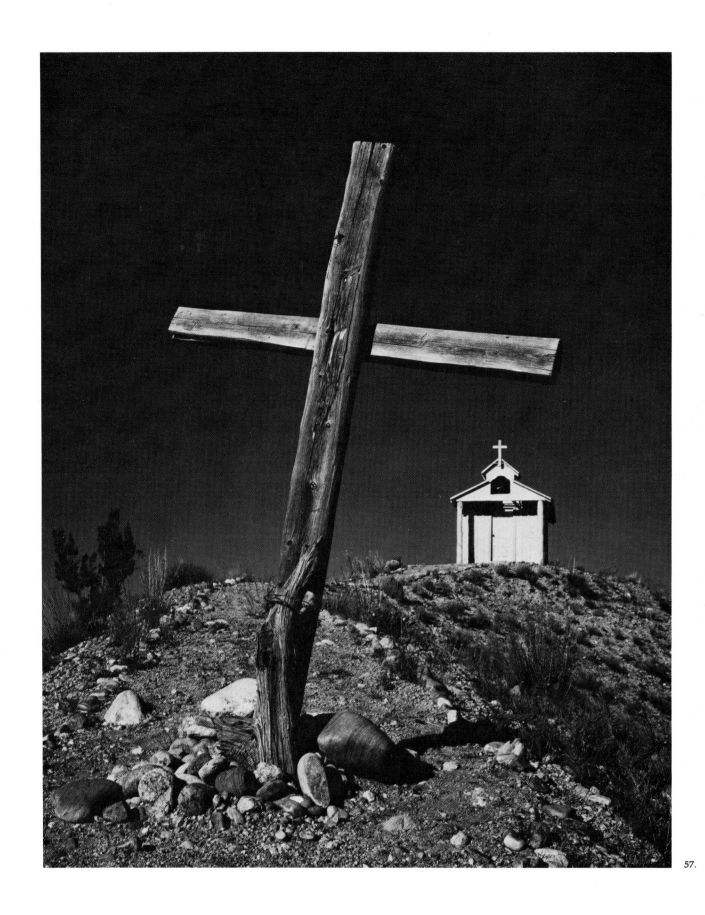

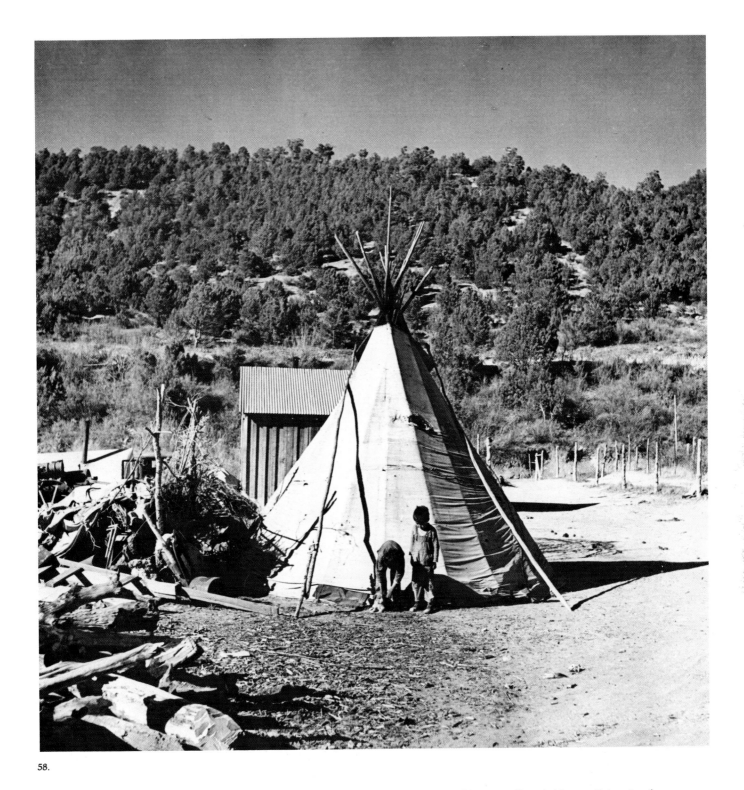

58.

57. John S. Candelario, *Two Crosses*, c. 1942. Silver print. Extended loan to University of New Mexico Art Museum.

58. Arthur Rothstein, *Mescalero Reservation Teepee*, 1936. Modern silver print. Collection of University of New Mexico Art Museum.

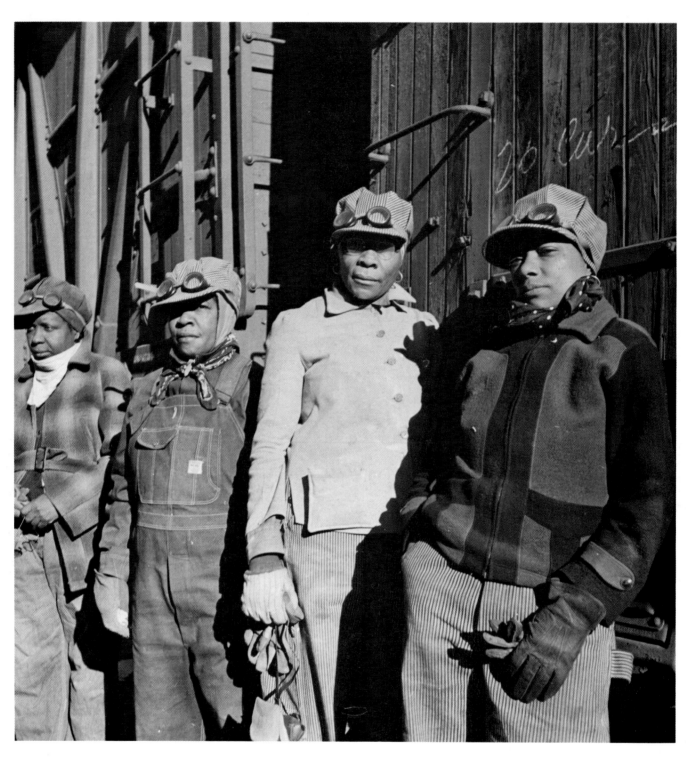

59.

60.

59. Jack Delano, *Almeta Williams, Beatrice Davis and Liza Goss Cleaning out Potash Cars, Clovis, New Mexico,* 1943. Silver print from Library of Congress. Collection of University of New Mexico Art Museum.

60. Russell Lee, *Caudill and Neighbor Building a Dugout, Pie Town, New Mexico,* 1940. Silver print from Library of Congress. Collection of University of New Mexico Art Museum.

61. Russell Lee, *Community Sing, Pie Town, New Mexico,* 1940. Silver print from Library of Congress. Collection of University of New Mexico Art Museum.

62. Russell Lee, *Dance at Penasco, New Mexico*, 1940. Silver print from Library of Congress. Collection of University of New Mexico Art Museum.

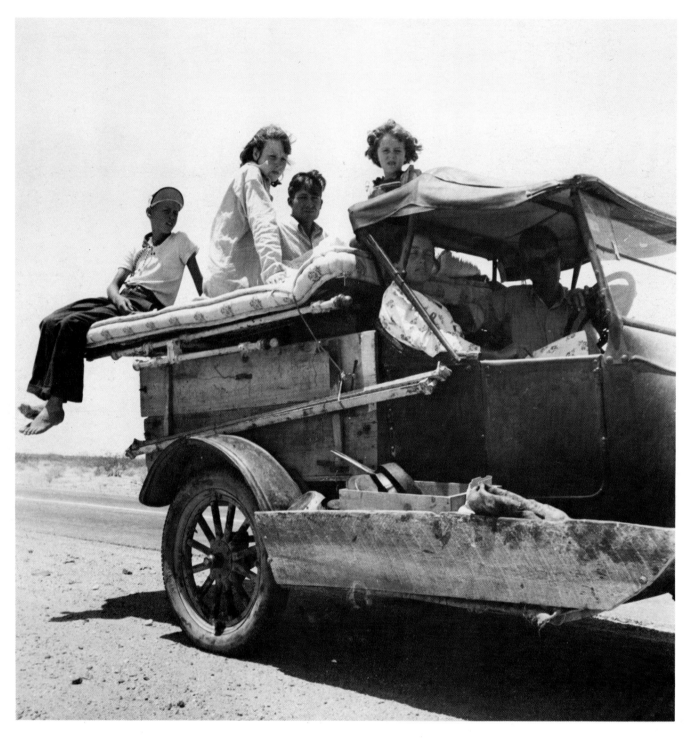

63.

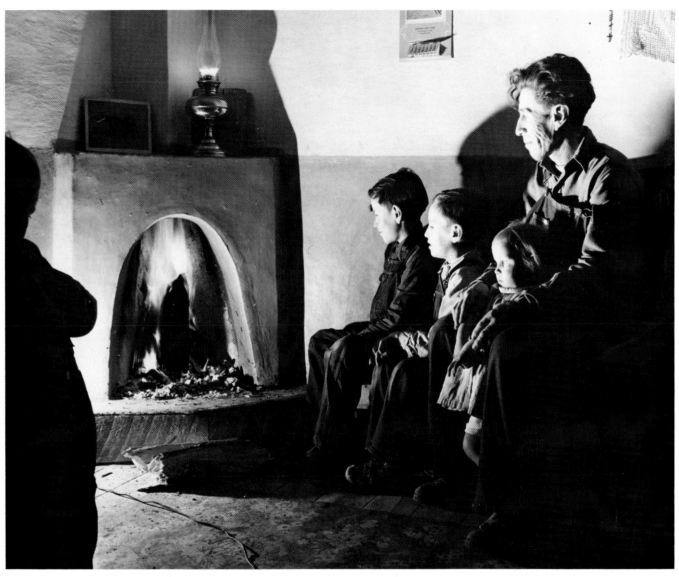

64.

63. Dorothea Lange, *Powell Family, Migrants Travelling Across U.S. Highway 70, Searching Work in Cotton Fields,* 1937. Silver print from Library of Congress. Collection of University of New Mexico Art Museum.

64. John Collier, *Lopez Home, Trampas, New Mexico,* 1943. Silver print from Library of Congress. Collection of University of New Mexico Art Museum.

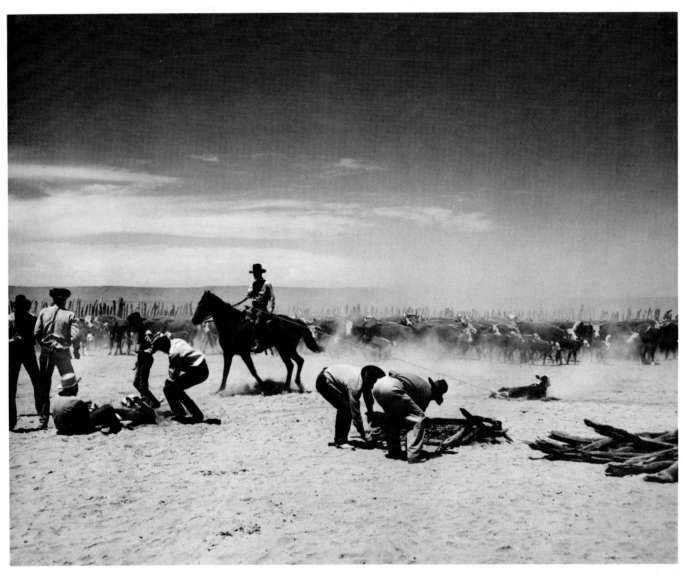

65.

65. Harvey Caplin, *Bell Ranch* (round-up), 1946. Bromide print. Courtesy of the artist.

66. Henri Cartier-Bresson, *Taos, New Mexico,* 1947. Silver print. Collection of University of New Mexico Art Museum.

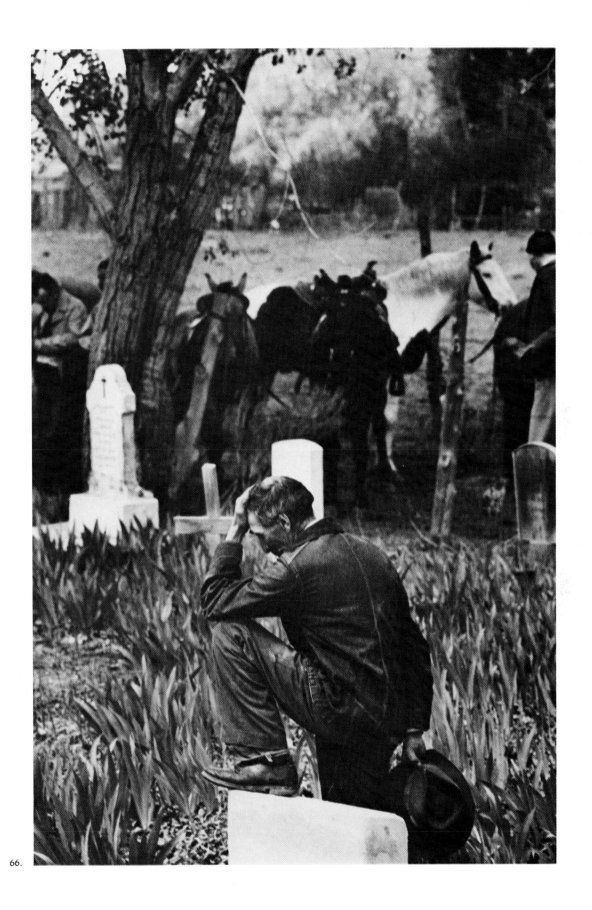

66.

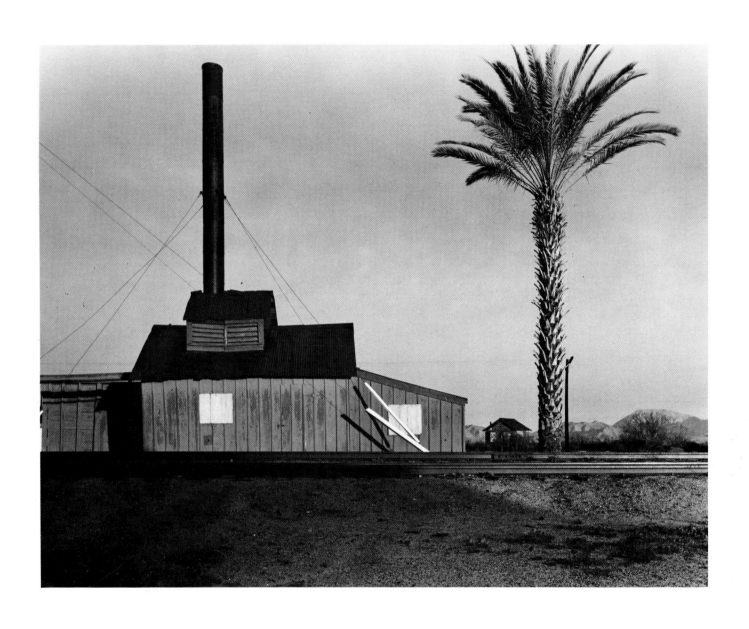

67. Wright Morris, *Powerhouse and Palm Tree,* 1940. Silver print. Collection of University
of New Mexico Art Museum.

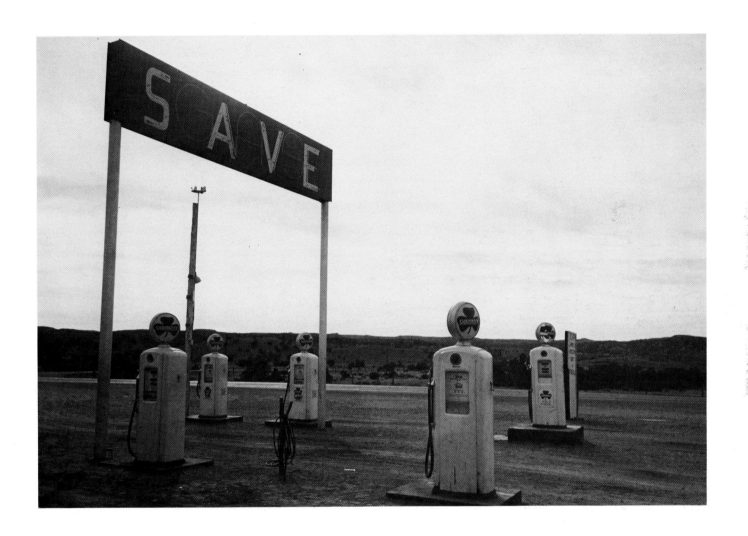

68. Robert Frank, *Santa Fe, New Mexico,* 1955. Silver print. Courtesy of Lunn Gallery, Washington, D.C.

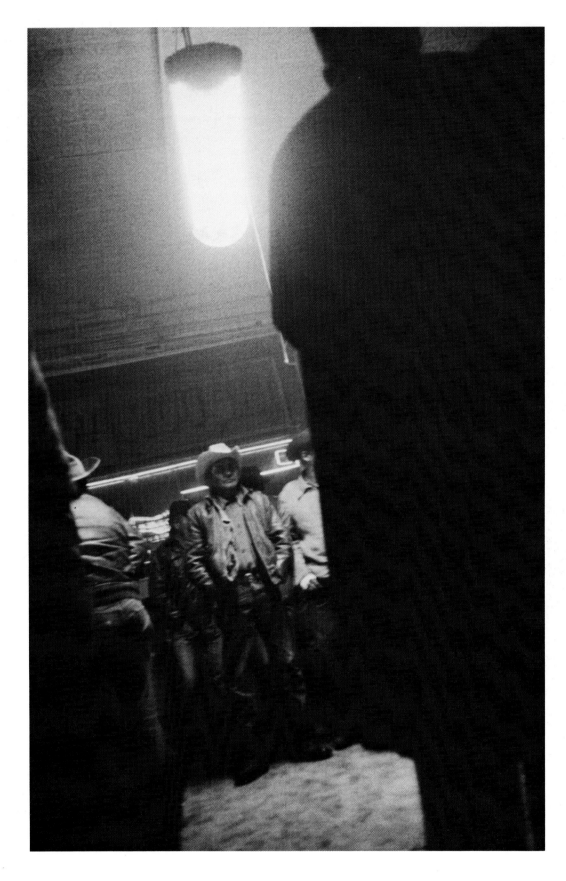

69. Robert Frank, *Gallup, New Mexico,* 1955. Silver print. Collection of University of New Mexico Art Museum.

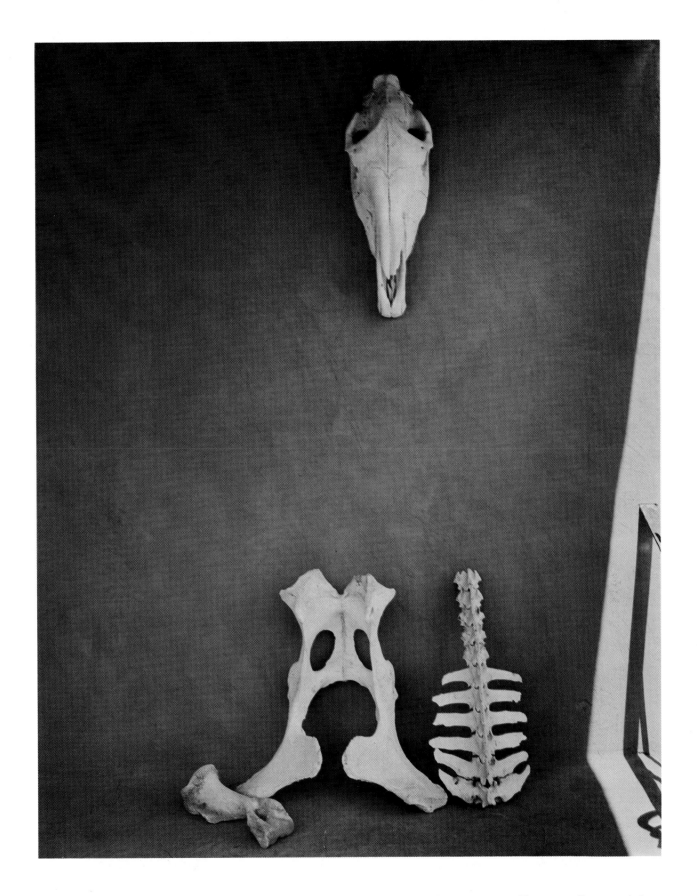

70. Todd Webb, *Untitled* (bones in Abiquiu), c. 1968. Silver print. Courtesy of the Museum of New Mexico, Santa Fe.

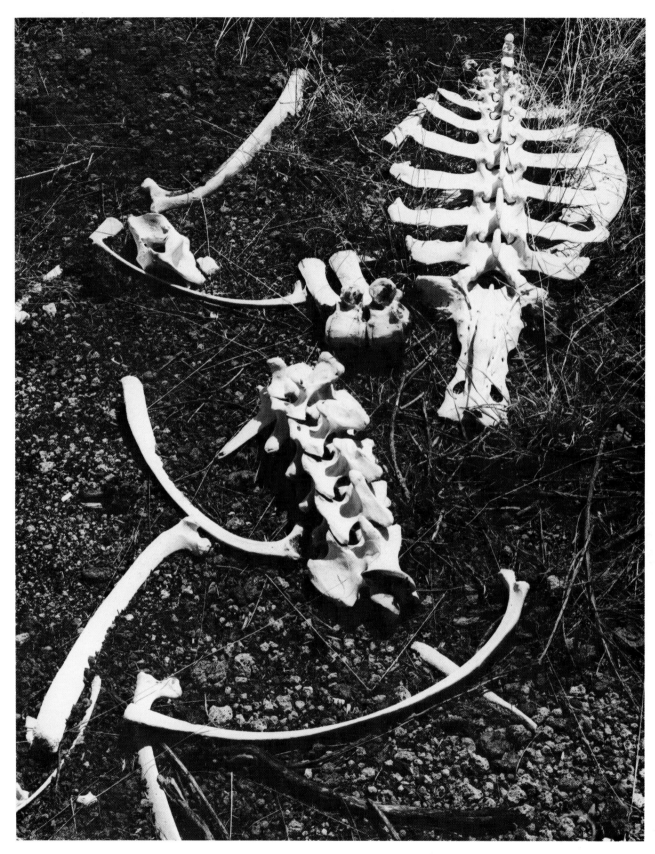

71.

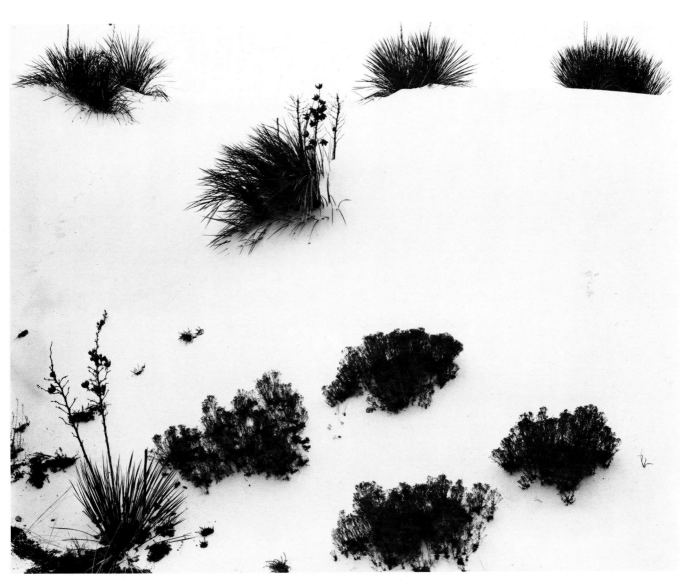

72.

71. Eliot Porter, *Cow Bones, New Mexico,* 1972. Silver print. Gift of the artist to University of New Mexico Art Museum.

72. Brett Weston, *Untitled* (sand and scrub), 1946. Silver print. Courtesy of the artist.

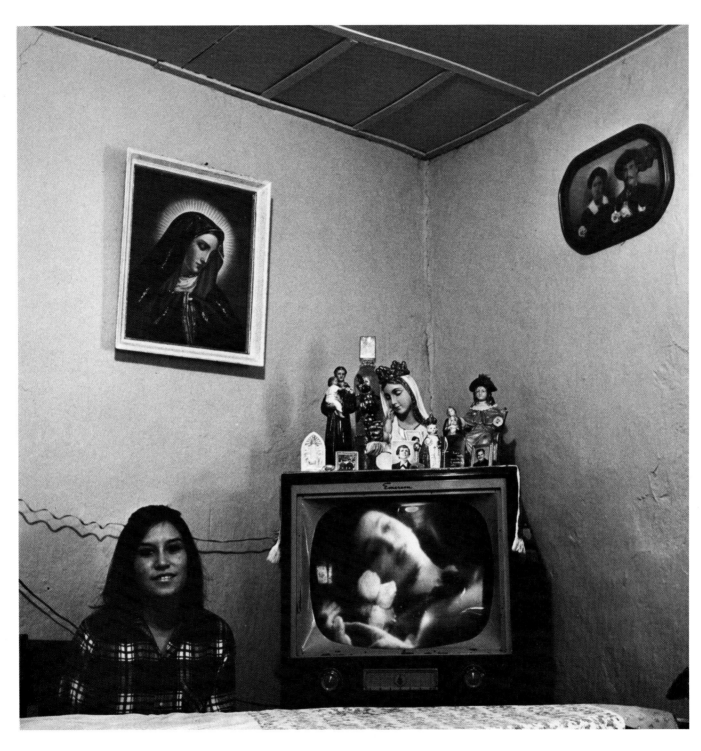

73.

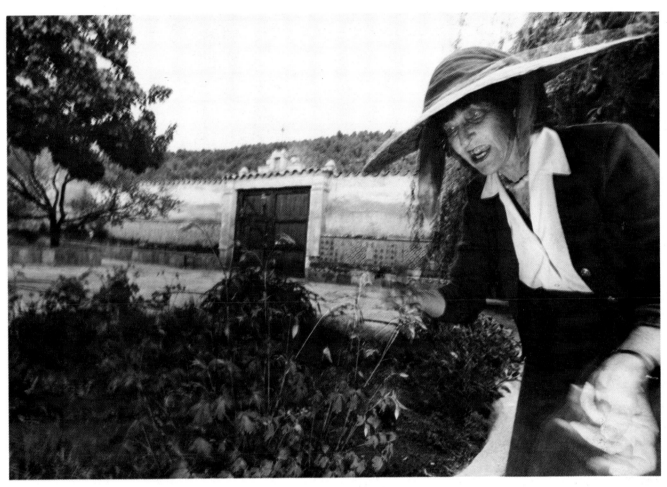

74.

73. Cavalliere Ketchum, *Stella Silva, Maureen O'Sullivan and the Virgin Mary* (from the series "Village of Manzano"), 1970. Chlorobromide print. From M.F.A. Dissertation Exhibition, Collection of University of New Mexico Art Museum.

74. Anne Noggle, *Santa Fe Summer No. 1*, 1976. Bromide print. Gift of the artist to University of New Mexico Art Museum.

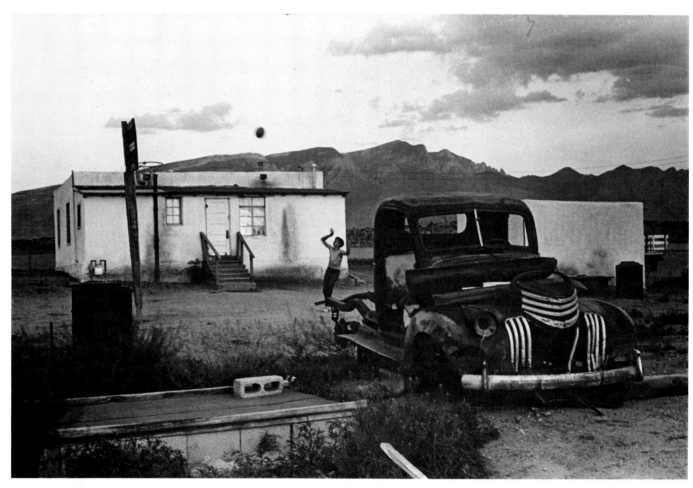

75.

75. Danny Lyon, *Llanito,* 1970. Chlorobromide print. Gift of the artist to University of New Mexico Art Museum.

76. Thomas E. Zudik, *John D. Robb,* 1969. Silver print. Courtesy of the artist.

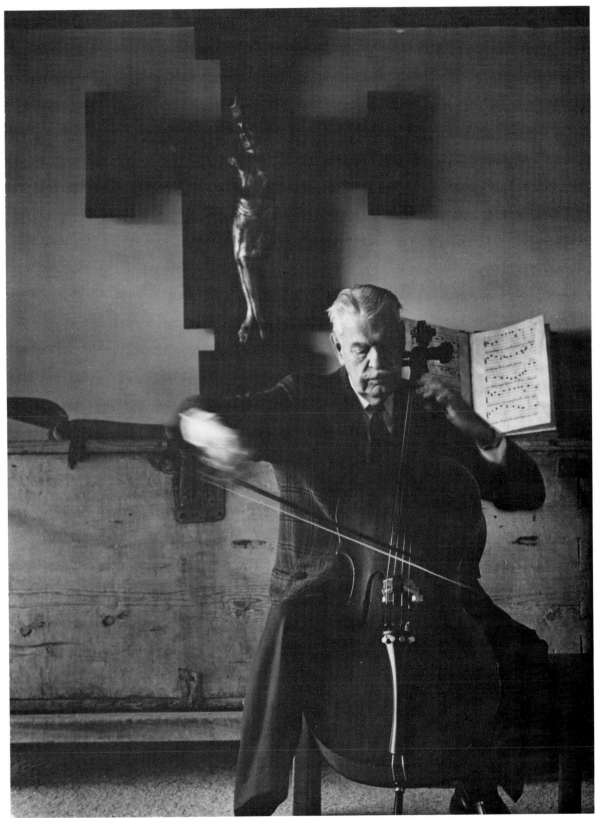

76.

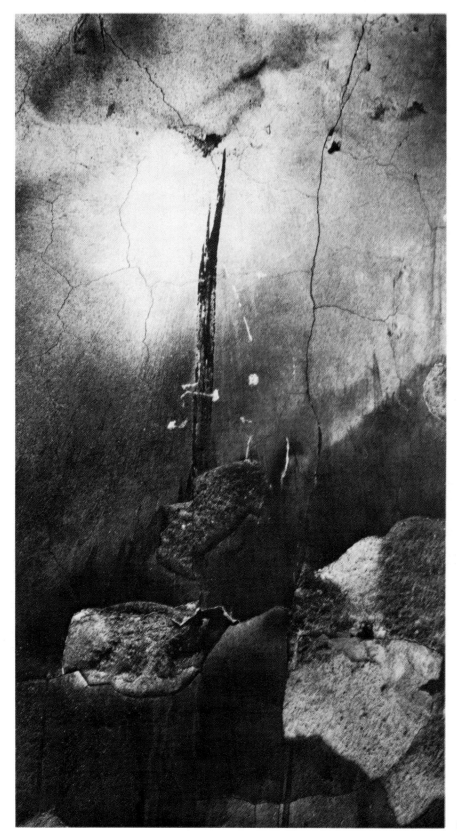

77.

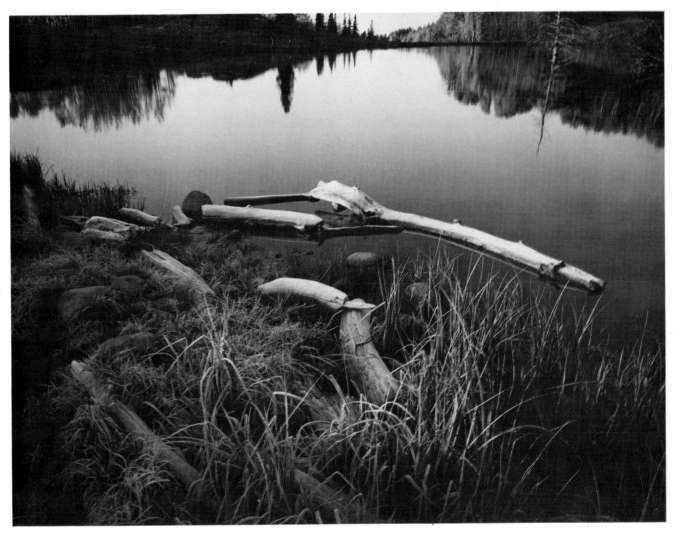

78.

77. Minor White, *Wall, Santa Fe, New Mexico,* 1966. Silver print. Minor White Archive, Princeton University.

78. Wayne Gravning, *Canjilon Lakes,* 1966. Silver print. Courtesy of the artist.

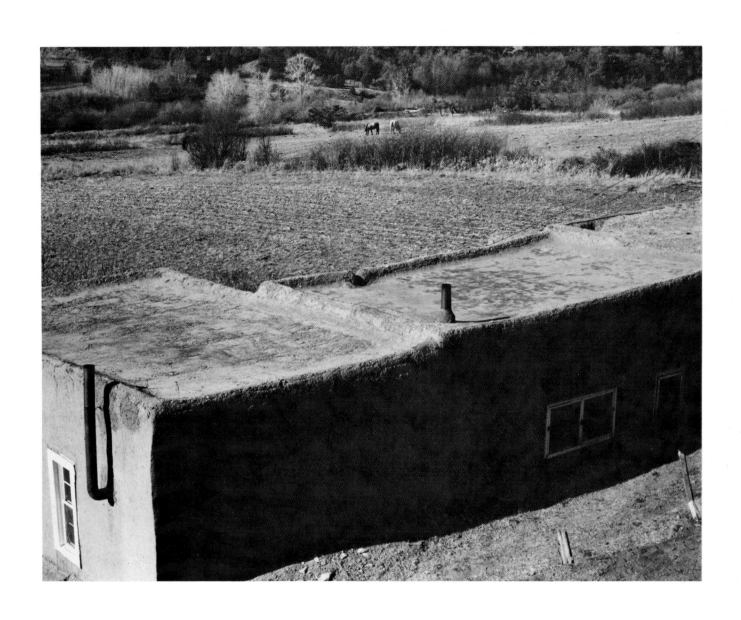

79. Arthur LaZar, *Rooftop—Cordova*, 1973. Silver print. Collection of University of New Mexico Art Museum.

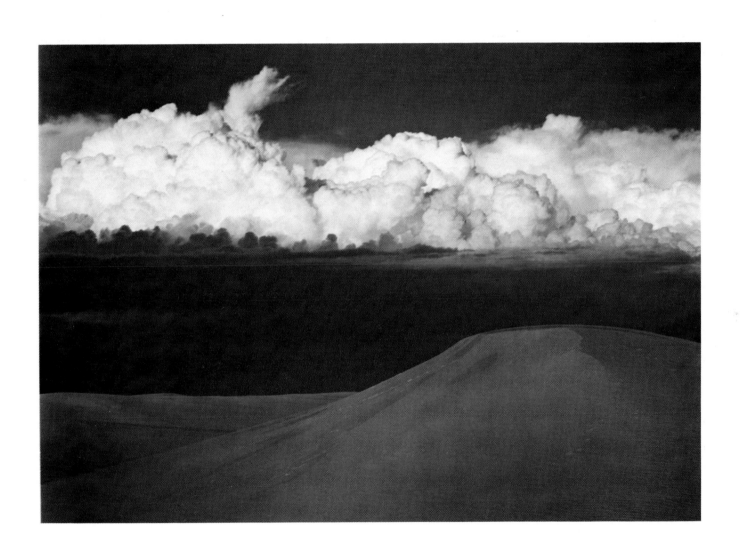

80. Richard Faller, *White Sands,* 1969. Silver print. Courtesy of the artist.

81. Thomas J. Cooper, *Untitled* (woods), 1972. Silver print. Gift of the artist to University of New Mexico Art Museum.

82. Arthur LaZar, *Lava Flow, New Mexico,* 1970. Silver print. Collection of University of New Mexico Art Museum.

127

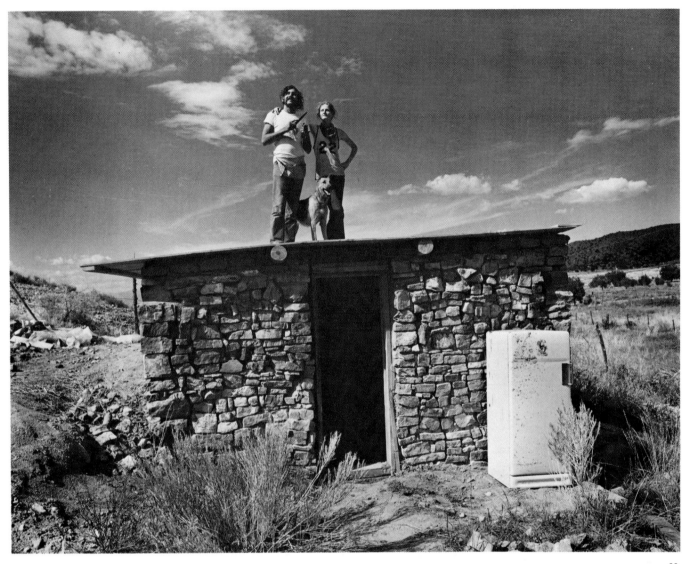

83.

83. Robert d'Alessandro, *John and Susan and Jimmy, Placitas,* 1976. Silver print. Courtesy of the artist.

84. Meridel Rubenstein, *C. C. Cass and "The Good Old Days,"* 1976. Silver print. Greater University of New Mexico Fund Grant, Collection of University of New Mexico Art Museum.

128

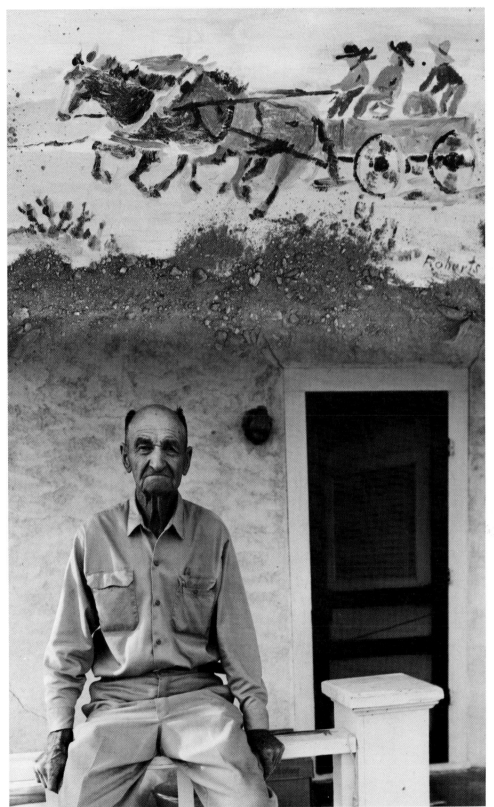

84.

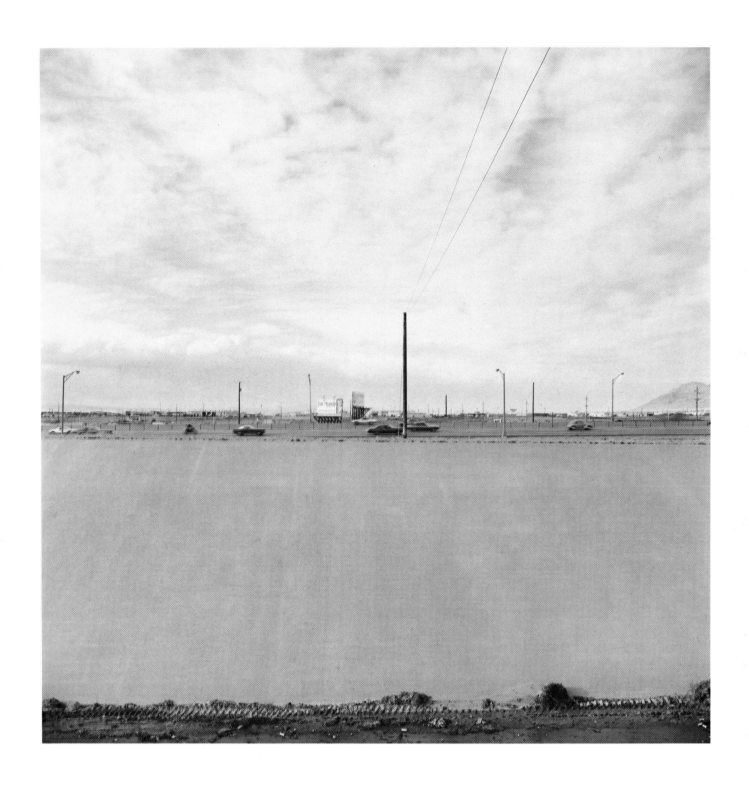

85. Frank W. Gohlke, *Landscape—Albuquerque, New Mexico, 1974*, 1976. Chlorobromide print. Collection of University of New Mexico Art Museum.

86. Rick Dingus, *Untitled #12, 1977*. Crayon/bromide print. From M.A. Thesis Exhibition, Collection of University of New Mexico Art Museum.

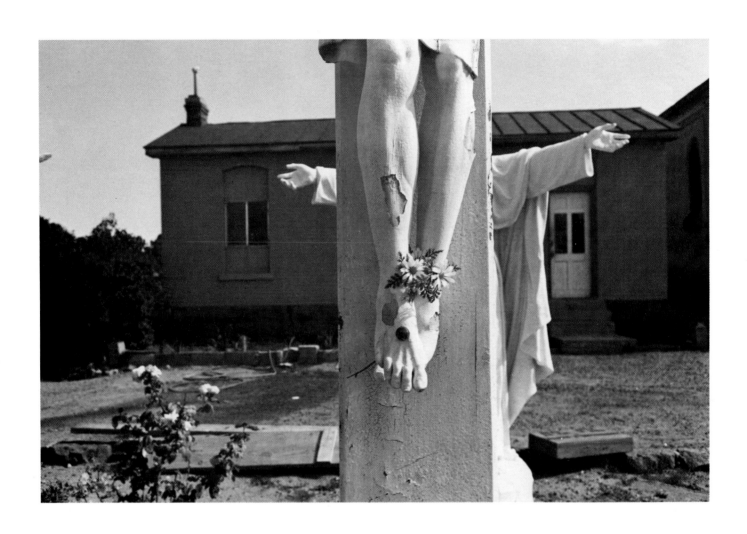

87. Lee Friedlander, *Santa Fe,* 1975. Chlorobromide print. Collection of University of New Mexico Art Museum.

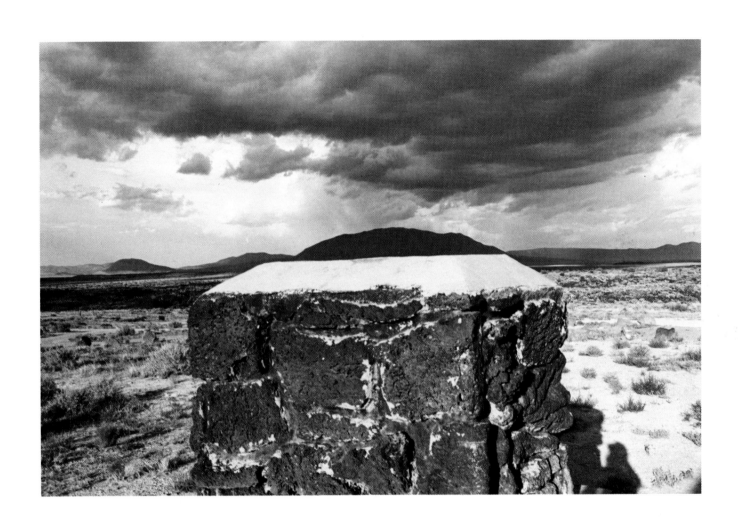

88. Lee Friedlander, *Valley of the Fire, New Mexico, 1975.* Chlorobromide print. Courtesy of the artist.

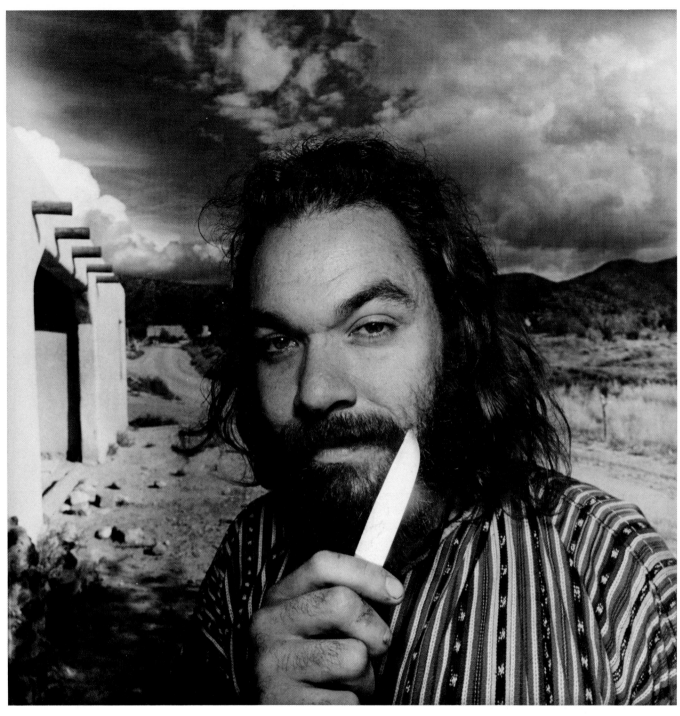

89. Paul Diamond, *Tourist, New Mexico,* 1971. Silver print. Collection of University of New Mexico Art Museum.

90. Betty Hahn, *Starry Night Variation #2,* 1977. Silkscreen print. Courtesy of the artist.

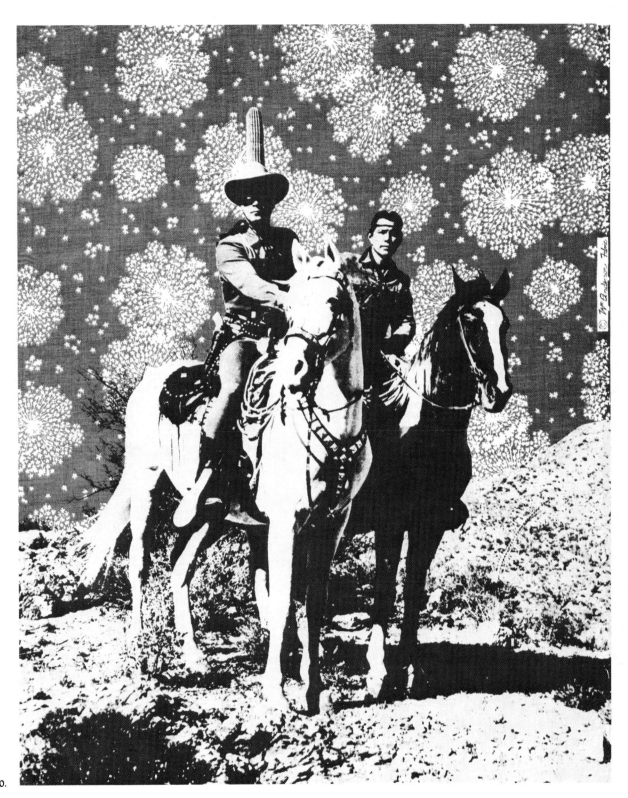

90.

135

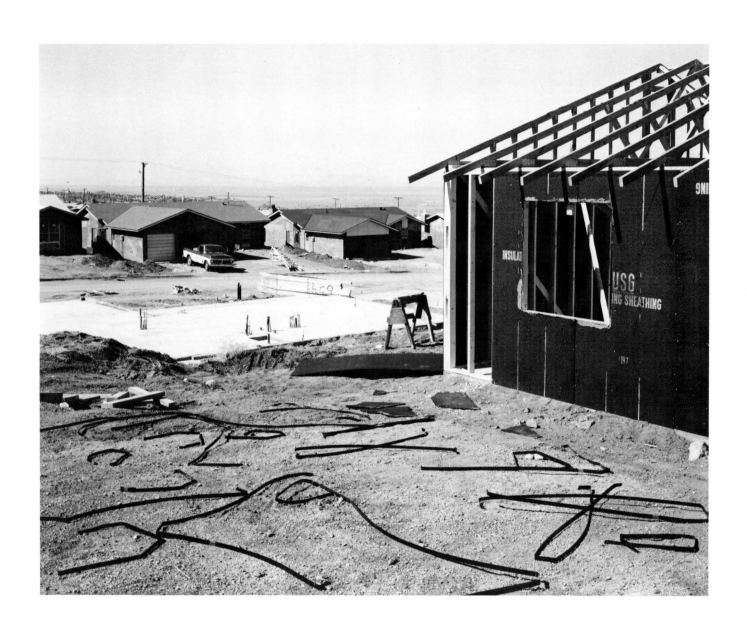

91. Kevin Wrigley, *#6: Impregnated Sheathing, 905 Oro Real, Pleasant Hills Subdivision,* 1977.
Toned silver print. Courtesy of the artist.

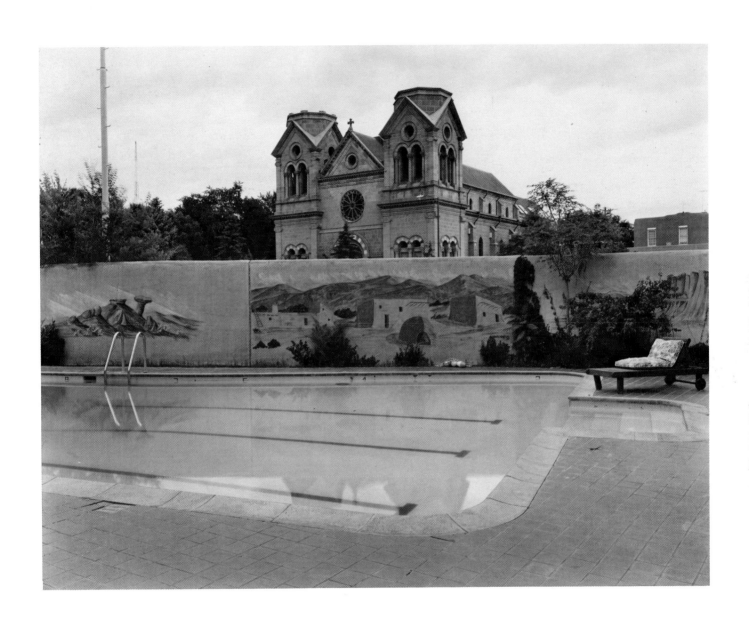

92. Nicholas Nixon, *La Fonda, Santa Fe, New Mexico,* 1973. Silver print. Collection of University of New Mexico Art Museum.

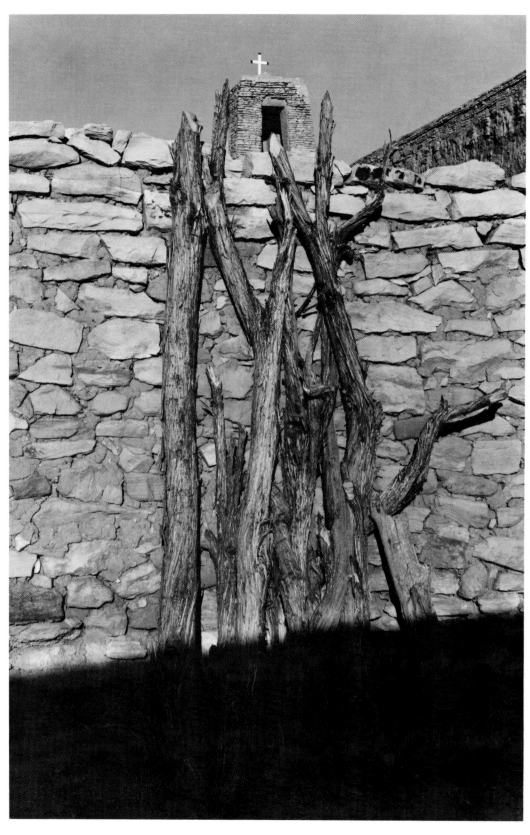

93.

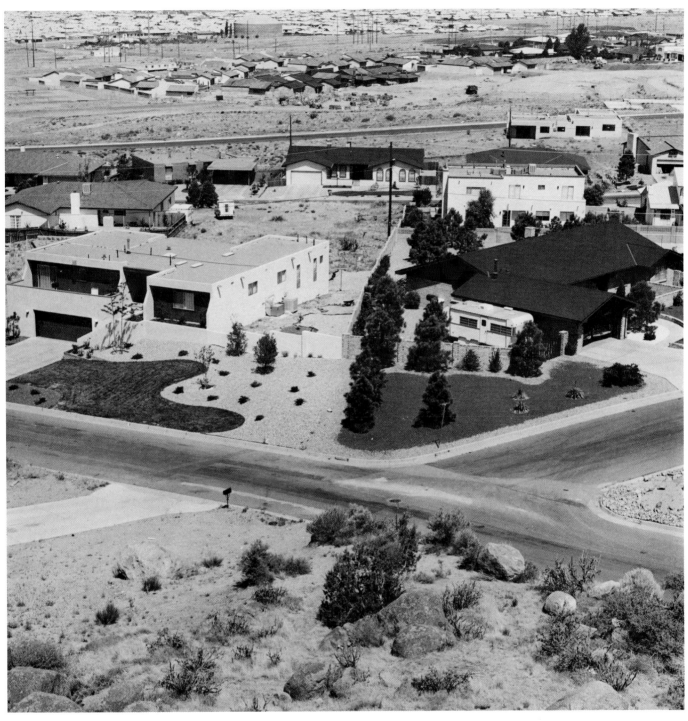

94.

93. Paul Caponigro, *Acoma Pueblo*, 1970. Silver print. Courtesy of the artist.

94. Joe Deal, *Untitled View* (Albuquerque), 1975. Silver print. From M.A. Thesis Exhibition, Collection of University of New Mexico Art Museum.

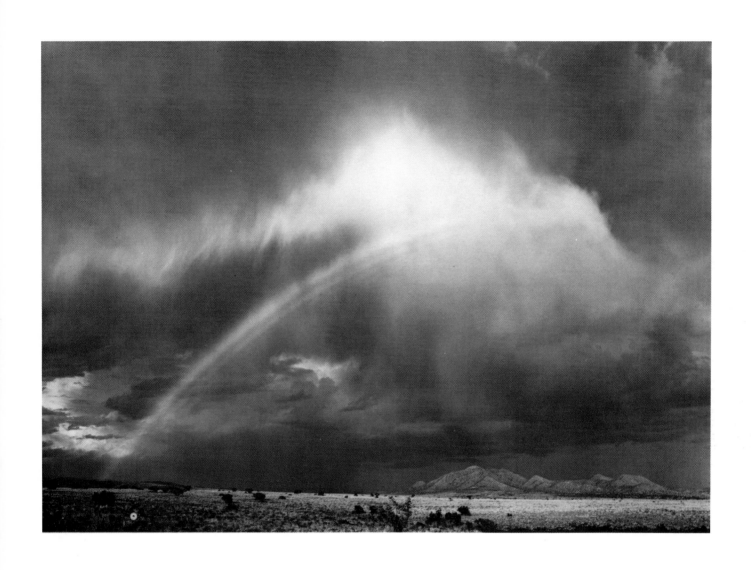

95. William Clift, *Rainbow, Waldo, N.M.*, 1978. Silver print. Courtesy of the artist and the Bell System.

140

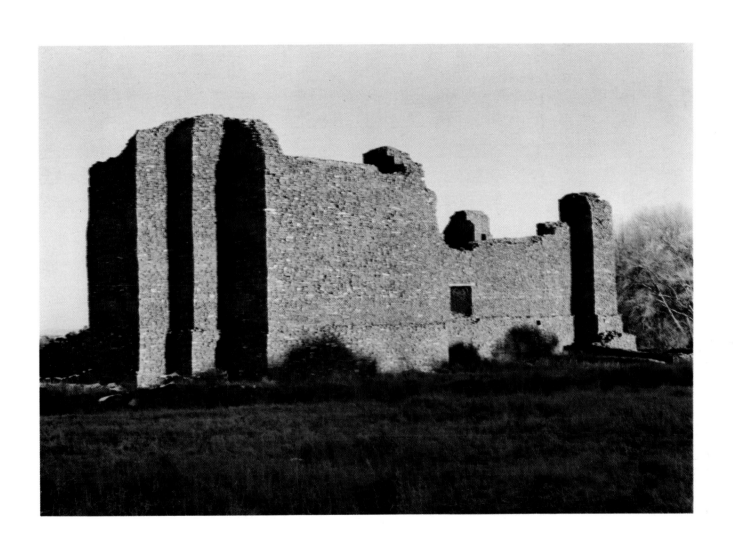

96. Edward Ranney, *Quarai, N.M.,* 1978. Silver print. Courtesy of the artist.

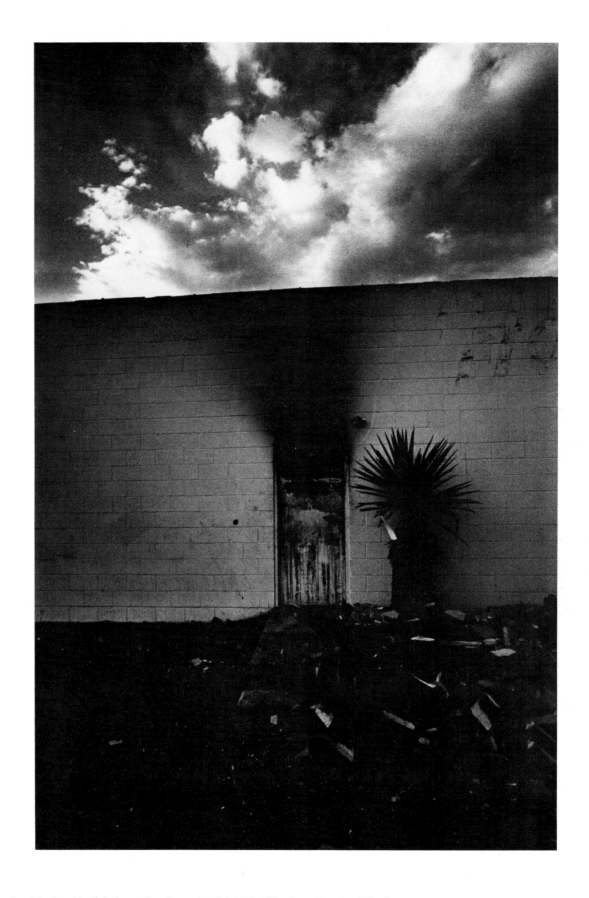

97. Ray Metzker, *Untitled* (sky, wall, palm, and rocks), 1972. Chlorobromide print. Gift of
the artist to University of New Mexico Art Museum.

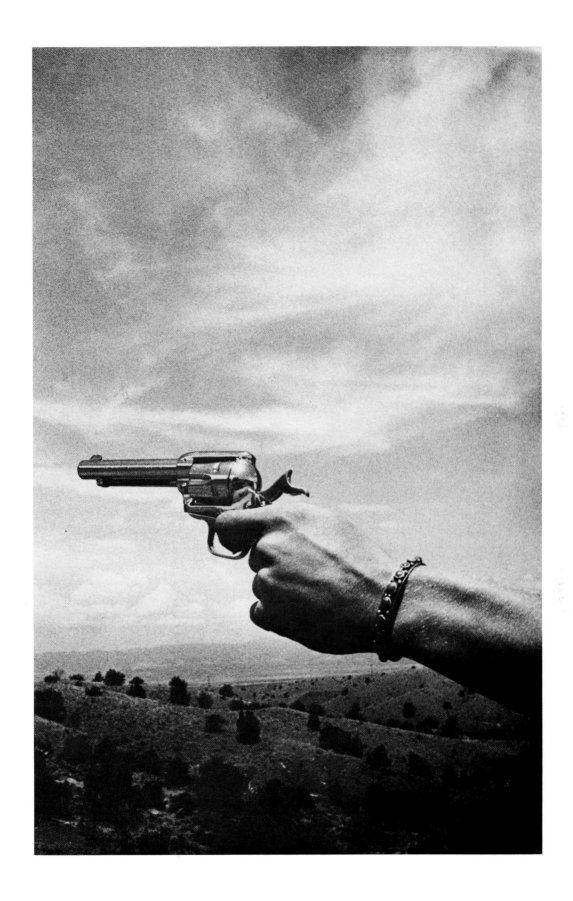

98. Ralph Gibson, *Untitled* (hand with gun), 1972. Silver print. Courtesy of the artist.

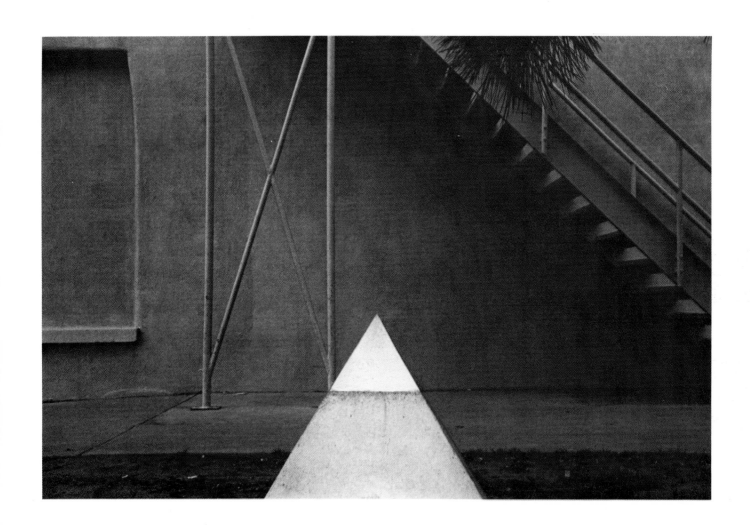

99. Thomas Patton, *Untitled* (wall with stairwell from the series "Isolations and Intrusions"), 1977. Silver print. From M.A. Thesis Exhibition, Collection of University of New Mexico Art Museum.

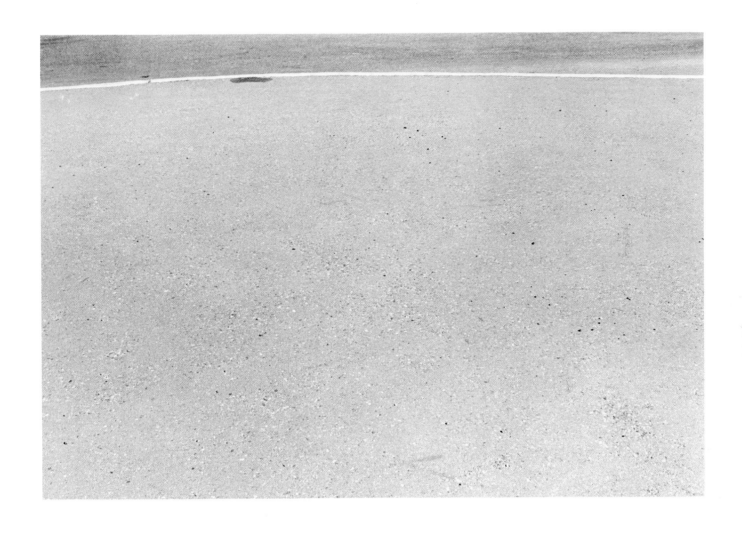

100. Richard Barish, *Untitled* (asphalt with strip), 1977. Silver print. From M.A. Thesis
Exhibition, Collection of University of New Mexico Art Museum.

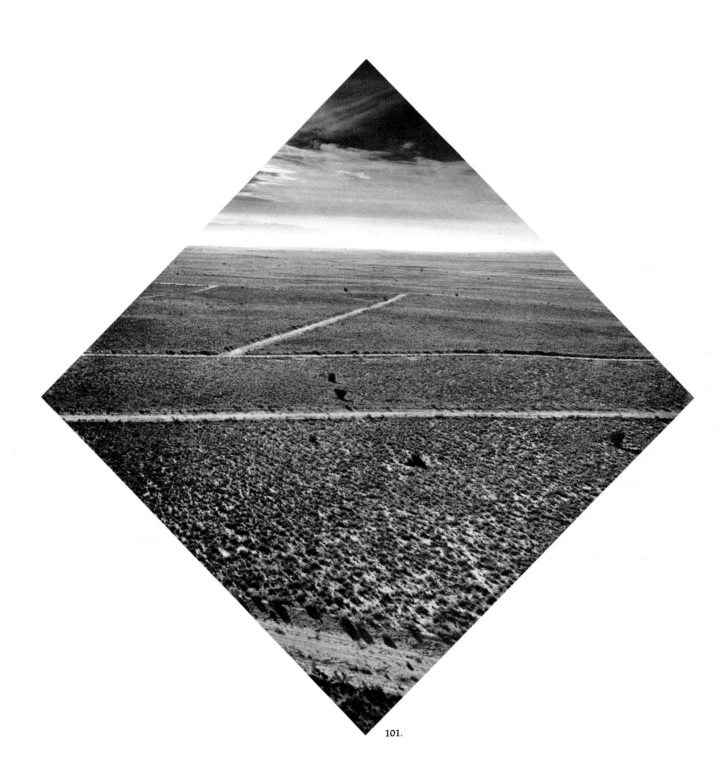

101.

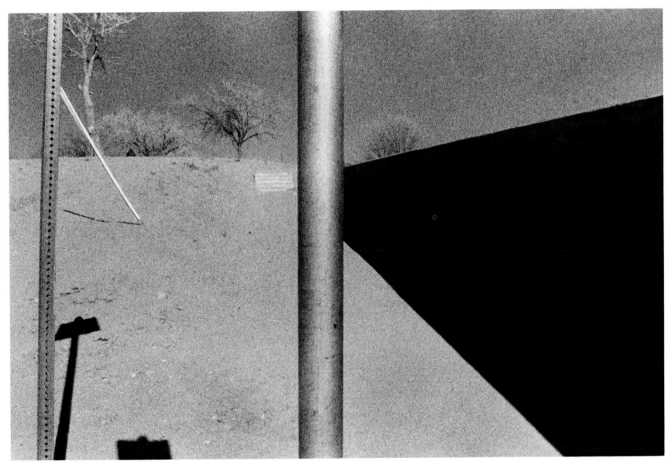

102.

101. Kenneth W. Baird, *Untitled* (from the series "The Horizon: Visual Concepts"), 1977. Silver print. From M.A. Thesis Exhibition, Collection of University of New Mexico Art Museum.

102. James K. Dobbins, *Albuquerque 76Z178,* 1976. Chlorobromide print. From M.A. Thesis Exhibition, Collection of University of New Mexico Art Museum.

Notes

1. Nancy Newhall, *Ansel Adams,* vol. 1, *The Eloquent Light* (San Francisco: Sierra Club, 1963), p. 48.

2. *The Philadelphia Photographer* 12, no. 133 (1875):30.

3. This list is from a catalogue found in the Archives of the Museum of New Mexico, History Division.

4. *The Philadelphia Photographer* 19, no. 221 (1882):9.

5. Charles F. Lummis, *The Land of Poco Tiempo* (1928; rpt. Albuquerque: University of New Mexico Press, 1966), p. 91; Marc Simmons, *Two Southwesterners: Charles Lummis and Amado Chaves* (Cerrillos, N.M.: San Marcos Press, 1968), p. 16.

6. Theodore Roosevelt, foreword to *The North American Indians,* by Edward S. Curtis (New York, 1907).

7. Curtis, *North American Indians,* introduction.

8. Information contained in letter to author from Naomi Rosenblum, May 19, 1978.

9. The information on Strand's association with Cornelia Thompson is derived from Harold Jones, "The Work of Photographers Paul Strand and Edward Weston: With an Emphasis on Their Work in New Mexico" (M.F.A. diss., University of New Mexico).

10. Calvin Tomkins, "Look to the Things Around You," *The New Yorker,* Sept. 16, 1974, p. 62.

11. Paul Strand, "Photography to Me," *Minicam* 8, no. 8, (1945):90.

12. Nancy Newhall, *The Eloquent Light,* p. 60.

13. Ibid, p. 51.

14. Ibid, p. 65.

15. Edward Weston, "I Photograph Trees," *Popular Photography* 6, no. 6 (1940):121.

16. Edward Weston and Charis Weston, *California and the West* (New York: Duell, Sloan and Pierce, 1940), p. 104.

17. *Ibid.,* p. 103.

18. Henri Cartier-Bresson, *The Decisive Moment* (New York: Simon and Schuster, 1952), plate 16.

19. Margaret Weiss, "Eliot Porter: Conservationist with a Camera," *Saturday Review,* Oct. 2, 1971, p. 58.

20. Quoted in Edna Bennett, "Black and White Are the Colors of Robert Frank," *Aperture* 9, no. 1 (1961):22.

Selected Bibliography

Compiled by Amy Conger

The entries in the first section of this bibliography were chosen because they deal specifically with the history and character of photography in New Mexico. In a few cases, photography in New Mexico is not actually mentioned, but the material in these entries is of such value that it cannot be omitted. In the second section, the entries were selected because they give information about or are unusually relevant to the work of individual photographers in New Mexico.

GENERAL

Andrews, Ralph W. *Photographers of the Frontier West: Their Lives and Works, 1875 to 1915*. Seattle: Superior Publishing Co., 1965.

—————. *Picture Gallery Pioneers: 1850 to 1875*. New York: Bonanza Books, 1964.

Bell, William A. *New Tracks in North America: A Journal of Travel and Adventure whilst Engaged in the Survey for a Southern Railroad to the Pacific Ocean during 1867–8*. London: Chapman & Hall, 1870. Reprint, Albuquerque, N.M.: Horn & Wallace Publishers, 1965.

Biebel, Charles, and William Baurecht. "Documents of Cultural Change: Albuquerque, 1881–1976." *New America* 3 (1977):63–66.

Butler, Tom. "Museum Collection Puts History at Your Fingertips." *Afterimage* 6, no. 3 (October 1978):20–21.

Christiansen, Paige W., ed. *Pictures of Old Socorro and Catron Counties*. Socorro County Historical Society Publications in History, vols. 2 and 5. Socorro, N.M.: 1966 and 1970.

Coke, Van Deren. *Nineteenth Century Photographs from the Collection*. Albuquerque: Art Museum, University of New Mexico, 1976.

—————. *Photographs, Photographically Illustrated Books, and Albums in the UNM Libraries: 1843–1933*. Albuquerque: Art Museum, University of New Mexico, 1977.

—————. *Twelve Contemporary Artists Working in New Mexico*. Albuquerque: Art Museum, University of New Mexico, 1976.

Davis, Keith F. "Photography at the University of New Mexico." *Artspace* 1, no. 4 (Summer 1977):12–20.

—————. *Stereo-views of New Mexico*. Albuquerque: Department of Art, University of New Mexico.

Fawcett, Waldon. "Photographing the Indians of the Southwest." *The Photographic Times* 38, no. 1 (January 1906):5–11.

Fitzpatrick, George, and Harvey Caplin. *Albuquerque: 100 Years in Pictures, 1875–1975*. Albuquerque: Calvin Horn Publisher, 1975.

Glover, Vernon J., ed. *The Railroad Collection*. Vol. 1. Santa Fe: Museum of New Mexico, 1977.

Goetzmann, William. *Exploration and Empire*. New York: Alfred A. Knopf, 1966.

Hume, Sandy, Ellen Manchester, and Gary Metz, eds. *The Great West: Real/Ideal*. Boulder: University of Colorado, 1977.

Newhall, Beaumont. "Early Western Photographers." *Arizona Highways* 22, no. 5 (May 1946):4–11. Reprinted in *International Photographer* 19, no. 3 (March 1947):4 ff.

Ostroff, Eugene. *Photographing the Frontier*. Washington, D.C.: Smithsonian Institution Press, 1976.

Robertson, Jamie. "Excavations—Photography in the Southwest to 1912: An Annotated Bibliography." *New America* 3, no. 1 (Spring 1977):76–78.

Rudisill, Richard. *Photographers of the New Mexico Territory: 1854–1912*. Santa Fe: Museum of New Mexico, 1973.

Scherer, Joanna Cohan, with Jean Burton Walker. *Indians: The Great Photographs that Reveal North American Indian Life, 1847–1929, from the Unique Collection of the Smithsonian Institution*. New York: Crown Publishers, 1973.

Strel, Don. "New Mexico Photographers/The Museum of New Mexico." *Artspace* 1, no. 4 (Summer 1977):37–40.

Taft, Robert. *Photography and the American Scene: A Social History, 1839–1889*. New York: Macmillan Co., 1938. Reprint, New York: Dover Publications, 1964.

INDIVIDUAL PHOTOGRAPHERS

Ansel Adams

Adams, Ansel. *Photographs of the Southwest*. Boston: New York Graphic Society, 1976.

—————, and Nancy Newhall. "Sanctuary in Adobe." *American Heritage* 13, no. 3 (April 1962):68–75.

Austin, Mary, and Ansel Adams. *Taos Pueblo*. San Francisco: Grabhorn Press, 1930.

Cooper, T., and P. Hill. "Camera-Interview: Ansel Adams." *Camera* 55, no. 1 (January 1976):15 ff.

Newhall, Nancy. *Ansel Adams: The Eloquent Light*, vol. 1. San Francisco: Sierra Club, 1963.

Kenneth Baird

Baird, Ken. "Albuquerque Experience." *British Journal of Photography*, July 14, 1978, pp. 598–602.

Thomas Barrow

Barendse, Henri Man. "Thomas Barrow." *Artspace* 1, no. 4 (Summer 1977):21–25.

Jenkins, William. *The Extended Document: An Investigation of Information and Evidence in Photographs*. Rochester, N.Y.: International Museum of Photography, 1975.

Tucker, Jean S. *Aspects of American Photography, 1976*. St. Louis: University of Missouri, 1976.

Wise, Kelly, ed. *Photographer's Choice*. Danbury, N.H.: Addison House, 1975.

John Candelario

"New Mexico: John Candelario's Photographs of the Southwest." *U.S. Camera* 7 (August 1944):22 ff.

Harvey Caplin

Armstrong, Ruth, and Harvey Caplin. *Enchanted Land, New Mexico*. Albuquerque: Calvin Horn Publishers, 1973.

Tiedebohl, Harriet. "Selling New Mexico in Pictures: Harvey Caplin." *New Mexico Magazine* 36, no. 10 (October 1958):23 ff.

Paul Caponigro

Bunnell, Peter C. "Paul Caponigro: Portrait of Nature." *Modern Photography* 37, no. 12 (December 1973):82–91.

Caponigro, Paul. *Landscape*. New York: McGraw-Hill, 1975.

Tucker, Jean S. *Aspects of American Photography 1976*. St. Louis: University of Missouri, 1976.

Weiss, Margaret R. "Caponigro's Sense of Site." *Saturday Review*, May 15, 1976, pp. 46–48.

Henri Cartier-Bresson

Cartier-Bresson, Henri. *The Decisive Moment*. New York: Simon & Shuster, 1952..

William Gunnison Chamberlain

Harber, Opal M. "A Few Early Photographers of Colorado." *Colorado Magazine* 33, no. 1 (1956):284–95.

William Clift

Coke, Van Deren. *Twelve Contemporary Artists Working in New Mexico*. Albuquerque: Art Museum, University of New Mexico, 1976.

Edward Sheridan Curtis

Andrews, Ralph Warren. *Curtis' Western Indians*. Seattle: Superior Publishing Co., 1962.

Brown, Joseph Epes. *The North American Indians: A Selection of Photographs by Edward S. Curtis*. New York: Aperture, 1972. Also published as *Aperture* 16, no. 4 (1972).

Curtis, Edward S. "Indians of the Stone Houses." *Scribner's Magazine* 45, no. 2 (February 1909):161–75.

———. *The North American Indian*. 20 vols. 20 portfolios. Cambridge, Mass.: University Press, 1907–30.

Ewing, Douglas C. "'The North American Indian in Forty Volumes." *Art in America* 60, no. 4 (July–August 1972):84–88.

Fowler, Don. *In a Sacred Manner We Live*. Barre, Mass.: Barre Publishing Co., 1972.

Graybill, Florence Curtis, and Victor Boesen. *Edward Sheridan Curtis: Visons of a Vanishing Race*. New York: Thomas Y. Crowell Co., 1976.

Joe Deal

Hajicek, James, ed. "Joe Deal: New Topographics." *Northlight* 4 (1977).

Jenkins, William, ed. *New Topographics: Photographs of a Man-altered Landscape*. Rochester, N.Y.: International Museum of Photography, 1975.

Ratcliff, Carter. "Route 66 Revisited: The New Landscape Photography." *Art in America* 64, no. 1 (January–February 1976): 86–91.

Wise, Kelly, ed. *Photographer's Choice*. Danbury, N.H.: Addison House, 1975.

Paul Diamond

Wise, Kelly, ed. *Photographer's Choice*. Danbury, N.H.: Addison House, 1975.

Richard Faller

Ott, Wendell. *Photographs by Richard Faller*. Roswell, N.M.: Roswell Museum & Art Center, 1972.

Robert Frank

Frank, Robert. *The Americans*. New York: Grove Press, 1959.

Lee Friedlander

Friedlander, Lee. *Lee Friedlander Photographs*. New York: Haywire Press, 1978.

Tucker, Jean S. *Aspects of American Photography, 1976*. St. Louis: University of Missouri, 1976.

Alexander Gardner

Sobieszek, Robert. "Alexander Gardner's Photographs Along the 35th Parallel." *Image* 14, no. 1 (January 1971):6–13.

Arnold Genthe

Genthe, Arnold. *As I Remember*. New York: Reynal & Hitchcock, 1936.

Laura Gilpin

Gilpin, Laura. *The Enduring Navaho*. Austin: University of Texas Press, 1968.

———. *Pueblos: A Camera Chronicle*. New York: Hastings House, 1941.

———. *The Rio Grande: River of Destiny*. New York: Duell, Sloan & Pearce, 1949.

Hill, Paul, and Tom Cooper. "Camera-Interview: Laura Gilpin." *Camera* no. 11 (November 1976):11 ff.

Laura Gilpin Retrospective. Santa Fe: Museum of New Mexico, 1974.

Tucker, Jean S. *Aspect of American Photography 1976*. St. Louis: University of Missouri, 1976.

Vestal, David. "Laura Gilpin: Photographer of the Southwest." *Popular Photographer* 80, no. 2 (February 1977):100 ff.

Frank W. Gohlke

Jenkins, William, ed. *New Topographics: Photographs of a Man-altered Landscape*. Rochester, N.Y.: International Museum of Photography, 1975.

Nixon, N. "Frank Gohlke." *Light and Substance*. Albuquerque: Art Museum, University of New Mexico, 1974.

Porter, Allan. "Dialogue with the Present to Document the Past." *Camera* no. 5 (May 1976):12–17.

Ratcliff, Carter. "Route 66 Revisited: The New Landscape Photography." *Art in America* 64, no. 1 (January–February 1976):86–91.

Betty Hahn

Bogardus, R. F. "Betty Hahn." *Light and Substance*. Albuquerque: Art Museum, University of New Mexico, 1974.

Eden, Abby. "Betty Hahn" [interview], *Artspace* 1, no. 2 (Winter 1976–77):14–19.

Murray, Joan. "Anne Noggle/Betty Hahn," *Popular Photography* 76, no. 3 (March 1975):30–32.

James Hajicek

Barendse, Henri Man. "James Hajicek" [interview], *Artspace* 2, no. 3 (Spring 1978):10–13.

Philip Embury Harroun

Olivas, Arthur, ed. *The Philip Embury Harroun Collection.* Santa Fe: Museum of New Mexico, 1975.

John K. Hillers

Darrah, William Culp. "Bedman, Fennemore, Hillers, Dellenbaugh, Johnson and Hattan: Photographers and Other Members of Expedition." *Utah Historical Quarterly* 16–17 (1948–49): 491–503.

Debooy, H. T. "Pioneer Photographers," *New Mexico Magazine* 37, no. 2 (February 1959):22–23.

William Henry Jackson

Howe, Hartley. "William Henry Jackson, Frontier Lensman." *U.S. Camera Annual* 1 (1941):65–92.

Jackson, Clarence S. *Picture Maker of the Old West: William H. Jackson.* New York: Charles Scribner's Sons, 1947.

Jackson, W. H. *Descriptive Catalogue of Photographs of North American Indians.* Washington, D.C.: Government Printing Office, 1877.

Newhall, Beaumont, and Diana E. Edkins. *William H. Jackson.* Fort Worth, Texas: Amon Carter Museum of Western Art, and Dobbs Ferry, N.Y.: Morgan & Morgan, 1974.

Ernest Knee

Knee, Ernest. *Santa Fe, New Mexico.* New York: Hastings House, 1942.

Dorothea Lange

Heyman, Theresa Than. *Celebrating a Collection: The Work of Dorothea Lange.* Oakland, Calif.: Oakland Museum, 1978.

Arthur LaZar

Bunting, Bainbridge. *Of Earth and Timbers Made: New Mexico Architecture.* Albuquerque: University of New Mexico Press, 1974.

Coke, Van Deren. *Twelve Contemporary Artists Working in New Mexico.* Albuquerque: Art Museum, University of New Mexico, 1976.

Russell Lee

Hurley, F. Jack. "Russell Lee." *Image* 16, no. 3 (September 1973):1–8.

————. *Russell Lee—Photographer.* Dobbs Ferry, N.Y.: Morgan and Morgan, 1978.

Lee, Russell. "Life on the American Frontier—1941 Version: Pie Town, N.M." *U.S. Camera* 4, no. 4 (1941):39 ff.

Charles Fletcher Lummis

Fiske, Turbesé Lummis, and Keith Lummis. *Charles F. Lummis: The Man and His West.* Norman: University of Oklahoma Press, 1975.

Gordon, Dudley. "Lummis, Pioneer Photographer and Writer." *New Mexico Magazine* 42, no. 9 (September 1964): 17 ff.

Hajicek, James Richard. "The Photography of Charles Fletcher Lummis: 1887–1892." M.F.A. dissertation, University of New Mexico, 1978.

Lummis, Charles Fletcher. *Some Strange Corners of Our Country: The Wonderland of the Southwest.* New York: Century Co., 1892. This was enlarged as *Mesa, Cañon and Pueblo: Our Wonderland of the Southwest.* New York: Century Co., 1925.

Powell, Lawrence Clark. "Song of the Southwest." *Westways* 65, no. 5 (May 1973):44 ff.

Sarber, Mary A. *Charles F. Lummis: A Bibliography.* Tucson: University of Arizona Graduate Library School, 1977.

Danny Lyon

Butler, Tom. "Danny Lyon, Photographs." *Artspace* 2, no. 1 (Fall 1977):47–48.

Lyon, Danny. *The Paper Negative.* New York: Addison House, 1979.

McCoy, Dan. "Conversations from a Phone Booth on Route 66: Danny Lyon." *U.S. Camera Annual* (1972):145–50.

Ray Metzker

Edwards, Owen. "Exhibitions: Ray Metzker." *American Photographer* 1, no. 6 (November 1978):10–11.

Wise, Kelly, ed. *Photographer's Choice.* Danbury, N.H.: Addison House, 1975.

Karl E. Moon

Carew, Harold D. "History of the Pueblos Told in Photographs; No Greater Wealth of Art Material than that Found in Land of Indians." *The Dearborn Independent,* September 8, 1923, p. 8.

Jerome, Ward. "Karl Moon's Photographic Record of the Indian of Today." *Craftsman* 20 (April 1911):24–32.

Rankin, Antoinette. "He Knows the Redman." *Sunset* 54, no. 2 (February 1925):28–29.

Wright Morris

Morris, Wright. *God's Country and My People.* New York: Harper & Row Publishers, 1968.

————. *The Inhabitants.* New York: Charles Scribner's Sons, 1946. Reprint, New York: Da Capo Press, 1972.

Wright Morris: Structures and Artifacts. Photographs 1933–1954. Lincoln: Sheldon Memorial Art Gallery, University of Nebraska, 1975.

Nicholas Nixon

Jenkins, William, ed. *New Topographics: Photographs of a Man-altered Landscape.* Rochester, N.Y.: International Museum of Photography, 1975.

Ratcliff, Carter. "Route 66 Revisited: The New Landscape in Photography." *Art in America* 64, no. 1 (January–February 1976):86–91.

Anne Noggle

"Anne Noggle: Presidigitation, Eyesight and Hindsight." *Album* no. 10 (October 1970):12–17.

Costello, Michael. *Anne Noggle.* Santa Fe: Santa Fe Gallery of Photography, 1977.

Lloyd, Valerie. "Time, Space, Women and Aging." *ArtWeek* 8, no. 33 (October 8, 1977):12–13.

Murray,.. Joan. "Anne Noggle/Betty Hahn." *Popular Photography* 76, no. 3 (March 1975):30, 32.

Noggle, Anne. "Prestidigitation, Eyesight, Hindsight." M.A. thesis, University of New Mexico, 1970.

Timothy O'Sullivan

Horan, James. *Timothy O'Sullivan: America's Forgotten Photographer.* New York: Bonanza Books, 1966.

Newhall, Beaumont, and Nancy Newhall. *T. H. O'Sullivan, Photographer.* Rochester, N.Y.: George Eastman House, 1966.

Thomas Patton

Jacobs, James. "Prelude 1976," *ArtWeek* 7, no. 5 (January 31, 1976):14.

Eliot Porter

Caulfield, Patricia. "The Art and Technique of Eliot Porter: An Interview," *Natural History* 76, no. 10 (December 1967):26–31, 92–94.

Tucker, Jean S. *Aspects of American Photography 1976.* St. Louis: University of Missouri, 1976.

William H. Rau

"Our Picture," *Philadelphia Photographer* 19, no. 221 (May 1882):129–30.

Herbert F. Robinson

Brewer, Robert J., ed. *The H. F. Robinson Collection.* Santa Fe: Museum of New Mexico, n.d.

Meridel Rubenstein

Rubenstein, Meridel. *La Gente de la Luz: Portraits from New Mexico.* Santa Fe: Museum of New Mexico, 1977.

Henry A. Schmidt

"Henry A. Schmidt, Photographer." *New America* 3, no. 1 (Spring 1977):18–27.

"Pioneer Photographer." *New Mexico Magazine* 35, no. 8 (August 1957):18–19.

Joseph Edward Smith

McKee, John Dewitt, and Spencer Wilson. *Socorro Photographer: Joseph Edward Smith, 1858–1936.* Socorro County Historical Society Publications in History, vol. 7. Socorro, N.M., 1974.

Phillips, David R., ed. *The Taming of the West: A Photographic Perspective.* Chicago: Henry Regnery Co., 1974.

———. *The West: An American Experience.* Chicago: Henry Regnery Co., 1973.

Paul Strand

Jones, Harold Henry. "The Work of Photographers Paul Strand and Edward Weston, with an Emphasis on Their Work in New Mexico." M.F.A. dissertation, University of New Mexico, 1978.

Tomkins, Calvin. *Paul Strand: Sixty Years of Photographs.* Millerton, N.Y.: Aperture, 1976.

———. "Profile: Look to the Thing Around You." *The New Yorker,* September 16, 1974, pp. 44–94.

Adam Clark Vroman

Lummis, Charles Fletcher. "The Disenchanted Libbey." *Land of Sunshine* 7, no. 5 (October 1897):200–202.

Mahood, Ruth, ed. *Photographer of the Southwest: Adam Clark Vroman.* Los Angeles: Ward Ritchie Press, 1961.

Vroman, Adam Clark. "Katzimo, the Enchanted Mesa." *Photo Era* 7, no. 4 October 1901, pp. 140–45.

———. "Photography in the Great Southwest." *Photo Era* 6, no. 1 (January 1901):225–32.

———. "The Pueblo of Zuni." *Photo Era* 7, no. 2 (August 1901):59–65. Reprinted with an introduction by Ruth I. Mahood in *The American West* 3, no. 3 (Summer 1966):42–55.

Webb, William, and Robert A. Weinstein. *Dwellers at the Source: Southwestern Indian Photographs of A. C. Vroman, 1895–1904.* New York: Grossman publishers, 1973.

Todd Webb

Newhall, Beaumont. "Todd Webb." *Todd Webb Photographs: Early Western Trails and Some Ghost Towns.* Fort Worth, Texas: Amon Carter Museum of Western Art, 1965.

Edward Weston

Elkort, Martin. "A Portfolio of Edward Weston's New Mexico Photographs." *New Mexico Magazine* 39, no. 1 (January 1961):14–23 [12 photographs selected from the 24 originally published in the same magazine in June, July, August, September 1939 and January 1940].

Jones, Harold Henry. "The Work of Photographers Paul Strand and Edward Weston, with an Emphasis on Their Work in New Mexico." M.F.A. dissertation, University of New Mexico, 1978.

Weston, Charis Wilson, and Edward Weston. *California and the West.* New York: Duell, Sloan & Pearce, 1940.

George Ben Wittick

Packard, Gar, and Maggy Packard. *Southwest 1880, with Ben Wittick. Pioneer Photographer of Indian and Frontier Life.* Santa Fe: Packard Publications, 1970.

Valkenburgh, Richard Van. "Pioneer Photographer of the Southwest." *Arizona Highways* 18, no. 8 (August 1942):36–39.

Chronology

c. 1847 Unknown cameraman makes daguerreotype portrait of Padre Antonio José Martínez in Taos or Santa Fe.

c. 1851 Siegmund Seligman opens daguerreotype studio in Santa Fe, the first known in New Mexico.

1866 Nicholas Brown and his son, William Henry Brown, establish portrait studio in Santa Fe.

1867 Alexander Gardner photographs in New Mexico for Union Pacific–Eastern Division Railroad survey.

1873 Timothy O'Sullivan photographs in Zuni Pueblo area and at Canyon de Chelly.

1877 William Henry Jackson photographs in New Mexico with dry plates, which prove to be defective.

1878 Ben Wittick arrives in Santa Fe.
George C. Bennett active in Santa Fe making stereographs and view cards.

1879–80 John Hillers, accompanying James Stevenson's ethnological expedition, photographs the pueblos of New Mexico.

c. 1880–1906 Joseph Edward Smith operates a studio in Socorro, N.M.

1881 Jackson photographs in New Mexico during the summer.
Wittick opens studio in Albuquerque.

1884–1900 Wittick operates a studio in Gallup, N.M.

1888–92 Charles Lummis lives at Isleta Pueblo and photographs Indians in the region.

1889 William Henry Cobb settles permanently in Albuquerque.

1890 Eddie Ross (later Cobb) begins work in W. H. Cobb's studio.

1897–99 Adam Clark Vroman makes several trips to the Rio Grande pueblos and to Zuni, Acoma, and Laguna.

1899 Arnold Genthe photographs in New Mexico, including Western pueblos.
Jackson photographs in the Acoma and Laguna pueblos areas.

1900 Vroman returns to Rio Grande and Western pueblos.

1902 Vroman returns to Rio Grande and Western pueblos.

1903–4 Edward S. Curtis photographs Indians in New Mexico.

1904 Vroman returns to Western pueblos.

1904–8 William Pennington has a portrait studio in Albuquerque.

1904 Karl Moon establishes a studio in Albuquerque.

1911 Moon moves from Albuquerque to Grand Canyon, Arizona.

1923 Laura Gilpin begins photographing in New Mexico.
Ray Davis, with magnesium flashlight powder, takes first photographs in Carlsbad Caverns, New Mexico.

1925 Curtis returns to New Mexico to photograph Indians at Laguna, Cochiti, Santo Domingo, Picuris, Pecos, San Juan, and Tesuque pueblos.

1926 Genthe returns to New Mexico.
Paul Strand comes to New Mexico for the first time.

1927 Ansel Adams visits New Mexico for the first time and photographs in Santa Fe and Taos areas.

1930 *Taos Pueblo* is published, with text by Mary Austin and photographs by Adams.
Dorothea Lange visits Santa Fe and Taos.

1930–32 Strand comes to New Mexico each summer to work in and near Taos.

1931 Willard Van Dyke and Edward Weston photograph in New Mexico during the summer.

1932 Ernest Knee moves to Santa Fe.

1933 Weston photographs in New Mexico.

1935 Lange photographs migration from Oklahoma for the FSA in New Mexico.

1936 Arthur Rothstein photographs for FSA in New Mexico.

1937 Weston receives Guggenheim fellowship; photographs in Albuquerque, Santa Fe, and Taos.

1939–40 Russell Lee photographs in Pietown, N.M., and elsewhere in the state for FSA.

1940 Wright Morris photographs in New Mexico.

1943 Jack Delano photographs for FSA in Albuquerque and along the Santa Fe Railroad route in New Mexico.
John Collier photographs for OWI in New Mexico.

1945 Harvey Caplin establishes studio in Albuquerque.

1946	Gilpin moves to Santa Fe.
	Eliot Porter moves to Tesuque, near Santa Fe.
1947	Henri Cartier-Bresson photographs in New Mexico.
1955–56	Robert Frank photographs in New Mexico.
1963	Van Deren Coke begins the creative photography program in the Department of Art and starts collecting photographs for the Art Museum of the University of New Mexico.
1964	Anne Noggle begins working in photography in New Mexico.
1965	Ann Dietz founds the Quivira Gallery in Corrales to exhibit photographs.
1966	Richard Rudisill joins the University of New Mexico Department of Art to teach history of photography.
	Minor White teaches workshop in Albuquerque.
1968	James Alinder receives the first MFA in creative photography at University of New Mexico.
1969	Ellie Scott founds the f-22 Gallery in Santa Fe to show photographs.
1970	Danny Lyon moves to Bernalillo.
1971	Beaumont Newhall retires as director of George Eastman House and is appointed professor of the history of art at the University of New Mexico.
	William Clift moves to Santa Fe.
1973	Paul Caponigro moves to Santa Fe.
	Thomas Barrow comes from George Eastman House to the University of New Mexico Department of Art to teach both creative photography and history of photography.
1976	Keith McElroy receives the first University of New Mexico Ph.D. in art history with a major in the history of photography.
	Betty Hahn moves to Albuquerque from Rochester to teach creative photography and nonsilver processes in the University of New Mexico Department of Art.

Index

Italicized page numbers refer to illustrations.

Acoma Pueblo, 9, 11, 14, 20
Adams, Ansel, 1, 24–25, *84, 85, 86*
Armitage, Merle, 26
Atchison, Topeka & Santa Fe Railroad, 10, 11, 18, 20, 31
Atlantic and Pacific Railroad, 10
Austin, Mary, 24, 25

Baird, Kenneth, 43, *146*
Bandelier, Adolph, 15
Barish, Richard, 44, *145*
Barrow, Thomas, 38, *39*, 45
Bell, Dr. William, 4, 13
Bender, Albert, 24
Bennett, George C., 11
Brady, Mathew, 4, 5
Brown, Calvin W., 19, *59*
Brown, Nicholas, 2, *2*
Brown, William Henry, 11, 12, *51, 68*

Cahill, Holgar, 28
Candelario, John, 33, *102*
Caplin, Harvey, 35, *110*
Caponigro, Paul, 1, 41–42, *138*
Cartier-Bresson, Henri, 1, 33, *111*
Cassidy, Gerald, 28
Chamberlain, W. G., 13
Chase, Dana B., 18, *69*
Chaves, Ireneo, 15
Chaves, Manuel, 14
Chávez, Carlos, 23
Clift, William, 41, *140*
Clinton, J. L., 13, *68*
Cobb, William Henry, 19, *73*
Cochiti Pueblo, 13, 15, 20
Coke, Van Deren, 37
Collier, John, 30, *109*

Connell, Will, 28, *28*
Cook, Gen. George, 14
Cooper, Thomas, 34–35, *126*
Couse, Irving, 21, *21*
Curtis, Edward, 1, 18, *81, 82*

d'Alessandro, Robert, 43, *128*
Davey, Randall, 32
Davis, Benjamin, 19
Deal, Joe, 43–44, *139*
Delano, Jack, 30, *104*
Denver and Rio Grande Railroad, 11, 13
Diamond, Paul, 35, 36, *134*
Dietz, Ann, 45
Dingus, Rick, 45, *131*
Dobbins, James, 44, *147*

Elaine Horwitch Gallery, 48
El Paso, Texas, 10

f-22 Gallery, 45
Faller, Richard, 34–35, *125*
Farm Security Administration, 1, 30
Fort Defiance, Arizona, 6, 9
Fort Sumner, New Mexico, 2, 3
Fort Wingate, New Mexico, 10, 11
Frank, Robert, 1, 34, 35, 36, *113, 114*
Friedlander, Lee, 35–36, *132, 133*
Furlong, James, 20, *74*

Gaige, J. G., 2
Gallup, New Mexico, 10, 11, 17
Gardner, Alexander, 1, 4, 5, 6, 17, 48, 49
Genthe, Dr. Arnold, 18, *77*
Geronimo, 11
Gibson, Ralph, 36, *143*
Gilpin, Laura, 1, 32, *83, 99, 100, 101*
Ginsberg, Allen, 35
Gohlke, Frank, 43, *130*

Grants, New Mexico, 14
Gravning, Wayne, 34–35, *123*
Graves, Julius K., 3
Gurnsey, B. H., 13

Haas, Les, 37
Hahn, Betty, 39, 45, *135*
Hajicek, James, *42*, 43
Harper's Weekly, 8
Harroun, Philip E., 21, *96*
Hayden, F. V., 8
Heister, Henry T., 3
Hillers, John K., 6, 7, *7*, 8, *52, 53, 54*
Hill's Gallery, 45
Hook, William E., 18
Horwitch, Elaine. *See* Elaine Horwitch Gallery

Isleta Pueblo, 14, 15, 20

Jackson, William H., 1, 8, *9*, 10, 13, 17, *61, 62, 63, 64*
James, William, 23
Jeffers, Robinson, 25
Jones, Harold, 23
Jones, Paul Edwards, 27
Jonson, Raymond, 43
Judd, Donald, 43

Kansas Pacific Railroad, 4, 5
Keller, Thomas F., 19
Kent, Dick, 35
Kerouac, Jack, 35
Ketchum, Cavalliere, 38, *118*
King, Clarence, 6
Knee, Ernest, 26, *27*, 28, 33, *98*
Knee, Gina, 26
Kress, Maggie. *See* Maggie Kress Gallery

Laguna Pueblo, 5, 8, 9, 14, 18, 20
Lange, Dorothea, 1, 24, 30, 31, 36, *108*
Las Vegas, New Mexico, 11
Laval, Joseph, 35
Lawrence, D. H., 25
LaZar, Arthur, 34–35, *124, 127*
Lazorik, Wayne, 37
Lee, Russell, 30, *106, 107*
Leslie's Weekly, 11
Lockwood, Ward, 26
Los Cerrillos, New Mexico, 12
Luhan, Antonio, 25
Luhan, Mabel Dodge, 22, 25, 28
Lummis, Charles F., 14, *16*
Lyon, Danny, 42, *120*

Maggie Kress Gallery, 45
Marin, John, 28
Martínez, Padre Antonio José, 1, 2
Meem, John Gaw, 24
Mees, Dr. Kenneth, 28
Metzker, Ray, 40, *142*
Moon, Karl, 19–20, *79, 80*
Morgan, Barbara, 25, *97*
Morgan, Willard, 25
Morris, Wright, 31, *112*
Museum of New Mexico, 45

Nachee, 11
Nambe Pueblo, 20
Nash, Willard, 26
Newhall, Nancy, 24
Nims, Franklin A., 13, 18
Nixon, Nicholas, 41–42, *137*
Noggle, Anne, 38–39, *119*
Noskowiak, Sonya, 26, 27
Nusbaum, Jesse L., 21

O'Keeffe, Georgia, 22, 34
O'Sullivan, Timothy, 1, 4, 5, 6, *11, 55, 56, 57*

Palmer, Gen. Wilbur, 5
Parkhurst, Harmon T., 21, *94*
Patton, Thomas, 44, *144*
Pecos Pueblo, 12
Penitentes, 15
Pennington, William, 19, *78*
Philadelphia Photographer, 13
Pie Town, New Mexico, 30
Porter, Eliot, 33–34, *116*
Powell, Maj. John Wesley, 6, 7

Quivira Gallery, 45

Ranney, Edward, 42, *141*
Raton, New Mexico, 3
Rau, William H., 13, 14, *50*
Robinson, Herbert, 20, *95*
Roosevelt, Theodore, 18
Rosenblum, Naomi, 22
Ross, Eddie, 19
Rothstein, Arthur, 30, *103*
Rubenstein, Meridel, 43, *129*
Rudisill, Richard, 37
Russell, R. W., 10

San Felipe Pueblo, 11, 20
San Ildefonso Pueblo, 20
San Juan Pueblo, 6, 9, 13, 20
Santa Clara Pueblo, 20
Santa Fe Gallery of Photography, 45
Santo Domingo Pueblo, 11, 13, 20
Schmidt, Henry, 17, *71, 72*
Scott, Ellie, 45
Seligman, Siegmund, 1

Sharp, Joseph, 21
Smith, Joseph, 18, *70*
Smith, William A., 3
Stackpole, Peter, 28
Steichen, Edward, 34
Stella, Frank, 43
Stevenson, Col. John, 6, 7
Strand, Paul, 1, 22–24, *23, 87, 88, 89*
Stryker, Roy, 30, 34

Taos Pueblo, 11, 12, 20
Tahoma, Quincy, 21
Tesuque Pueblo, 12
Thompson, Cornelia, 23
Thonson, William, 29
Tomkins, Calvin, 24

Union Pacific Railroad, 4, 8
Updike, L. C., 19
University of New Mexico Art Museum, 45

Van Dyck, Willard, 26, 27–28, *93*
Vroman, Adam Clark, 17, *75, 76*

Webb, Todd, 34, *115*
Weiss, Margaret, 34
Wells, Cady, 32
Weston, Brett, 33, *117*
Weston, Edward, 1, 25–27, 28, 33, *90, 91, 92*
Wheeler, Lt. George, 6
White, Minor, 34, 35, 40, 42, *122*
White Oak Gallery, 45
Wittick, Ben, 10, *11, 65*
Wrigley, Kevin, 44, *136*

Zudick, Thomas, 43, *121*
Zuni Pueblo, 5, 6, 7, 11, 14, 17